THE LITERATURE OF PHOTOGRAPHY
AN ARNO PRESS COLLECTION

THE LITERATURE OF PHOTOGRAPHY

An Arno Press Collection

Advisory Editors:

PETER C. BUNNELL
PRINCETON UNIVERSITY

ROBERT A. SOBIESZEK
INTERNATIONAL MUSEUM OF PHOTOGRAPHY
AT GEORGE EASTMAN HOUSE

NONSILVER
PRINTING PROCESSES

Four Selections, 1886-1927

Edited by
PETER C. BUNNELL

ARNO PRESS
A NEW YORK TIMES COMPANY
NEW YORK ★ 1973

Reprint Edition 1973 by Arno Press Inc.

Elements of Photogravure was reprinted
by permission of Crosby Lockwood Staples Ltd.
The Oil and Bromoil Processes was reprinted
by permission of Hazell Watson and Viney Ltd.

Elements of Photogravure and *The Oil and Bromoil Processes*
were reprinted from copies in The George Eastman House Library

The Literature of Photography
ISBN for complete set: 0-405-04889-0
See last pages of this volume for titles.

Manufactured in the United States of America

LIBRARY OF CONGRESS CATALOGING IN PUBLICATION DATA

Bunnell, Peter C. comp.
 Nonsilver printing processes.

 (The Literature of photography)
 Reprint of Elements of photogravure, by C. N.
Bennett, first published 1927; of the 2d ed., 1898, of
Photo-aquatint, or The gum-bichromate process, by A.
Maskell and R. Demachy; of The oil and bromoil processes,
by F. J. Mortimer and S. L. Coulthurst, first published
1909; and of Platinotype, by G. Pizzighelli and Baron A.
Hubl, published 1886.
 1. Photography--Printing processes. 2. Photogra-
vure. I. Title II. Series.

TR350.B83 1973 770'.28 72-9221
ISBN 0-405-04928-5(clothbound) 0-405-04952-8(paperbound)

CONTENTS

ELEMENTS OF PHOTOGRAVURE

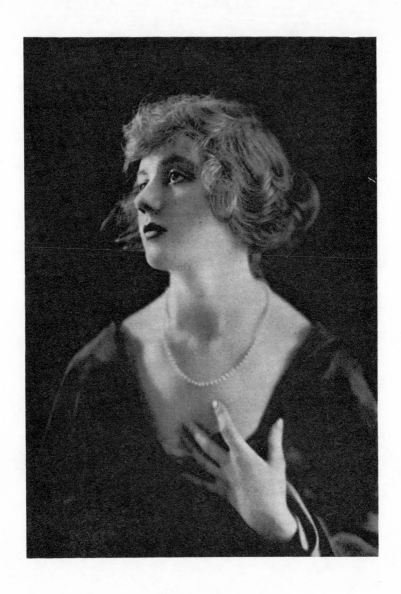

PHOTOGRAVURE PRINT.

Printed with Dark Sepia Photogravure Ink No. 18192 by Lorilleux & Bolton, Ltd.

ELEMENTS OF PHOTOGRAVURE

Photo Printing from Copper Plates

Screen photogravure simply explained
with full working instructions and an
explanatory chapter on modern rotary
gravure printing

*A book of practical interest to all enthusiastic
Photographers, Printers and Etchers*

By

COLIN N. BENNETT

F.C.S., F.R.P.S.

TECHNICAL ADVISER TO " THE BIOSCOPE "

SECOND IMPRESSION

BOSTON, U.S.A.

AMERICAN PHOTOGRAPHIC PUBLISHING CO.,

428, NEWBURY STREET, BOSTON 17, MASS.

LONDON

CROSBY LOCKWOOD & SON

1927

PREFACE

THE greater part of the contents of this little book made its first appearance as a series of articles in the " British Journal of Photography " during the early months of 1925. About the same time, greatly daring, I delivered a lecture on photogravure before the Royal Photographic Society, hoping against hope that experts would kindly keep away on that night. However, for my sins, they did not do so, and you may imagine my heightened nervousness when such audience as there was turned out to be composed mostly of those who knew more than I. That they treated my remarks kindly and found therein no sufficient reason for (technically) tearing me into shreds may further justify passing on knowledge given forth at that time together with what more has been collected during intervening months of inky enthusiasm. Photogravure as a direct photo-printing process is really wonderful, a method combining truly photographic precision of outline with the inimitable velvety shadows and tonal values of a finely proofed etching. Nor is photogravure complicated, or expensive in material, and if it calls for careful working is not this also an advantage ? Who among true well-wishers of the craft of illustration would feel drawn toward the product of sloppy workmanship ?

<div style="text-align:right">COLIN N. BENNETT.</div>

1, CAMBRIDGE PLACE,
 PADDINGTON, LONDON.

CONTENTS

CHAPTER I

*Introductory.—The many advantages of photogravure,
whether as a photographer's direct printing process
or as a process of photo-reproduction, with a brief
general survey of how it is done.*

AT the present time very few photographers work
photogravure. Nor do they know anything about it
except that it is a photo-mechanical process made
use of in the ink printing trade for finer reproduction
work than can be obtained in any other way. Ask
the same man who explains this to you what Bromoil
transfer is, and he will inform you it is an exceptionally
flexible and controllable method of direct photo-
graphic printing. The truth is, Bromoil transfer and
photogravure are equally photo-mechanical repro-
duction processes or direct photo-printing processes,
according as you choose to accept them. The one, we
photographers have re-christened (its original names
were brush-inked, grainless collotype, and collotype
photo-litho transfer) and have taken it to our arms
in its new dress. The other we have not re-christened,
for the simple reason that we have not, as a body,
realised its enormous adaptability to our uses. My
aim in writing the directions which follow is to open
photographers' eyes to splendid possibilities we are
neglecting by leaving photogravure solely in the hands
of the book and magazine trade.

1

Before I go further, however, it is only fair to explain how I came by whatever of the practice of photogravure I know. Some part I puzzled out for myself. The rest was dug out of printed notes and added to by such oral hints as I could muster. The first and greatest help came of studying Denison's unique (and out of print) work on the subject, notwithstanding that Denison has no mention of modern screen photogravure, but deals only with the dust grain process. Later on Mr. Rouse, of the Autotype Co., Mr. Laws, of Penrose & Co., Ltd., and Mr. Kimber, all helped most kindly. As a result of it I have managed to piece together working details of a process which I am confident can save the situation for many a man who in the past has tried his hand at Bromoil only to realise that it is not nearly so much a technical printing method as an individual gift denied to him. Bromoil transfer is pre-eminently a process giving broad effects which are never twice alike, and which call for fresh expenditure of time and of great skill with each print made. Photogravure, while also permitting enormous individual control at every stage, makes possible effects either broad or detailed at will. Further, it possesses the outstanding advantage that the printing plate holds upon it a permanent record of the photographer's skill. Once his plate is as he wants it, it prints the same again and again over editions of hundreds or thousands without further question, except when controlled for some special or varied effect.

Photogravure prints are true continuous tone photographs built up of varying *depths* of ink deposited upon ordinary paper of any sort or kind. They have

nothing whatever in common with half-tone newspaper illustration, and can easily be turned out indistinguishable from silver prints or platinotypes if desired. When worked along the lines I shall describe, very little apparatus is required for photogravure in addition to a photographer's usual equipment. As a commercial photographic printing process for editions between fifty and a thousand, photogravure will undoubtedly prove the true missing link between good silver printing and the best class of photo-reproduction, while giving a subtle tonal quality not present in any other photo-printing process at all.

Now to make a start with the process itself. First I had better give a brief outline of what text-books euphoniously call the " modus operandi," after which we will begin to collect necessary materials. Well, then, photogravure is an intaglio (pronounced inta*r*lio) copper-plate process, which means that prints are taken by pressing damp paper heavily down upon an inked copper plate which has previously been etched to a depth corresponding with the depth of tone, or amount of ink, to be transferred to the paper at any given point. The usual method of getting printing ink into the copper plate is first of all to smudge the ink promiscuously all over the surface, then to wipe it gently and evenly with special wiping cloths till ink only remains in the minute hollowed-out portions of the metal, the flat, polished top of the plate being once more clean, as if it had never been inked at all. The word " intaglio " stands in the printing industry to signify that ink is transferred from hollows in the metal to the paper, and not from raised portions of the metal, as in typographic printing.

Before one of these intaglio copper plates can be printed from, it has to be made. That is done by first of all laying down upon the bare copper a " resist " permeable to a suitable etching fluid in proportion to the shadow-printing depth of the original negative which controlled the resist in the making. In screen photogravure the actual substance of the resist is a thin film of gelatine, and the way of getting it on to the copper and of arriving at the density graduation necessary to give us our controlled etching values is not unlike ordinary single transfer carbon printing. So here, at any rate, photographers find themselves up against nothing radically off the beaten track. At the same time certain more minute details are quite different, and at the outset be it said of photogravure that the great necessity is exact attention to detail procedure if creditable results are to be secured. While the routine is by no means difficult or over-intricate, you can " slop " nothing at all without paying for it very dearly indeed. So the slap-dash worker may at once take the hint and either mend his ways or give this most beautiful process a wide berth.

I have said that depth of etching of the copper plate decides the amount of ink to be deposited on the paper when we come to proof printing. Again, the depth of gelatine forming the photographic resist we first lay down on the copper determines the extent of etching. Therefore it must follow that parts of the plate covered by the thinnest resist film will be those which will give rise to the deepest shadow tones in photogravure prints. In carbon work the thinnest gelatine films are those left after development where light action has been least, so that if we were to use

a negative to print our photogravure resist from, we should get a plate which on proofing gave negative instead of positive pictures. What has to be done, on this account, in photogravure is to use a positive as the " negative " for the gravure resist printing. This, while it involves another step in the total procedure of plate preparation, at the same time affords us an invaluable advantage in that we may introduce into this intermediary positive any control methods we may find desirable, and whatever benefit they give rise to will be faithfully carried over to the final result on the proofing paper.

Here I may mention one of the minor, but I think important, detail modifications I have preferred in adapting photogravure to the photographer's immediate needs. The accepted method of positive making for resist printing is by the use of a particular gravure tissue known as 171 diapositive tissue in the Autotype series. This tissue is excellently adapted to working from copies when printing by contact from large negatives. A simple alternative is to make our printing diapositives upon bromide emulsion plates in the projection printer or enlarger, merely turning the negative about so that the glass side faces the easel.

I have talked about the gelatine resist as controlling depth of etching of the copper plate, but in screen photogravure it does more. And here it would be as well to differentiate between the modern " screen " and the old-fashioned " dust-grain " processes. Herbert Denison, for instance, in his admirable text-book tells us that before putting down the carbon transparency upon the copper, the plate has first to be grained in a dusting box. This dusting box is a large

case (about the size of a sugar box) having a pivot at its middle and a stand upon which it can swing bodily round like a milk churn. About three-quarters of the way down the box there is a shelf, with access to the shelf through a trap-door, so that the trap can be opened, a copper plate slid in upon the shelf, and the door closed again at once. The way you used the box was, roughly, this : You put inside it a quantity of very finely powdered bitumen, and proceeded to make the box fly round and round on its pivot till the whole of the inside was one cloud of bitumen dust. Then you waited a minute or two (actual timing was highly important) with the box stationary, till a certain portion of the heavier bitumen dust motes had settled, and then you slid in your copper plate upon the shelf, and again timed it. On withdrawing the copper it would have a coating of fine dust particles. These were caused to adhere to the metal by heating it till the bitumen went glossy. You now had a plate wherein alternate microscopical areas of the metal were left bare and were covered by spots of a substance —bitumen—which is *resistant to the etching fluid*. Later on, however deeply (within reason) the plate was etched, these minute covered portions would remain sticking up like little props ; and this was actually their function. They, *or their equivalent*, have to be present on every photogravure plate to prevent the wiping cloths from dropping bodily down into the etched hollows in the copper and wiping the ink out of them, at the same time as it is wiped off the bare top of the metal (fig. 1).

To give a homely simile : If a boy has the ill-luck to drop a penny down through the grating of an area,

he cannot get his penny again, not because the area is hermetically sealed by the grating, but simply because the bars are too close together for him to be able to get down between them. The dust grains (or their equivalent) leave on the printing plate, after etching, a barrier of close-placed copper spurs which, while they do not seriously prevent the surface of a soft, damp piece of paper from dropping down between them sufficiently to pick up the ink from the plate

Fig. 1.—Showing section of etched plate with screen ruling acting as protection for ink pockets between.

hollows, do prevent the relatively hard-faced and stiff wiping cloths from doing the same thing.

All the same, dust graining is a very delicate bit of technique, and grained printing plates are equivalently delicate to etch and to proof. In modern screen photogravure the same thing is arrived at far more sturdily by making the gelatine resist carry a heavily printed screen pattern in addition to its continuous tone image from the diapositive (figs. 2 and 3). Impressing this pattern upon the gravure tissue prior to printing upon it the picture to be rendered in photogravure is called " screening." Hence the modern process has become differentiated from dust graining by being given its name of *screen photogravure*.

CHAPTER II

*Materials we shall want : screen and screen-printing
frame, tissue, Beaumé hydrometer, press, and
copper plates in addition to the usual dark room
and resources of a photographer.*

WE now know enough of the general outline of photo-
gravure to be able to make a rough list of the more
important (and incidentally more expensive) apparatus
and materials needed for a trial. In that way we may
find within a little the cost of making experiment—
in so far as one may call a process an " experiment "
wherein the result of reasonable care and skill will be
certain success. I assume each prospective worker
has at his command the usual resources of an averagely
well-appointed dark room, including an artificial light
enlarger or projection printer ; water supply, and some
means of heating water ; also electric current, which
may be either D.C. or A.C., and of any voltage, for, with
my way of printing, arc light is not a necessity. As
etching troughs for copper plates ordinarily enamelled
iron flat-bottomed dishes will be found quite satisfac-
tory. Alternatively, dishes may be knocked up out of
any odd planks of wood, afterwards being pitched over
inside to render them waterproof. Of course, every
photographer will possess printing frames, but here
we encounter our first probable expense in photogravure,
for you cannot be *sure* of screening at all a large piece of

tissue well in an ordinary printing frame. The regular thing for this is a " vacuum frame " made by Messrs. Penrose and costing in the 15 by 12 size £7 10s. (fig. 4). However, first experiments will hardly be made in sizes much above 7 by 5 inches, for which a small

Fig. 2.—Photo-micrograph of actual portion of a stripped gravure resist. × 4½ magnifications.

pressure frame costing about thirty shillings, and also obtainable from Messrs. Penrose, is perfectly suitable (figs. 5 and 6). With the artificial printing light I have devised, or using bright sunlight, a worker making experiments with plates up to half-plate size or there-

B

abouts can even make an ordinary printing frame do throughout if he will glaze it for the occasion with a sheet of plate glass one-eighth to one-quarter of

Fig. 3.—Higher power micrograph of the same printed gravure resist. × 10 magnifications.

an inch thick, and will replace the usual back springs of springy brass with much stronger strips of mild sheet steel, increasing the strength of their pivoting screws in proportion.

So there, for a start, one considerable out-of-pocket expense is got over. The actual printing light arrangement for an all-weather outfit may cost anything from almost nothing at all up to about £3, according to the number of accessories going to make it up which can already be found in the studio or dark room. I will leave details of this till we get to the appointed place

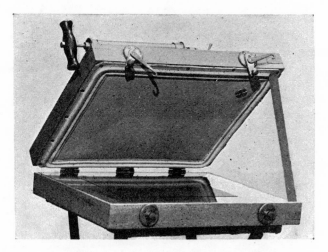

Fig. 4.—Vacuum frame open. Shows : Front glass with celluloid gravure copy screen lying on it. Frame with rubber blanket for backing. Vacuum pump mounted on frame back. The frame is kept open by an ordinary 12-inch metal rule, seen on right, to allow of inspection.

for them, merely saying at the moment that the great majority of photographic establishments will already have everything necessary to hand, and only needing re-assembling upon any available free table or work bench.

That brings us to our first *certain* and considerable

expense, which is the cost of the photogravure " copy screen " itself. My own one, a very nice screen on a flexible celluloid base, was supplied me by the Autotype Company at the price of £3 10s. for the 12 by 10 size. Other sizes, I understand, are priced more or less in proportion. Penrose offers small experimental screens on glass at a little over two guineas for a size of approxi-

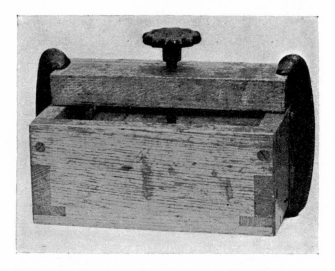

Fig. 5.—Small photo-mechanical " pressure " printing frame, closed.

mately 7 by 5 inches. Probably with the growth of a demand for such small photogravure copy screens they would soon become much cheaper. I have just heard that the Autotype Company supplies an 8 by 6 celluloid screen for 30s.

Gravure tissue for the resist costs something under £1 the " band." As you can buy it by the quarter band or alternatively can buy it in ready-cut pieces

the same as with any other grade of carbon tissue,
first expense of trial tissues is small.

We still need a few things. We must have a thermo-
meter, costing a shilling or so, an accurate Beaumé
hydrometer (fig. 7) with testing glass, which may run
into half a sovereign, etching fluid (that we can make

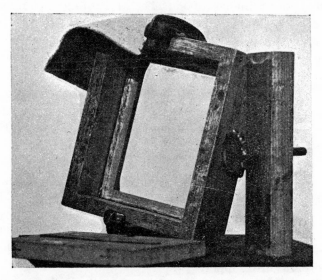

Fig. 6.—Photo-mechanical " pressure " frame open. Shows : Box of
frame with front glass ; cramping strut with set screw ; back of
frame ; blanket to go inside back on assembling.

up for about fourpence a pint), acid-resist varnish,
of which half-a-crown's worth will cover our needs for
months to come and some copper plate ink. Very
good quality ink can be had in four-ounce tubes at
three shillings the tube. Those of us who have tubes
of bromoil ink knocking about, that we would like to
use up, may ink our plates with it instead, and will
find it excellent.

There remain the actual copper plates themselves to be bought. Prices of these vary enormously according to the firm quoting for them. Haddon of Salisbury Square supplies English-made copper (eighteen gauge) at an approximate price of one shilling for each twenty square inches of surface. A six by four-inch plate has twenty-four inches of surface, and would, therefore, cost just under one and threepence. Buying by weight the price works out at about three shillings and sixpence a pound. Kimber supplies copper plates suitable for photogravure at much the same rate as this. Both the above firms are, moreover, open to sell plates in quantities as small as the buyer may wish even, so I understand, a single plate at a time. For those who appreciate the hardest of hard photogravure copper and who have progressed beyond the experimental stage, Penrose is a likely source of supply and the copper is of a thoroughly satisfactory grade. There is a saving in ordering copper plates in dozen lots or more of a size from the firms mentioned. The Autotype Company supplies also a high quality photogravure copper.

For transparency making by projection I have found nothing to beat a backed plate coated with lantern-slide emulsion, except where the negative worked from is excessively soft. Then a process plate may occasionally come in useful. Ilford, Ltd., supplies plates in any size coated with lantern-plate emulsion, and apparently they must be a stock line, for they nearly always arrive by return of post. Where a negative has, for some reason, to be printed by contact, use may be made of Imperial " stripping " process plates. They need careful handling and don't stand for too

much after-treatment, being in some ways rather like
the ordinary plates of my boyhood, which had films
that let you know when they had been dodged about
with enough by incontinently floating away from their
glass support. But Imperial strip-
ping plates are all right if you go at
them carefully. When dry you just
lay down the stripping plate trans-
parency gelatine side upward, run
a sharp knife along the coating
one-eighth of an inch from the
edge of the glass, insinuate the tip
of the knife blade under one corner
of the gelatine and it will rise and
leave the glass back easily. There-
upon you have a very thin but
tough flexible transparency which
may be printed with equal sharp-
ness from either side. In the
directions which follow I assume
that projection printing either
with enlargement reduction, or to
the original scale will be our more
usual practice.

We still need a copper plate
printing press and supply of paper
if we are to proof our own plates
(and precious little fun I for one

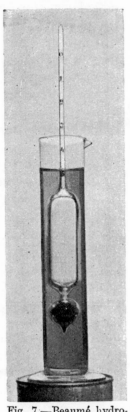

Fig. 7.—Beaumé hydro-
meter and testing glass.

should find in photogravure if I
left this, the most exciting part of it all, to anyone
else). The cheapest price I have heard quoted for a new
copper plate press capable of proofing plates up to
eight inches in diameter is £6. Such a press may be

had from W. Kimber, from Newman & Sinclair, or from Penrose, to mention three sources which come immediately to my mind. Second-hand copper plate presses come upon the market from time to time at ridiculously low prices, but that means waiting for them and seizing your opportunity as it arrives. Paper, on the other hand, will worry no one on the score of expense for the simple reason that there is no sort of paper whatever which cannot be made use of for proofing from copper plates. Typing paper will do, so will blotting paper, to mention in the same breath two uttermost extremes. It is all a question of soaking, which matter can now wait over for further comment when we are ready to tackle it. The proofing paper I have used mostly of late costs three-halfpence a sheet, each sheet cutting into nine pieces approximately ten by seven inches in size. Compare that with the cost of printing bromides of the same or equivalent dimensions.

Finally, in computing the cost of fitting up apparatus and providing materials for first steps in photogravure, suppose we allow another pound note for odd and incidental expenses ? Thus we shall arrive at a reckoning which places our full bill of probable costs at something between ten and fifteen pounds, though great care and strict economy might keep the figure actually below the ten-pound mark.

CHAPTER III

The right kind of negative for gravure and hints on how to make a suitable printing positive from it. Making ready the positive for printing gravure tissue.

THE best type of negative from which to make a projection positive for direct photogravure is an "enlarging" negative, and a rather thin one at that. Bromoil workers will need little further guidance at this point, for a good Bromoil negative, verging slightly to the thin side, but free from veil and with plenty of fine shadow detail, will also be found just right as the starting point of photogravure. In my own experience —which I put forward for what it may be worth—it has proved a good plan *not* to embellish this negative with much in the way of hand-work. Local reduction of the sky with hypo and ferricyanide reducer often helps cloud rendering, even where the negative has been made on a panchromatic plate, using a yellow colour screen. Also I do not hesitate to build up shadow detail locally if necessary by the application of a one-solution mercuric iodide intensifier made as required by dissolving a dram of soda sulphite and a grain of mercuric iodide in an ounce of water. Exact proportions of these constituents are somewhat unimportant, so that in practice one soon gets to make up the intensifier in small quantities by guesswork. In local intensification it is necessary to remember that the intensified

parts of the negative will have when dry considerably greater printing depth than hand inspection of the same negative while wet would seem to suggest. A good rule, therefore, in local chemical treatment of a negative for projection positive making is to be less afraid of slight over-reduction than of overdoing intensification. Choked up high-lights leading to blank white areas in the resulting positive are to be avoided wherever possible, while large areas of detail-less shadow are only slightly less objectionable. In both local intensification and reduction the solution is applied gently on a camel-hair brush. Use the brush rather dry where small areas are being treated, or where only slight action is wanted, and have ready a dish of clean water or preferably a running water tap for rinsing the plate at the first sign of the reagent overrunning its appointed part of the image. Over-intensification with mercuric iodide can be removed by immersing the negative in a clean hypo bath of moder ate strength.

So far we are going over old ground to many of us. The dry negative further needs to be spotted with any good opaque pigment to fill up pinholes, but here great care should be taken to do the spotting as neatly as possible, for the least untidiness will make trouble later on.

Where the entire negative is over-dense we have two obvious ways of going to work in making a photo-gravure positive from it. We can either reduce the negative first of all with ammonium persulphate or develop the positive with a soft-working developer such as rodinal, or with metol to which has been added about one-half its own weight of hydroquinone,

for plain metol developer gives too grey a positive to be of much use for anything.

The negative may now, optionally, be varnished, but I have not found advantage from the application at this stage of retouching medium or lead. On the contrary, it always comes out more or less upon the positive, and the positive in due course hands over these traces of hand finishing to the printing plate, whereas, if hand work is held over to the positive stage, the printing plate, for some reason or other, absorbs it in a true blend with the strictly photographic part of the image.

Let us at once, therefore, get the negative in the enlarger carrier, remembering to place it reverse way round so that the image on the easel is also laterally reversed. The general method of focussing, exposing and developing the transparency is as usual for good enlargement or reduction printing. I make a rule of working with plates coated with lantern-plate emulsion (Ilford Special lantern) and invariably order them backed. My enlarger is of the condenser type, the illuminant being a gas-filled focus lamp, but between the light source and condenser face there is a sheet of ground glass. The enlarger lens is a photographic anastigmat (T. T. & H. " Cooke ") of very good defining quality but of no considerable rapidity, and is usually kept at $f/11$. Focussing is done upon a fogged undeveloped plate, using a magnifying glass of just sufficient power to allow definition of the silver grains to be used as a focussing guide. When the transparency is to be at all a large one I first of all get my exposure timing exactly correct by cutting a quarter plate coated with the same emulsion into two or three slips in steps by

placing an opaque card over it and moving the card along a short distance at *equal* time intervals. In that way each next greater density step on the emulsion will be the result of adding one more timing unit to the plate exposure. Thus, if our units are to be five-second ones, shifting along the covering card will expose the plate in equal steps representing five seconds, ten seconds, fifteen seconds, twenty seconds, twenty-five seconds, and so on. The beauty of this grading method is its unbeatable simplicity, for with it you cannot go wrong. There is no need to remember multiples or special progressions and no need to be able to identify independently which end of the plate you started from. After development you simply take out the slip, count along to the density you like best, and the density count is your count of time units also.

The great importance of exact timing lies chiefly in the necessity of hitting your exposure exactly and developing the transparency plate right out. Cut-short development leads to grey sloppy shadows and running together of the finer details in the highlights, both fatal defects for the photogravure worker, because clean high-light detail rendering is of the essence of a good printing plate, and half-baked shadow tones in the plate further give it the appearance of being worn out from the very first printing impression.

On the other hand, the transparency, while being of the sparkling order, must be free from any trace of soot and whitewash. No part of it need be of greater density than we would aim at in a not-over dense lantern plate intended for use as a slide in actual

optical projection. While small points of high-light should be almost clear glass the next thinnest highlight may be even slightly over-emphasised, for the reason already implied—that slight flattening here is more likely to be found in the finished plate than in the more pronounced mid-tones and shadows.

Having got the transparency as near to our liking as we can by correct exposure and complete development, and having well fixed it and washed it, the next thing is to consider, as with the negative, whether good can be done by local reduction or intensification, or both. This time we may with advantage err rather on the heroic side, for our opportunity has fully come to get a real start with control methods and, if we should unhappily push them too far, after all it only remains to prepare another transparency and try again. Any fair-sized touches of light we may help with the hypo-ferricyanide reducer. Cloud forms. and foliage may call for judicious touching up with mercury iodide intensifier, washing the plate well between the two treatments, of course. After mercuric iodide applications to the transparency plate it is necessary to follow a good rinsing with a five-minutes' soak in normal strength M.Q. or similar non-staining developer prior to final washing. Otherwise the mercury-reinforced part of the image will be coarse and brownish, and will not blend properly with the untreated part of the transparency plate.

Now comes the time for hand work. My way is to flow the *gelatine side* of the transparency with " Bildup " varnish and proceed to work up the shadows with as soft a lead pencil as can be got hold of. Nothing harder that 6 B will do for heavy shadows, but 2 B or

3 B is suitable for fine detail emphasis in the light tones or for filling in clear glass resulting from previous spotting of the negative with opaque pigment. In our first trials we may even be tempted to use water colour put on lightly with a sable-brush—but only the first time. Even the least touch of pigment comes out later on as a black patch on the photogravure proof. However, ink-black shadows can be, and should be, added where required in just this way.

For very brilliant small patches of light the transparency may be " shaved " with a retouching knife before or after flowing with " Bildup." First of all dry the plate before a fire or radiator till it is thoroughly warm, then pare down the film, holding the knife blade almost parallel with it, so as to get a razor action. This is well-known retouching practice.

If the positive then appears to your liking it may be made ready for printing the resist by bordering. My favourite way of bordering is not by affixing opaque paper, or painting out, but, on the contrary, by cutting through the gelatine and scraping away the rim between the cut and the plate edge (fig. 8). Enough rim must be removed to leave the picture which remains of the exact dimensions decided upon for the photogravure to be etched. Above all things, be careful that removal of the unwanted gelatine is done cleanly and true to shape. The simplest aid I have so far discovered to ensure making a good job of transparency border marking is a plasterer's steel T square. It is flat, and shaped like a draughtsman's celluloid T square, but being of mild steel you can run the knife along its edge without throwing it out of truth. These T squares can be ordered of any ironmonger.

What is to my mind a strong point about using an accurately transparent-bordered positive for tissue printing is that where this is done it is possible, with careful and skilful etching, to get a gravure plate with a

Fig. 8.—Positive transparency with clear scraped border supported on retouching desk.

delicate natural boundary line to the picture, a line somewhat like (though distinct from) that made by artists upon hand-drawn and etched copper plates. An alternative and in some ways simpler method is to follow ordinary carbon printing practice, by giving the positive an opaque " safe edge " of tinfoil or thin black paper. Where this is done the whole work of

providing suitable limits to the etched area of the copper depends upon a properly controlled application of acid resisting varnish to the copper later on, after the resist has been developed. That will be dealt with when the time for it comes.

I have already mentioned a possibility of getting reversed positives by contact printing through using plates coated with stripping film. Another way of arriving at the same result in a silver printing process is by using cut film—which should be coated upon as thin a celluloid base as possible—and resist-printing with the celluloid side next to the tissue in the printing frame. This simple expedient works quite satisfactorily where there is a strong concentrated light available of the sort which gives rise to sharp cast shadows.

By far the most widely used way of getting a good gravure diapositive by contact printing is by the single transfer carbon process itself, using diapositive tissue 171 and transferring on to thin celluloid. The celluloid needs no special preparation whatever, for an image printed on Autotype 171 tissue has the property of holding on to it without requiring the usual hard gelatine substratum generally regarded as necessary in single transfer carbon work. To sensitise this tissue it should be soaked for a couple of minutes in bichromate of potash solution and dried in contact with a glass or ferrotype plate in the way that will presently be described for preparation of gravure resist tissue. Development, too, is similarly with hot water. Please read the description to be given of the way to put down and develop a resist upon copper, then just substitute celluloid sheet for the fully prepared copper plate and proceed in the same way, with this important exception.

*Do not use any methylated spirit with the water in which
171 tissue or the celluloid sheet is placed, and let the
developed positive dry naturally by drainage, and not
by dabbing, or by blowing with hot air.*

Reversed carbon diapositives so made are full of
delicate gradation but have little " pluck." Some
workers find them all the better for that. Others, who
would rather have a steeper range of contrasts, can
intensify the positives easily enough. To do so, let
them dry first. Then prepare a strong solution of
potassium permanganate and dip each positive in it.
Strength of the solution is not very material. One
dram to four ounces of water is useful, and the immer-
sion need not be for more than half a minute or so.
Apparently the pigment undergoes an oxidation change
which greatly deepens its colour and at the same time
turns it from a rather washed-out purple-brown to a
much more non-actinic brown-sepia. After intensifica-
tion, rinse out all free permanganate and hang the
diapositives up to dry again.

With our transparency plate or " diapositive " made,
worked up and bordered, we are ready to start upon
sensitising the " gravure " tissue and getting it
" screened " and printed for putting down the resist.

c

CHAPTER IV

*More necessary details about gravure screens and their
function. The correct handling of vacuum frames
and some help in choosing copper. Different
characteristics and behaviour of copper plates.*

THE time has now come to go more carefully into the
question of materials needed for preparing the gravure
resist and getting it safely down on the metal. Let us
take these in their order of appearance, as with the
actors in a West End theatre.

The standard British tissue for either flat plate or
rotary screen photogravure is Autotype G 12. It is a
carbon tissue pure and simple, lightly impregnated
with burnt sienna pigment. Several other gravure
tissues are prepared by the Autotype Co., notably
G 7, wherein the pigment is brown instead of reddish ;
G 14, the gelatine of which, instead of having a pigment
colouring, contains an aniline dye, and G 15, a tissue
made to a special formula, which aims at giving greater
control of etching in detail in the high-lights. Sensi-
tising, printing and etching directions which follow
though worked out primarily for G 15 and G 12 tissue,
apply with little modification to the others also.

Next we need the " copy screen " and a suitable
screening frame. I can best describe a copy screen by
explaining that it is a photographic contact print or
" copy " from a master screen kept in the hands of the

screen makers. The master screen does not therefore
directly concern us, though knowing what it is may
help us to understand the copy screen the better.
Well, then, a master screen is made by ruling a plate
with black lines equally spaced apart and crossing
each other at right angles (fig. 9). The width of each

Fig. 9.—Photogravure master screen ruling, much enlarged.

line is not more than one-half, and may be as little
as one-fourth, the width of the spacing between it and
the next line. (In the more familiar " half-tone "
screen lines and spaces are of equal width.) (Fig. 10.)
Let us imagine such a photogravure " master " screen
as being used as a negative from which a contact
transparency is made. The transparency will be the
copy screen. It will be a right-angle hatchwork of
transparent lines upon a dead black opaque ground,
each transparent line of not more than one-half the

width of the adjacent opaque square (fig. 11). As
previously stated, copy screens are made upon either
glass or celluloid. Personally, I prefer celluloid,
because it goes more snugly into a pressure or vacuum
frame, and because of the absence of any steep sharp
edge, and its comparative thinness. Standard photo-
gravure screen ruling is 150 lines to the inch. For
very fine work 175 and 200 line rulings are made.

Fig. 10.—Enlarged reproduction of ruling of ordinary
typographic half-tone screen.

Coming to the screening frame, if we decide to start
with an ordinary photo-mechanical worker's pressure
frame, this is a heavily built metal-braced box, fronted
with a slab of plate glass at least three-quarters of an
inch in thickness. The back of the frame is a sturdy
hard-wood board strengthened with a plate or plates
of sheet steel. The whole is completed by a removable
screw clamp which, after the back of the frame has been
lowered into place, allows of it being forced tightly
up against the front glass by turning one or more screw-
heads, pressure between glass and back of frame being

controlled exactly after the same style as when screwing down an old-fashioned letter-copying press. The regular photogravure " vacuum frame " is a very different thing. It is comparatively lightly built ; its front is a sheet of quite thin plate glass, and its back is made of rough-surfaced india-rubber sheeting

Fig. 11.—Photogravure copy screen ruling, much enlarged. The copy screen is the one actually used.

rimmed with a deep groove. When the frame is closed a tongue of rubber fitted round about the edge of the front glass engages with this groove so as to make an air-tight joint. Either attached to the side of the frame or supplied as a separate unit (according to the frame's size) is a simple vacuum pump worked like a motor tyre inflator, but arranged to suck air out instead or forcing it in. A flexible tube from the pump goes to a union in the back rubber sheet (called the " blanket," probably because

in the printing industry any soft backing seems to be referred to as a blanket).

We shall by now appreciate that when the frame has been closed the action of working the vacuum pump will be to exhaust most of the air between its rubber " blanket " and front glass. Upon this being done atmospheric pressure acting against the internal vacuum brings front and back of frame together under an internal pressure not much short of the theoretical fifteen pounds to the square inch. Thus, without the structure of the frame or its glazing being subjected to any breaking strain at all, screen and tissue placed inside will have a thorough squeezing together.

Let us proceed to the selection of copper plates. The first thing to decide is what size plates we will use. I made my own start with four-inch by three-inch plates, an obvious merit of them being that the cost of early trials was thereby kept down to a proportionately small amount. Even without taking particular care to buy plates of this size in the cheapest market, they will not cost more than sixpence or sevenpence each.

People who do not favour very small work can start with five by four-inch plates, costing about a shilling each. I think these dimensions approach too nearly to the square to be ideally proportioned, but a six by four sized plate is excellent, and pulls from it show up well on mounts measuring as much as ten by seven inches. Also you can print a post-card off a six by four-inch plate so as to carry the picture right up to the margin of the card. Therefore the size has a double application. Larger plates preserving equally pleasant relative proportions are seven by five (the exact dimensions of a two-diameter enlargement from a three and a

half by two and a half negative), ten by seven, twelve by eight. etc. To make a rough estimate of the cost of any sized plate, multiply together the measurement in inches of any two adjacent sides and divide by twenty, the approximate answer being in shillings and fractions of a shilling.

Plate size can therefore be easily settled to our satisfaction. A far more important question is that of estimating hardness and quality of the copper. For the beginner at photogravure this is the worst " snag " he may encounter. Just as with Bromoil an unlucky worker sometimes makes his first attempts with a batch of paper which will not pigment properly, so may the Photogravure tyro chance upon copper which is over-soft, or of bad surface, or (worst of all) copper which to the inexperienced eye looks all right but suffers from stress veins due to faulty rolling. The latter can, with a little practice, be recognised if you catch the light reflected off the metal at an angle from the polished side, stress marks then having an appearance somewhat similar to those variations of gloss seen as narrow pathways about the edges of a well danced-over ball-room floor. When you notice markings like that on bright copper suspect them at once. If the markings are not easily removed by treatment with wet willow charcoal you will be sure they are going to affect the etch, and a wise man will turn the plate over to some other purpose and not waste good time and patience with it.

Softness or hardness of the copper comes next in importance. Though both grades of copper will etch, their etching characteristics are entirely different. Thus, experience gained with a certain degree of

hardness does not hold for other degrees of it. On this account my counsel to the serious beginner is to select as hard a " gravure " copper as he can get, and to buy up enough plates of the same batch to give him time wherein to find his feet before a possible necessity arises for revising precious details of his etching timing. One simple way to tell hard from soft copper is to make a little scratch with the blade of a pocket knife, or better with an etching point, upon the *back* of the plate. A man accustomed to handling copper plates can gauge their hardness roughly by flicking his finger nail against the metal to make it " ring." The brighter the note the harder the metal. Scratching the back of one plate with the corner of another plate from a different batch will give rough indication of which copper is the harder.

Even now we have not done with the necessary precautions in choosing copper. Not all plates show the same etching colour. By this I mean that in attacking the metal through the gelatine resist the etching fluid gives rise to a gradual colour change. As this colour change is the etcher's chief means of knowing how the " biting " of the plate's printing surface is proceeding his control of etching, more especially in the super-important high-light details—that is to say, in the most difficult portion of the plate—is about proportional to the visibility of the etching colour. How much of the final etches he will see will again be determined by the extent to which the etching colour of the attacked copper contrasts with that of the semi-transparent gelatine resist overlying it. It has been said that G 12 tissue has a burnt sienna colouring. Therefore a plate which etches black, or

green-black, beneath this resist will reveal the progress of etching far better than will a plate which etches red-brown. For red etching copper G 7 (cold brown) tissue may be preferable.

Some of the staunchest, hardest gravure copper I have handled has etched precisely the red-brown tint which has made sky detail and high-light detail formation literally impossible to keep watch upon with a G 12 resist. As a sporting proposition for the man with a little experience, this copper is fine, but a black-etching sample, even though not quite so hard, is a more practicable proposition for the beginner.

Why should hard copper be so important in photogravure ? For two reasons. The first one is that, with soft copper, etching is apt to " bolt," as it were, and so rush out of the worker's control in the final baths, just when strict control is most necessary to avoid flattening down the printing quality of the plate by creating a " tone " over the highest lights. The second reason for hard copper has to do with inking the plate for printing. Remember, the ink has first of all to be forced down into the minute hollows etched out in the metal. Afterwards excess of ink must be wiped off the surface of the plate before each impression is pulled from it. Both wiping operations involve friction, and both leave a loophole for minute particles of gritty dust to get somehow upon the wiping cloths. With soft copper the least accidental scraping of the plate's surface with grit will cause ruts deep enough to hold ink and print as hair-like scratch lines. Even very hard copper is not immune from the fear of scratch markings, but it is more so than soft copper.

CHAPTER V

In which a carbon printing actinometer is described, minor materials are got ready and we proceed to sensitise gravure tissue.

OF minor accessories for gravure tissue printing the most important is an actinometer, the one most general being named the Sawyer actinometer. It costs only a few shillings, and is exceedingly simple and quite accurate enough, although I cannot honestly say it is an instrument of precision. The Sawyer actinometer is a japanned tin case about three inches long and one inch wide and deep. Its front carries a glass strip bearing a series of graded and numbered density steps. Behind the graded grass is provision for a narrow roll of sensitive albumenised paper (fig. 12). The roll can be pulled out as required to make a strip of the sensitive paper lie against the graded actinometer glass when the frame is closed. On either side of the strip runs a rim of " test tint," of sickly plum-pink colour. An element of chance lies in that test tint, for not once in ten times does the albumenised paper darken to match it. In fact, so far as colour is concerned, albumenised paper hardly ever repeats itself, being very sensitive to atmospheric changes Therefore, there happens to be one way only of using the Sawyer actinometer correctly, which is to judge the matching of printing depth and test strip with the whole thing held well out at arms' length. In that way failure of *colour*

matching is no longer obtrusive, while comparison of the test paper's printing depth with the edges of the standard tint can still be made. Refills of albumenised paper for the Sawyer actinometer should be stored in a calcium tube or storage tin if they are to be kept for a considerable time prior to use.

Unlike ordinary carbon tissue, gravure tissue must be dried after sensitising by squeegeeing it against a flat surface, though not necessarily against a glazed surface. Also, it is not advisable to use a waxing compound or solution on the surfacing board, or plate, as it may prejudice the adherence of the resist to the copper later on. Either plate glass or ferrotype is suitable for drying tissue with a glazed surface, while matt pulp board or finely matted ebonite will do

Fig. 12.—Sawyer actinometer open, showing : front swung on its hinge, disclosing test paper and test tint.

if an unglazed surface is preferred. Workers in the trade mostly use the glazed tissue, but not all of them, so the choice is in our own hands. In my small way I have found that really good ferrotype is as suitable and simple as anything.

In the instructions which follow I shall presume that we have available a portable electric fan and a small electric fire or radiator. Exact size or pattern of either is unimportant, and both are usual items of equipment of any modern studio. We need also the following :— Potassium bichromate, ammonia, ordinary whiting, small amounts of chromic acid and sulphuric acid, calcium storage tin, a block of American soft willow charcoal for copper plate surfacing, chamois leather, methylated spirit, a few enamelled iron or china flat-bottomed dishes in good condition with the glaze intact, a flat squeegee and a copper plate burnisher.

The burnisher is not a machine, as was the old-time print burnisher, but simply a small metal tool rather like a stuggy bradawl (preferably curved at the end) polished to complete bluntness where one would expect the cutting edge to be (fig. 13). It is used on the flat to press down the burred-up edges of small scratches which may be marring the surface of the metal.

There is just one standard sensitising bath for gravure tissue. It is made by dissolving one ounce of potassium bichromate in forty ounces of water and slowly stirring in, drop by drop, ammonia till the orange-coloured solution turns to a pure lemon yellow. You can know beyond question when the right amount of ammonia has been added because at the same time as the colour change is complete the bath takes a faint *permanent* smell of ammonia. Slight over-neutralisation will not matter, but it is wise to let the excess of ammonia be as little as possible. I find a most handy strength for the stock ammonia bottle for photogravure is half and half of the " liq : ammon : fort : .880 " and water. At a rough estimate somewhere about four fluid drams

of this half-strength solution will be needed to neutralise a forty-ounce bichromate bath.

To sensitise the gravure tissue, cut up as many pieces as you want to a size which will allow of them going comfortably on their squeegeeing plates. Go into the dark room and switch on the brightest yellow-screened light you have got. Fill a suitable-sized dish with the

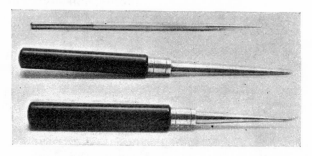

Fig. 13.—Copper plate tools. (Back) Old type double-ended tool : Etching needle one end and blunt-nosed burnisher the other. (Middle) New pattern Kimber large straight burnisher. (Front) Kimber thin curved burnisher (my favourite shape).

sensitiser, plunge a piece of tissue in it, turning sides and removing air bubbles rapidly. In from one to three minutes, according to temperature, the tissue will be flat and limp but not quite flaccid to the point of sliminess. At this point get it down on the drying plate and squeegee well into contact with a flat squeegee. One way of avoiding air bubbles is to slip the surfacing plate or glass into the sensitising dish underneath the tissue and lift the two out together in contact, draining excess solution back into the dish.

Did I mention the correct preparation of the squeegeeing plate's surface to ensure tissue stripping

off again when dry without trouble ? It is the usual :—
French chalk wetted with a little methylated spirit,
rubbed well over the plate with a clean linen rag and
thoroughly polished off again.

Next the tissue must dry thoroughly, evenly, and in
a definite period of time. It must either strip itself
or be ready for stripping
in not less than two, nor
more than four, hours.
To do that a simple way
is to play a steady cur-
rent of cool air from the
electric fan upon the
back of the squeegeed
tissue for two hours to
three hours, then, and
not before then, start-
ing up the radiator and
standing it in such a
position that the fan

Fig. 14—Conventional marking of
back of sensitised tissue to indicate
surface blemish.

will blow warm air from it evenly on to the squeegee
plate. The air must be no more than warm. If so hot as
to cause tissue to snap off the surfacing plate within
half an hour the position of the radiator is too close.
Minute attention to such detail matters as the above is
of great importance for success in photogravure.

When the tissue is stripped from the drying plates
examine its surface under *yellow screened* light, looking
for any minute imperfections such as traces of air-bells,
particles of dust, and so forth. Mark the position of
each on the back of the tissue with a black chalk pencil
and cut up for printing in such a way as to throw out the
blemished portions (fig. 14).

Unless tissue is to be printed from within thirty-six hours I most strongly advise storage in a calcium storage case. Even with such storage I consider ten days the outside safe keeping time of gravure tissue after sensitising.

CHAPTER VI

Screening and printing gravure tissue. Suitable and unsuitable light. Mottling and the way to avoid it. Suitability of sunlight. Preparing copper for the tissue. Getting tissue on to the copper.

OUR tissue being sensitised and trimmed to a size rather larger than the size of the transparency and a trifle less than that of the copper plate upon which it is to be put down we are ready to print it. I have explained that in screen photogravure the tissue has to be printed twice over, the first time being called " screening." This screening may be either to direct sunlight, to the direct rays from the unobscured crater of an arc lamp, or (as I have found) to approximately parallelised rays from a collimating lens set before an incandescent high-power lamp of the kind known as a gas-filled focus lamp. Focus lamps differ from the ordinary street-lighting type of gas-filled high-power lamp in that their filament coils are arranged as closely together as possible, so as to bring the light-source more nearly to a " point." Generally the coils are set in the shape of a flat grid, which enables most of the light from them to be approximately parallelised by mounting in front of the lamp a single bi-convex condenser lens. It should have a diameter at least equal to the diagonal of the largest sized transparency to be printed from.

Diffused lighting of any kind, and no matter how bright, is absolutely unsuitable for *screening* photogravure tissue. We had better understand why, and so save ourselves from delay and tissue waste later on. The reason is that the diameter of the actual lines printed on the tissue from the screen being no greater than approximately one four-hundredth-and-fiftieth part of an inch, the slightest creeping of light round them or between them causes their form to be lost. Also we must understand that in practice no amount of pressure will bring screen and tissue absolutely into contact at all points. That being so, the one way of ensuring a clean-cut and perfect screen printing is to use bright direct light and rely upon the screen's cast shadow printing cleanly even where there is slight failure of contact. Printing to diffused light gives rise to a series of humpy alternations of alternate running together of the screen lines and entire failure to record them. In the resist these markings develop and etch as a mildew-like mottle, especially and ruinously obtrusive in high-light details of the picture. Its appropriate name of " mottling " stands as a dread word to the photogravure plate maker, though, curiously enough, quite a number of first-class workers do not seem to understand the true cause of it, but tell you vaguely, " You can't use anything else except a single actinic arc lamp for screening the tissue, or mottling will result."

As a matter of fact, there is another kind of mottling, due to heating of the screen and tissue behind it when the screen light is over-hot or over-close to the printing frame. Heat mottle markings come through steam baked out of a not perfectly dry tissue. The

D

two preventives of it are storage of tissue in calcium cases, and taking means (which I shall shortly describe) to keep the screening light cool.

Meanwhile let us deal first with the simplest of all screening methods where the simplest of all lights is available. For this the screen is laid in the pressure or vacuum frame, carefully dusted, tissue is laid upon it, also carefully dusted, the frame closed, pressure put on, and the loaded frame taken out into *bright sunlight*. Here it must be stood down squarely facing the sun and left to print, the Sawyer actinometer being stood by the side and printing being carried until the actinometer shows two full tints. That is to say, the ground round about the figure 2 printed out on the albumenised paper must at least match the shade of the test strip edging. Personally, I like to take screening on to nearly three tints. With a good quality screen the extra time does no harm. Afterwards, at once return the frame to the yellow-lit room, remove the screened tissue from the screening frame, and place it behind the prepared transparency in an ordinary printing frame.

This time, if the photogravure plate is to have its etched part evenly and squarely set on the copper, it is necessary to see that the tissue is so laid in the frame that at least one edge is parallel with the corresponding edge of the transparency being printed on it. There is no difficulty over that, for the tissue, if of sufficient size, will overlap the positive picture all round, its edges being clearly seen through the clear glass rim. Having got an edge of the transparency picture and an edge of the tissue parallel, turn the printing frame over, and holding the tissue steadily

in place, mark upon it with the chalk pencil a mark
indicating which boundary has been selected. I also
mark near the upper edge of the print (to be) a T,
denoting "top," (fig. 15). The frame may now be
closed and the second printing (transparency printing)
done to *diffused* light. The most rapid diffused light
I know is sunlight, with the printing frame covered
with a thickness or two of ground glass. Arrange a
simple frame or stand to hold a good-sized ground-
glass sheet, and place this a little in front of the frame
between it and the light. Once again we judge print-
ing time by the same actinometer as before, exposing
it, like the printing frame, to sunlight behind the
ground glass, or to simple diffused daylight. This
time we give an exposure of not less than three tints,
though in some of my work I have found etching go
better when the picture printing had been taken to
four or even five tints.

Possibly it will strike you that in what I have
written about screening and printing photogravure
tissue there has been little call for the exercise of
individual discretion. This is true, and is due partly
to exposure latitude of the tissue both in screening
and transparency printing being great. The real call,
and a very severe call, upon individual judgment will
come only with actual etching of the copper. When
that time arrives there will be plenty to induce con-
centration of mind.

We next turn to the preparation of the copper plate
for its resist. Copper plates are, or should be, supplied
each in a separate paper wrapping to protect the surface
from scratches. Take the plate out, holding it by the
edge as though it were a wet gelatine plate, for it is

important to make a habit of keeping one's fingers off it. Hold the plate in a good light, and examine its surface minutely. If small scratches are seen they should be rubbed out gently with the burnisher moistened with a little water and applied almost flat-on, with a gentle and slow backward and forward motion. Hard or rapid use of the burnisher heats the copper at the point of contact, and may cause more scratches instead of removing the old ones. Decide whether the surface of the plate is so discoloured by tarnish as to be the better for a chemical cleaning bath. I always omit chemical cleaning where possible. If it is needed, a suitable bath will contain half a dram each of pure chromic acid and strong sulphuric acid in a pint of water. Lay the copper plate in an enamelled or china dish and pour on the tarnish-remover as if flooding a negative with developer. The effect is very rapid, and the plate should not be left in the bath any longer than necessary to change its brown-black shiny surface into a light brick-red one. As the bath gets used up it becomes green in colour. It should be thrown away, and a fresh one made up, at about the yellow-green stage. Up to that point it can be used over and over again.

The next thing, after getting the tarnish, or most of it, removed, is to burnish the plate with the willow charcoal block. Rinse the copper well under the tap, also hold the charcoal under the tap for a moment to wet the end of it, and apply the end of the block to the copper, using the cross-grain of the charcoal as a polishing surface. Work the charcoal over the metal with brisk, smooth, circular motion until the whole of the matt appearance left by the tarnish-removing

bath is gone and the plate takes much the same mottled shininess as though the copper had been gently beaten to a polish with a hammer.

The third cleaning operation is to place a pinch of whiting in a saucer, or in a quarter-plate dish, moisten it with a few drops of the half-strength stock ammonia solution, which we shall bear in mind we have already made up for ourselves, dip the hairs of a strong, cheap nailbrush in the whiting-ammonia paste, and proceed to scrub the plate vigorously all over, first across and across, then in circular sweeps of the brush. The ammonia attacks the copper slightly, but the whiting cleans the surface again just as quickly, so that provided the work is gone at with good speed and the plate is rinsed under the tap copiously as soon as ever the brush is taken off it, we shall in this way get a bright even copper surface, so free from all trace of grease that the tap water will flow over it without a sign of formation of droplets.

In the event of any readers being familiar with the routine of plate preparation for other photo-mechanical processes I will add that this bright metal surface is the only one I have found suitable for laying down the photogravure resist upon. A nice " tooth " which one might think to be more calculated to hold the resist firmly down, really defeats its object by permitting the etching fluid to undercut the gelatine at an early stage of the etching, the result being that our unhappy experimenter finds at the end of his trouble he has not really succeeded in creating any printing image at all.

Cleaned copper plates can be left under the running tap or covered with plain water in a dish while printed tissue is soaked and made ready for them. The

waiting interval will not be more than two or three minutes.

Up to now I have not touched upon one fault sometimes found in copper plates as they are sent out by the dealer. This is the presence in them of quite deep but, small pits. Personally I have never made the attempt to correct these, though it can be done by a

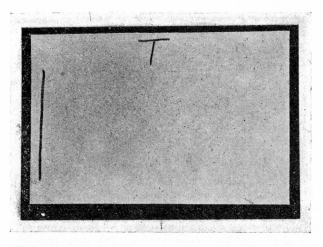

Fig. 15.—Tissue showing back with code markings denoting plate top " T " and side to be squeeged parallel with plate edge " I."

skilled copper plate worker. My mode of dodging the difficulty is to reject the plate or to cut it up into smaller ones in such a way as to throw out the pitted portion. The regular way to deal with a pit is the following : First of all, by means of a pair of callipers, find and mark the exact position of the surface blemish relatively to the plate's back. The plate must then be laid face downward upon a flat, polished steel anvil, a flat-nosed punch must be centred on the

marked spot, and some sharp blows given upon the punch with a light hammer. If rightly done, these hammer-blows will turn the pit into a bump on the face of the plate. The bump has to be levelled by scraping down with a copper plate scraping tool, used much the same as a motor mechanic used the scraper wherewith he faces bearings of engine shafts. It is a ticklish job, requiring skill and practice. Finally, the scraped portion of the plate is evened up by polishing first with powdered pumice and water, then with jewellers' rouge, and finally with willow charcoal and whiting-ammonia, as already described.

We are ready to soak the printed tissue for transfer. The soaking solution consists of three-quarters water and one-quarter methylated spirit. If it is possible to get hold of industrial spirit, this should be used. It can be bought from the Methylating Co., Ltd., Kinnaird House, Pall Mall East, London, S.W. 1, but only by persons holding a permit to buy. The permit has to be applied for to the local Supervisors of Customs and Excise, who will require to know the purpose for which the spirit is to be used and to be satisfied that it will not be mixed into any drug or compound intended to be sold for internal administration.

Those who prefer to make shift with ordinary methylated spirit (as I did at first) should try samples from different sources until a suitable one has been hit upon. Ordinary spirit, having paraffin and resinous matter dissolved in it, goes cloudy on mixing with water (which does not greatly matter), but after standing a little there arises a solid scum which can be got rid of by filtering the mixture through chamois leather.

Tissue must be placed in the weak spirit and water, air bubbles being rapidly removed from back and front of it with a camel-hair mop brush or a piece of clean linen rag. Immersion time usually is between one and two minutes. The tissue must be allowed to absorb enough of the mixture to flatten out and become moderately limp, but not at all slimily flaccid. At this point take the newly cleaned copper plate, place it in the tissue soaking dish, run the tissue over it, face to face, and manoeuvre it into its right position. Here comes in the use of the black chalk markings on the tissue back. From them you know which is the top and which the bottom of the picture ; also which edge of the tissue must be placed strictly parallel with its equivalent edge of the plate in order to ensure that the resist shall transfer squarely upon its copper basis. Having got the tissue rightly placed, pass your hand firmly over it, and it will stick upon the copper tightly enough to allow of the two being withdrawn from the soaking solution without shifting their relative positions. Lay the plate upon the bench top and squeegee out excess of solution with the flat squeegee. General practice at this point is the same as in ordinary carbon printing, or in " Carbro." Mop any remaining water-drops off the back of the tissue and stand the copper plate on edge for sufficient time to allow of the adhering tissue becoming practically dry to the touch. This will not take less than half an hour and should not take more than an hour and a half. My usual way is to let the plate stand for about an hour, then, if necessary, to play the breeze from the electric fan upon it for five or ten minutes as a finisher. On no account turn on artificial heat at this

point, and do not attempt to get the back of the tissue
hand-dry in a hurry, or the resist will show it later on.
As before, I favour bright yellow or orange light for
the soaking and setting of the tissue on the copper,
and total darkness or similarly screened non-actinic
light during the time of partial drying. The reason is
that bichromate-sensitised gelatine is slightly sensitive
to the actinic rays in ordinary unscreened artificial
light such as comes from modern metal filament
electric lamps. Progress of etching is so responsive
to every microscopic difference of thickness of the
gelatine resist that the risk of even slightly altering
this by carelessness with the work-room light should
be avoided.

CHAPTER VII

Describes a novel, inexpensive and reliable way of using
incandescent electric light for screening and printing
gravure tissue. The system is applicable to alter-
nating as well as to direct current supply at any
town-lighting voltage.

SCREENING and transparency printing directions so
far given have been for the benefit of those who live
in sunny enough lands, or who start their photogravure
experiments in a sunny enough season, to be able to
work in natural light with reasonable regularity. If
I left things at this point we wretched dwellers in the
Isles of Mist should not get very far. As you know
I have rigged up a simple accessory whereby our
screening and printing may be both cheaply and
certainly done in any studio or room where there is a
supply of electric energy, the light-source I am using
being a gas-filled focus lamp.

My present one is a G.E.C. tubular focus lamp con-
suming 1,500 watts, having a close-coiled grid filament
of tungsten wire and giving a nearly white light of
approximately five thousand candle power. To get
this brilliance of light I over-run the lamp by 10 per
cent. This means that if your current supply is
110 volts you order a 100-volt lamp to run on it. If it
is 220 volts you use a 200-volt lamp. On a 240-volt
circuit (as mine is) 10 per cent. overrunning is arrived

at nearly enough by using a 220-volt lamp. Average life of lamps overrun to this extent should be not less than 400 to 500 burning hours. Greater and whiter light still can be got by overrunning lamps even more, but the practice is uneconomic, for their burning life becomes so short and doubtful as to be ruinous in renewal expenses.

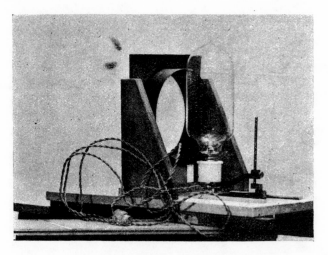

Fig. 16.—Lamp and collimator arranged for screening by artificial light.

My 1,500 watt focus lamp fits in a " giant " Edison screw holder which is attached to the arm of a " Focuslite " lamp tray. Thus the lamp burns like a great candle and can be swivelled and raised and lowered on the tray for optical centring behind the single plano-convex lens, which acts as collimator (fig. 16). My lens is an eight and a half inch diameter one, forming one glass of an old enlarger condenser. By setting the interval between collimating lens and light-source

correctly the light-beam from the condenser can be
made almost parallel. Actually I allow the beam to
err if anything on the slightly divergent side, for that
gives me a light-spot which at two feet before the
condenser lens is just right for screening and printing
tissue large enough for $8\frac{1}{2}$ in. by 6 in. plates. Lamp

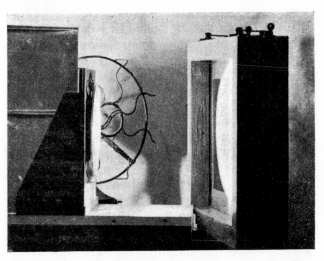

Fig. 17.—screening in progress. The vacuum frame is slightly
turned to show the light beam striking face of the copy screen.

and condenser are so built up in relation to each other
and to the screening table top that when the vacuum
frame is stood vertically in its appointed—and duly
marked out—position, the approximately parallelised
light-beam shall strike on the screen fully, and always
in the same place (fig. 17). That makes it a simple
matter to lay the tissue in the frame so that it all gets
screened with even intensity.

My artificial light-screening arrangement is com-

pleted by fixing a bracket or platform for a fan motor in such a position that all the while screening is in progress a brisk breeze of cool air is blown upon the frame's glass to keep it and the screen and tissue behind it from ever becoming more than mildly warm to the hand (fig. 18). There is the whole very simple and quite effective arrangement.

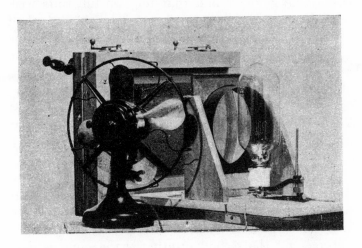

Fig. 18.—View of incandescent screening and printing arrangement, showing disposition of fan for cooling the light beam.

Those portraitists who have actinic arcs at their command can use them just as they are as screening lights. They should select one lamp only, and this a single crater lamp, for each screening unit, placing it from three to five feet away from the frame front, according to crater intensity. If possible it will be well to arrange a breeze fan to play upon the glass of the frame, as already described for the focus lamp arrangement.

With the focus lamp and condenser screening accessory, or with a good even-burning actinic arc, neither screening time nor transparency printing time need checking by the actinometer after the first once or twice. A worker will, by then, come to know what timing corresponds with two, three, four, or five tints. Henceforward his watch, or a timing clock, will do the rest. As a guide, I find that for two full tints with the overrun 1,500 watt focus lamp and eight and a half inch condenser, set as described above, screening time is seven minutes. For transparency printing to the same light-source, but with a sheet of ground glass interposed between it and the printing frame. timing for three and a half tints is just fifteen minutes. When printing to arc light, the second exposure (that behind the transparency) should also be done with ground glass as a diffuser before the printing frame.

At the risk of wearying the reader I ask him to bear in mind (it has already been explained in a former part of these directions) why screening *must* be to direct, undiffused light. The reason why diffused light is correct for the second printing is the same as why we prefer it when doing any other kind of photographic printing. It does not so searchingly reveal minor blemishes in the texture of the printing transparency, such as minute dust motes impaled in the varnish, or individual pencilling of the retouching.

Those who may not be able to tap a sufficiently heavy lighting supply circuit to draw from it fifteen hundred watts, can, if they have electric fires installed, make an arrangement with the electric supply company by which they may be permitted to plug the high power lamp off the heating circuit. Otherwise they

must be content with a smaller focus lamp, and increase screening and printing time accordingly. I have used for this purpose as small a lamp as one of 400 watts. Such a lamp of 200 volts, run on a 220 volt circuit, will take very little over two amperes, therefore being capable of being run off any ordinary house lighting bracket (through a lamp holder plug and flex) without fear of " blowing " the fuse and so temporarily throwing the sub-circuit out of use. The relatively low candle power may not be ideal for professional work, but an amateur or experimenter who does not mind waiting an hour and a half or thereabout for the total screening and transparency printing time will be quite able to get good results during the winter when the sunlight has deserted us. Miniature arcs consuming rather under five amperes are also possible screening and printing units, but the light from them is not very constant either in quantity or quality. Where they are used, timing had better be checked always by the actinometer.

CHAPTER VIII

Development of a photogravure resist. The stages by which it is evenly dried. How to judge the resist and decide if the plate is good enough for etching. Putting on its acid-proof border and backing.

IF you are well accustomed to the development of carbon prints I would still suggest that you do not turn up your nose at the attempt I am going to make at describing my way of developing photogravure resists. In general the practice is the same as with ordinary carbon work, but there are small differences between the two which stand between success and failure.

The first one of these the carbon worker will already have come up against. In photogravure, instead of " single transfer " being made on to a surface previously prepared by coating with a thin layer of toughened gelatine, and instead of the tissue being ready for development as soon as it has had a quarter of an hour's pressing in contact with the transfer support, we have to put our tissue down upon absolutely bare copper and to rely for its adhesion upon letting it dry to the point where it sticks. If you start development before then the image on the copper will frill, or bodily float away, and be ruined.

However, our tissue is, we will suppose, dry enough by now, which means almost, but not quite, dry. If

56

so, it is ready for immersion in water at 110 to 115 Fahr. Text-books and printed instructions tell us to start with the water at 105 Fahr. and raise the temperature gradually to 115 Fahr. I have found the lower temperature time-wasting, and if there are two things to be avoided in photogravure resist development they are waste of time and incomplete washing out of the unaltered gelatine. My way is to half-fill an enamelled iron dish with warm water, and to keep this water at 115 exactly, by the help of a small electric boiling stove (or gas ring) and a chemical or dairy thermometer. Dairy thermometers, also known as bath thermometers, are much cheaper than the regular chemical ones and are sold with removable wood covers which protect them from breakage when out of use.

Put the copper plate in the hot water, and at once free it and the adhering tissue plaster from air bubbles. This is easily done with the fingers, or with a camel hair mop brush. At first the copper will withdraw a good deal of heat from the bath so that its temperature will drop, and we must apply more warmth to bring it back to 115 or even 120 Fahr. Generally three or four minutes elapse before slight oozing at the edges of the tissue intimates that the time has arrived when the paper backing can be stripped off. To do this a needle point or thin knife blade has to be very carefully and lightly inserted between tissue and paper back at one corner of the plate. A slight attempt at upward pulling will show whether the paper is ready for stripping. If not, and in face of expert instruction to the contrary, I do not hesitate to raise the temperature of the water to 125 Fahr., and in the last event

E

to add a very little ammonia solution to it. Do not use ammonia as a regular practice. It ought not to be necessary, and it makes subsequent steps of our process more delicate. As soon as the corner of the paper backing is free, double it on itself and pull gently, and it should come away. But strip it off slowly and with circumspection, never losing sight of the fact that the bare copper has nothing like the grip of prepared transfer paper, so that to get the paper away without any hint of frilling is, if not a real test of skill, at least a sign of previous practice. Keep developing temperature down to 120 Fahr. if possible, 125 Fahr. is the absolute limit of safety.

Development is exactly as for carbon, and should preferably be done by generous laving with the hot water. Some workers finish up by very gentle appli- cation of a camel hair brush or of a tuft of absorbent cotton wool to make sure the last of the free pigment and soluble gelatine has been got rid of. I have tried it, and cannot deny that etching gets a rather better move on in the early baths when it is done, but believe the general gradation scale of the finished plate suffers. Anyway, lave quite hard at the finish and keep it up for at least a minute after the image seems to be fully out.

What will our plate look like at this stage ? Quite probably inspection of the image will lead us to believe we have got under-exposure. Anyway, take the developed plate out of the hot water, stand on end to drain for not more than two minutes, until the copper is just warm, then rinse with cold, or in winter with almost cold water, drain again for not more than another two minutes and plunge into a bath of half

and half methylated spirit and water. Rock evenly
in this bath for one minute or a minute and a half.
Meanwhile take a clean *dry* chamois leather and moisten
it in spirit and water mixture of exactly the same
strength as the resist is soaking in. That is of vital
importance. Pick out the plate, drain on end for
one minute, wring out the chamois leather, roll it
into a tight pad and rock the pad gently over the
surface of the resist. This is frankly a time when
the beginner will have cause to hold his breath. Any
friction between leather and resist caused by falling
into a wiping instead of a simple rocking action will
probably rip and spoil the resist image. On the other
hand the developed tissue has to be rapidly " blotted "
with the chamois leather till all surface moisture
has been completely and evenly removed. Wherever
drops or wet patches are allowed to remain, there the
etching solution will bite unevenly and the plate will
take to itself a crepe-like water mark in the final
etching baths. Success at this point of the operations
depends upon sheer manipulative skill. As soon as
the plate is completely surface-blotted it should be
stood on end and a smart current of air (which may be
warmed) should be blown upon it by the breeze fan
until the resist is dry. Drying time ought not to be
more than ten minutes at most, and it is essential
that all parts of the plate representing equal density
should dry simultaneously. A plate left to dry slowly
and progressively will etch with graduated density
from end to end as the result.

Now to examine the dry resist. First of all, apart
from any question of pictorial image, the whole surface
when viewed under a magnifying lens, should show its

screen ruling as a clean-cut hatching of pigmented gelatine cross-lines. Next, to judge of the image, the plate should be held at an angle to a good light so that the sheen from the underlying copper surface gleams brightly in the parts representing shadow and deeper half-shadow tones. Almost everywhere faint shadow details should then be just discernible as pigmented clouding of the full brightness of the metal. From this the density scale should ascend till high-light tones are covered with a thickness of pigment only a trifle less pronounced than the pigment covering of the picture border itself.

We proceed to a second general examination for blemishes. Mottling, if present, will show as small glossy pigmented areas which cannot be accounted for by reference to the printing transparency. Uneven drying marks also show glossy, but more or less as streaks, like the patches seen upon smooth streams in summer time. A different kind of blemish which, unfortunately, I find sometimes crops up upon an otherwise passable resist, is a small area of unduly thin density having in the middle of it a speck of embedded matter foreign. The whole defect is usually not much bigger than the head of a large pin, and can be likened to the " pin-hole " encountered in our negatives from time to time. Probably the cause of the trouble, as with pin-holes in gelatino-bromide plates, is iron rust. Generally so small a blemish can be touched out before the plate goes into the etching bath.

Where a spirit and water bath has not been filtered previous to each time of using, and sometimes even when it has been, small particles of fluffy matter will

be caught up from it and adhere to the dry resist surface. These may often be detached by the very gingerly use of the retouching knife in the hands of a fairly skilful worker, but the resist must not be cut through in the process. If they are left alone they tend to act as tiny wicks leading the etching fluid too rapidly to the copper immediately below them, with the result that a minute dark speck appears later on in the printing surface. On this account I take care to remove adherent fluffy particles from high-lights of the plate, but do not worry so much when they occur in the deeper half-tones, or shadows.

If on examination the resist shows clean screening, a full range of density tones from (apparently) bare copper to liberal pigmentation, and no surface defects, the plate can be accepted and be prepared for etching. If it shows mottling or uneven drying marks no attempt should be made to proceed further, but the resist should be re-wetted, scrubbed off with a clean nail brush, and the copper, if needed immediately for a further attempt, should be given another scrub with whiting and ammonia, as previously described. It will then be ready again for squeegeeing into contact with a new screened and printed tissue. But suppose the resist is, generally speaking, even, but has a pin-hole or two, or some similar defect occupying no large area of the copper, such as a minute rift in the resist surface only noticeable under the magnifier or when the plate is tilted underneath a lamp till the bright metal gives a flash ? What then ?

Should the resist be scrapped under these circumstances ? Let each man decide for himself, but I can say this : that many passable printing plates of my

own had to be doctored for more than one of these minor defects before they went to the etching room. That is one of the wonders of photogravure—the simple way in which the delicate photographic work and even quite clumsy hand work will mingle in the printing plate to one harmonious whole.

Fig. 19.—Plate etched and with the gravure resist removed, but the bitumen resist border still on, and the exposed metal within the border as yet uncleaned. Note that it looks like a failure.

To make ready the plate for etching not only must minute blemishes be touched out with acid resist varnish but a coating of the same varnish has to be applied to the back of the plate, to its *edge* and to the front border. Fig. 19 will show what the border appears like. My own practice is to do the bordering first of all. Remember, the tissue prints its own border of etch-resisting gelatine and so all that is, or

should be, necessary is to paint on a rim of acid resist varnish which will overlap this gelatine-pigment border and continue it to the plate's edge. Then, if we etch the plate just rightly, we shall stop short before the gelatine bordering has been penetrated by the etching fluid to the point of attacking the underlying metal.

It will be observed there is a " should be " about that. Anyway, a more certain picture bordering can be put on by ruling boundary lines about the edges of the resist picture. The lines should preferably miss the picture by about the thirty-second part of an inch. In that way the original photographically printed picture boundary limits, which are always best, will be those retained on the plate, but, in the event of slight penetration of the border gelatine occurring, the faint band of tint so produced will be too narrow to be noticeable.

Rule the border boundary lines with a ruling pen of the sort supplied by mathematical instrument makers and found in boxes of compasses. An ordinary pen nib will not do. If you try to rule with it on the resist the lines will run.

Acid resist varnish is made by dissolving bitumen in benzine and adding enough oil of lavender to prevent the bitumen coating chipping when dry. Or preferably buy thick resist varnish ready made. It costs only about half a crown a pint. A coating is thick enough to prevent action of the etching fluid upon the underlying metal when the colour of the copper cannot be seen through it. Keep a bottle of benzine at hand and dilute the resist varnish, a little at a time, till it is at the half-liquid, half-viscid consistency which just

allows of it flowing from the pen during border ruling. The same consistency will also be right for brush painting the edge and back of the copper.

If you keep a sheet of glass handy, it is simple to take out a little of the jelly-like concentrated varnish upon the tip of a palette knife, add a few drops of benzine, work up the whole to the right strength, and with it charge a small camel-hair brush. The same brush will do for filling the ruling pen, completing the bordering and coating the edges and back of the plate. The back can conveniently be left till last of all.

When a plate has been coated and the varnish is fairly dry, a little application of warm air from the radiator and breeze fan soon gets the coating hard enough to be ready for the etching operations. On no account heat the copper really hot at any time or the expansion of the metal, occurring coincidentally with contraction of the gelatine resist through extreme desiccation, will probably cause the resist to split off the copper again, just as a well glazed bromide jumps off its glazing plate on becoming bone dry. That has happened to me a time or two, and occurring as it does at the moment of thinking you are ready for the etching trough, it is more than a little irritating.

As to touching out small defects, this should be done with a fine sable brush dipped in a little well-thinned resist varnish, working under a reading glass.

One more use for acid resist varnish at this stage I have discovered for myself, though I am not enough of an artist to be able to take advantage of what I know. If you are working from a transparency wherein the sky is uninteresting, it is possible to add, or to rein-force, clouds by painting them in on the dry resist

with acid-proof varnish so diluted with benzine that it is no more than a faint brown stain upon the pigmented gelatine. Practice alone will enable a worker to know how deep a " tint " painted on the resist in this way corresponds with how great lightening of the printing tone on the plate eventually.

Another thing can be said here for the comfort of the beginner. Sensitive as the resist is at all times to traces of water, you may apply benzine, or even pure spirit of turpentine, to the gelatine face gently with a paint brush, or even on linen or cotton wool, for the purpose of removing unwanted varnish marks, and the plate will afterwards show no irregularity of etching on this account. So where a mistake is made with the ruling pen, or where spotting has been raggedly done, it is merely a question of taking the old work off cleanly with benzine and the resist can be re-ruled or re-spotted without harm. Now to etch it. Never touch the resist with your fingers.

CHAPTER IX

An etching bench and its simple arrangements. Etching baths, their graded strengths and their preparation. The necessity for a clock or watch and also for pencil and paper.

WHEN we come to the etching of gravure plates we part with the state of things where a simple " following the book of words " will see us through. If you ask me what is the most important accessory to gravure etching I say without hesitation it is the skill that can only come with practice. Any man who etches his first plate correctly can take to himself no credit for doing so. His success will only be a fluke. He has merely put off the evil day. We all have to learn.

Take seven pounds of crystallised ferric chloride. They call it crystallised because it is sold in shapeless lumps. The best lumps I have come across are supplied by Penrose. They are quite dry, and hold so little excess of acid that the process of " hydrating," about to be described, is comparatively easy. Place the ferric chloride (otherwise perchloride of iron) in a china or earthenware bowl (I have used a borrowed wash basin), and just cover it with boiling water. About two to three pints of water will dissolve the whole seven pounds, if it is poured on when really boiling. When the solution has cooled down somewhat, but before it has got cold, it may be poured into a five-pint Win-

chester bottle, which it should just about fill. Possibly,
as the contents of the bottle become quite cold, a certain
amount of the dissolved perchloride may crystallise out
again. It does not matter. The saturated solution,
if tested with the Beaumé hydrometer, will be found
to read approximately 45 on the scale. This is far
above etching strength, but it is a very convenient
strength for the stock solution from which etching
baths are made up by dilution. However, before
we come to that we must get the " hydrating " done.
The term signifies a particular routine way of getting
rid of the last traces of excess of acid in the bath, and,
as it is of prime importance to ourselves, it deserves to
be well understood.

Ferric chloride, then, as we may have surmised, has
the property of attacking and dissolving (" etching ")
copper, and, in fact, a good many other metals also.
It will even etch iron and steel more or less, for which
reason the stipulation was made that solutions of it
should be prepared only in china or earthenware vessels.
Fierceness of its attack depends upon the amount of
free hydrochloric acid present, and because the attack,
for purposes of photogravure, must only be gentle, and
because even the best commercial ferric chloride holds
within it a certain amount of free acid, this acid has to
be completely got rid of before we can use the etching
fluid. The way we remove it is by stirring into the
stock solution a sufficient proportion of a sludge of
freshly precipitated ferric hydrate for the whole of the
free acid to combine with the hydrate and form with
it further ferric chloride. Hydrating, in practice, is
simple enough. Pour one ounce of stock perchloride
solution into a chemical measure, dilute it with ten

ounces of water, and stir in enough stock-ammonia solu-
tion from our half-strength ammonia bottle to precipi-
tate the hydrate as a brick-coloured slime. Allow the
measure to stand for an hour or two till the hydrate
slime has settled well down, tip off the liquid from the
top of it, stir up with another ten ounces of clean
water, allow to settle once again, and this time,
after throwing away the wash water, pour the hydrate
into the perchloride stock bottle and stir well up.

Stirring should be repeated a few times at intervals
of a day or two, or when you think of it, and if a cloud
of unaltered hydrate precipitate still remains to settle
in the bottom of the stock bottle you may be satisfied
that the etching solution has been sufficiently " neutral-
ised " to be safe for use when at the right dilution.

Now about that dilution, and the Beaumé hydro-
meter. Those who have no previous acquaintance with
the characteristics of ferric chloride as an etcher will
probably find it hard to believe that within wide limits
this solution works faster according as you dilute it
down weaker. I remember, when I was young and
cocksure, making experiments with the Warnerke
process, which also depended upon using gelatine as a
resist when etching copper with ferric chloride. On
that occasion I failed lamentably, because I could not
believe the instruction to strengthen the solution for
gentler action was anything but a particularly gross
misprint. I hope enough has been said about it to
leave no room for any reader going to work wrongly
on account of a similar misapprehension. Next to
grasping this cardinal point, we need to realise the
extreme sensitiveness of the etching baths to small
alterations of strength. Thirty minims of plain water

added to two fluid ounces of etcher makes a very real
difference not only in its rate of action, but in its whole
characteristics as a working bath. Hence not only
must the Beaumé hydrometer be accepted as the high
priest of photogravure etching and its readings obeyed
scrupulously to half a degree, but the hydrometer
itself must be in the first place a very accurate and
finely graded one. In my own experience I bought
three at different times, and tried them out against
each other before finally settling down to be guided by a
special pre-war one discovered in the back of a showcase
in Penrose's process room. This is graded in clearly-
marked half degrees between 30 and 50 Beaumé. The
regular post-war stock article is not as finely graded,
and I doubt whether it is as accurate either. Should
photogravure become popular in the near future there
is no doubt that suitable Beaumé hydrometers will soon
come upon the market. The present price of one is
about four shillings, and a testing glass to hold the
solution the gravity of which is being taken costs
about another half-crown.

For a complete range of etching baths, which must
all be made up and ready at the right temperature
before we start, sufficient amounts of solution must be
prepared by diluting the stock hydrated solution to the
following strengths : 41, 40, 39, 38, 37, 36, 35$\frac{1}{2}$, 35
Beaumé. The worker had better have a 34 strength
also, to be on the safe side. In my own practice I
hardly ever find the need to go below 35, chiefly because
I make a point of preserving the utmost detail differ-
entiation in the high-lights of the plate and keeping
the highest points of light of all " natural," which
is copper plate parlance for toneless, or undegraded.

Enough of each strength of bath should be prepared
to fill a three-pound stone jam jar three-quarters full,
and on the front of each jar I paint black enamel
figures corresponding with the correct hydrometer
reading of the contained solution—all except the
$35\frac{1}{2}$ bath, the jar of which bears its strength marked

Fig. 20.—The complete etching equipment. The etching fluids are
contained in a row of stoneware jam jars. There is a sink and
water tap, a gas ring for heating the etching baths, a watch for
timing, and the paper and pencil for "logging" etching times.

in red enamel. That is done because it of all baths is,
in my experience, the most critical. Sometimes it
may need to be skipped over, at other times it is called
upon for a prolonged etching time (fig. 20).

The jars should be provided with tops, which may be
cleaned-off half-plate negative glasses. They keep out
dust and prevent undue evaporation when not in use.
A thermometer must be handy upon the etching
bench, also a small gas ring or electric heater with an
asbestos mat over it. Before the baths are used they

must all be warmed to a working temperature not less than 70 F., but possibly as high as 80 F., according to the hardness of the copper. A copper that will not start under 80 F. in moderate time with a normal thickness of etching resist will be very hard, and—once you have etched it successfully—very nice for printing from. Our jam jar containers can be warmed by simply standing them in turn upon the safety asbestos mat over the source of heat, and taking the temperature of the contents with the thermometer, remembering also that the heat absorbed by the stoneware itself will bring about a further rise of three or four degrees Fahrenheit after the jar has been stood down on the bench again.

For work in comfort there should be a water tap and sink close by the etching bench, shown also in fig. 20. Failing that, provide a copious amount of wash water so that the plate may be immediately rinsed practically free from perchloride solution the moment etching is over. Otherwise it will be spoiled even at the moment of its completion. A solution of washing soda makes a good " stop bath " to the etching fluid if running water is not handy.

Other adjuncts necessary upon the etching bench are a damp sponge or two for keeping it clean, an area marked off whereon to rest a lead pencil and some paper and lastly some means of timing the etching. If there is not a spare clock available having a minute hand, it will be sufficient to do as I have done, and knock a nail into the wall whereupon you can hang your watch where it will be at once ready to consult and out of the way of possible splashes of etching fluid.

CHAPTER X

An etching " log " and how to keep it.

THE obvious purpose of the pencil and paper is for keeping a " log " of the times of the plate's immersion in the various etching baths. To do this is a matter of highest importance. The paper may conveniently have written at the head of it the date, size of plate, subject, and whether it is the first plate etched of that subject, or whether a second or subsequent attempt. Under this heading my practice is to write the word " IN " at the extreme left-hand side of the sheet. Time (of day) of the plate's immersion (accurate to the half minute) is duly written against this and underneath in a parallel column is placed the figure representing the gravity of the etching solution to which the time refers. Immediately on pouring off an etching bath and substituting another the time and gravity of the new bath are similarly added in parallel columns, and so on till the plate's etching is complete, when I

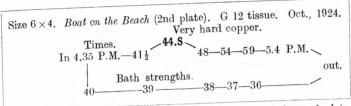

Size 6 × 4. *Boat on the Beach* (2nd plate). G 12 tissue. Oct., 1924.
Very hard copper.

Times. **44.S**
In 4.35 P.M.—41½ 48—54—59—5.4 P.M.
 out.
 Bath strengths.
40————————39——————————38—37—36——————————

Fig. 21A.—Specimen etching log of an average straightforward plate. Note that actual time of etch is time from start of etching (black type) to out—in this instance just 20 minutes. Result, a good plate.

72

bracket both columns together and write the word
" OUT " (fig. 21A).

It by no means follows that all the etching will
progress along a sequence of baths each of which is
weaker than the last. Quite often the desired effect
can best be got, or can only be got, by returning to a
stronger bath after a weaker one. To denote this we

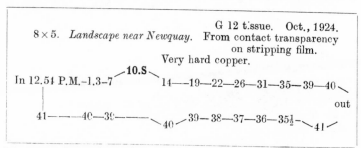

Fig. 21B.—Specimen etching log of a tricky plate that required two
returns to stronger baths. The return to a stronger bath is denoted
by a downward dip of the log line. Actual etching time, 30 minutes.
Result, plate deeply etched but satisfactory.

need some simple and quickly " loggable " code sign.
My way is to draw a line dipping down well below the
general level of the line upon which gravities are
recorded and to enter up the stronger gravity at the
foot of this line (fig. 21B). Any other convenient code
marking for this or any of the logging will do just as
well of course, the important point being to start
some adequate time and bath recording system with
the very first plate attempted. Only by frequent
comparison of previous etching times and strengths
can a worker rapidly acquire useful knowledge of what
gradation range he may expect from any bath or
sequence of baths. For the etching of the copper is

F

as the development of a photographic negative where two or more different developers are employed each for selective rendering of density or detail, except that no dual or triple bath negative development ever yet presented the complication, difficulty, and opportunity for wide control through seemingly trifling modificaticn that you will find in etching a photogravure printing plate.

CHAPTER XI

Etching with graduated bath strengths. Characteristics of the various baths described. Judging indications of the start, progress and finishing point of etching.

START (if in doubt) with bath 41, and leave the plate in it for two or three minutes. Pour on enough solution to keep the resist covered all the time the bath is rocked. *It needs no more than quite gentle rocking.* Just previous to putting the plate in the etching bath fan it over the heater for half a minute to dry out the resist thoroughly and evenly in case it should have absorbed traces of atmospheric moisture between now and when it was dried after development. Do not be surprised if bath 41 fails to etch the plate at all. Generally it has no action.

How to know whether it is etching ? You can tell that fairly definitely because as soon as the copper begins to be attacked in the deepest shadows the hitherto bright metallic copper surface goes black, green-black or brown-black, according to the sort of copper being etched. You can see the dark shadow representing actual shadow in the plate start up fairly suddenly and with remarkably clean-cut outlines. Start of etching should at once be " logged " on the etching sheet, my code being the time written within a pencilled circle, with the letter S attached to it, no corresponding change of bath strength appearing in

the parallel line below (see figs. 21A and 21B). In the log, as here printed, the starting time is shown in heavy type instead of being " ringed."

Necessity to log start of etching, as well as time of original immersion of the plate in the etcher, arises from the fact that though the various times in the various bath strengths which follow are for us to determine through the exercise of our own skill, total etching time for a particular grade of copper is a fixed quantity within quite narrow limits. In screen photogravure the plate should not be etched for less than twenty nor for more than twenty-five to twenty-seven minutes for hard copper and a good average printing depth with " rag wiping." Etching time is time from start to completion of etching. Where a plate is sluggish in showing its first change of colour this time may be very different from that between plate immersion and completion of etching.

Should the copper show colour change within three minutes in the 41 bath it is a sign that the resist is thin, that the copper is soft or the etching temperature too high. However, continue with the same bath until the darkening involves what are to be the deepest outlines of our subject ; that is those outlines which, if we were drawing them in on paper, would have been marked with the full depth of a soft pencil. Immediately the plate gets that far, change to bath 40, log the change and the time of it and carry on, watching narrowly while darkening of the copper underneath the resist extends to the next deepest set of shadow tones. That is the regular way of it, and all I can do to aid you further at this point is to give some general hints which may or may not prove to fit in well with

the technique it is up to you to elaborate for yourself, by trial and error.

Bath 41. Seldom calls for an etching time of more than three minutes after first signs of darkening of the copper. Where heavy-printing shadows are not of first importance in the plate this bath may even be done without altogether, beginning etching routine with bath 40 instead. Most of my own plates make no appreciable start of etching in bath 41.

Bath 40. An important bath and usually the one which seriously starts the etch, especially with extra-hard copper. A usual time to allow in this bath after start of etching is three to four minutes, but it is generally worth while waiting for eight or nine minutes if necessary to give a hard copper plate a chance to start in bath 40, where, for some reason, such as thickness of the resist, it will not get a move on before. The average three minute etching time is, as already explained, a timing taken from the moment of first copper darkening.

Bath 39. This bath also will tackle deep shadow tones and is the last of the series which can be depended upon to do so. Some quite good plates only make their start of etching in the 39 strength bath. In that event the etch in this strength of solution should be continued for six or seven minutes. Where the 40 bath has previously acted normally, etching time in 39 may be anything from two to four minutes, according to the characteristics of the plate.

Bath 38. This is the general purpose bath of the etching series. Authorities say that whereas the stronger baths must only be used sparingly, to etch deep shadows and more or less to outline the image,

bath 38 should be pushed pretty well to the limit of etching That might mean an etching time approaching eight minutes. Personally I have not found so good a result from pushing the 38 bath with G 12 tissue as other workers appear to do, though readers will understand I make no pretence to be more than an interested learner myself. I favour four or five minutes as the average for 38. This is the bath for etching the deeper mid-tones.

Bath 37. In my own experience, this and bath 36 are key baths of the process. In 37 you get out those mid-mid-tones which do most to richen and round off the general detail. Generally my aim is to give not less than four minutes here. Sometimes I have gone to seven or eight minutes, and been glad of it afterwards.

Bath 36. A high-light detail forming bath. To 36 generally comes the business of etching the more accentuated shadows of cloud forms and of other parts of the plate having similar position in the " light grey " end of the tonal scale. Bath 36 is the final bath with some plates where great accentuation of the lighter detail is called for and where the resist has been rather thinly printed. On these occasions the etch in it may be prolonged to eight or ten minutes. Where, as normally, the plate is to be transferred to a weaker bath etching time will be probably about five minutes, but seldom less than four.

Bath $35\frac{1}{2}$. This is the final bath for many of my plates, taking the place of 35, which in my experience has a habit of rushing the faintest high-light details together till they become clogged with a general printing tint over the plate. From three to five minutes in $35\frac{1}{2}$ usually brings us to the final point

where faint evidence of darkening of the copper can be seen underlying all but the thickest parts of the resist. Where the highest lights appear quite unchanged after five to six minutes in $35\frac{1}{2}$ the plate can be passed on to 35 bath.

Bath 35. With me the high-lights " go through " with something of a rush. This bath I have found of little use for differentiation of detail, but it supplies that slight extra rounding at the edges of rather faint shadows which is invaluable in some subjects. Usually three minutes in 35 brings out everything, and much longer etching time here causes the plate to take printing depth in the parts which should proof white, so that the whole tone rendering is flattened and foggy looking prints are given by plates wherein this bath's timing is overdone. The rule for the end point in photogravure is to give half a minute after the highest tone of the plate to be etched appears to have started biting, as well as can be judged by looking on the face of the resist.

Bath 34. All I can say about this bath is that I hardly ever find the necessity for it. At the same time other workers tell me they do so, and though I may suspect the truth to be that their hydrometers are graduated with a one degree error on the high side, it would be unseemly to deny the faint possibility that all of mine are graduated with a similar error on the low side. Or it may be just cussedness on the part of my copper plates or a tendency on my part to keep the temperature of my etching solutions nearer to 80 than to 70 Fahr.

To the experimenter I would say, therefore, have bath 34 ready in case you need it, remembering that,

unlike the development of a negative, once the etching of a photogravure plate has been commenced *it must be gone through with, right from start to finish.* You cannot stop in the middle and take up the work again at a future time. You cannot delay the plate for even a minute. If you dry the resist it is done for as a resist. If you soak the partly etched plate in plain water, that does for the resist also. Once in the first bath you can simply do nothing else whatever than go right on till the etch is complete. You know beforehand what time to allot for it—twenty-five minutes from start of etching or, say, a maximum time of three-quarters of an hour from first immersion of the plate.

When you judge etching to be complete take the plate and swill it rapidly and thoroughly under the tap. Alternatively, rinse it for a second or two in a large dish of plain water and transfer it to a second dish containing the " stop bath " : a cold solution of washing soda (soda carbonate). After that the resist may be cleaned off at leisure. The implement I find most handy is a tooth brush having long and strong bristles. Doubtless a nail brush would do quite well. And bear in mind from now on your chief enemy is grit. Every scratch upon the plate's surface above a certain depth will be a future ink-holding rut which will print in the press as a hair-line upon your proofs.

The above notes refer more particularly to G 12 and G 7 tissue. G 15 requires slightly stronger baths for the final etches, but the range already indicated will suit with very small modification of etching times.

CHAPTER XII

Etching troubles ; their meaning and avoidance. When to retrace from weak baths to stronger and a suggested code for " logging " this retraction. Distinctive behaviour of new baths and old.

THE last chapter attempted to give a useful sketch of the normal etching procedure, taken at its happiest. It is not always as plain sailing as there represented. Of this I will now tell. But first it may be helpful to give a specimen computation of times for the various baths for two typical resist printings.

The time "log" for average etching where the resultant plate possessed a long and even tonal scale shows : Time in bath 41 before start of etch, three minutes. Copper seen to have begun a slight colour change in deepest shadows, so etching time prolonged another two minutes. Colour change still very slight. Plate removed to bath 40 for three minutes, and thence onward to 39 for three minutes ; 38, four minutes ; 37, four minutes ; 36, five minutes ; 35½, four minutes and out. Total etching time : twenty-five minutes.

Example two is of a seascape the chief feature of which is the tonal rendering of breaking waves, deepest shadows in this plate being represented only by some fishing boats in the middle distance. Here etching started in bath 39 and was continued therein for seven minutes. In bath 38 the plate had only three minutes,

81

in 37 it had six minutes, in 36 another six minutes and out. Total etching time 22 minutes. You will perceive the times were chosen, firstly to get the greatest possible depth into the printing of the distant fishing boats, next to make an intentional step to the much lighter tones of the waves, thirdly to emphasise cloud forms in the sky of the picture to the uttermost.

These two examples fairly well show how individual judgment is to be used in etching, according to the subject dealt with.

Now to consider cases where a straight sequence of baths is not adequate to the proper rendering of the subject. It may happen that etching fails to start until a plate has got to bath 39, then makes a rush, several tonal values showing signs of coming through rapidly one on top of another. The thing to do here is to tip off 39 and substitute 41 without a moment's unnecessary delay. Keep 41 on the plate until the tones appear to have separated sufficiently, then pass on for a minute or so to 40 and back into 39, from which point the usual progress of etching may proceed.

Another problem may arise in that while the tones of the plate etch regularly you have reason to suspect that, possibly as a result of a slightly flat transparency, the completed plate as a whole will be lacking in richness in its deeper half-tones and shadows. That may be combated by returning the plate for a minute or so to the 40, or even to the 41 bath, after removal from what would ordinarily be the final bath of the etch. The 40 bath thus becomes the final bath. Used so, one minute is generally sufficient for it, while the two-minute time should not be exceeded or

mid-tones will be made heavy and the plate will print
with an over-loaded look.

Etching in photogravure provides no opportunities
for a similar practice to the " fine etching " of half-tone
typographic block making, but a thin plate may be
strengthened in its shadow and deeper mid-tones, after
removal of the resist, by re-etching. To do that you
need an inking slab, such as an old smooth litho stone,
some " finishing ink " (to be had at process engraver's
supply stores), spirit of turpentine and a "glazed
roller." The ink is thinned well down with turpentine,
distributed very thinly upon the stone with the glazed
roller, and the roller is passed over the surface of the
etched plate until an even film of finishing ink has
been deposited on all but the deeper etched
hollows. As soon as the turpentine has evaporated
the plate may be given a one minute etch in 38 bath.
For better protection of the inked surface it may be
dusted lightly with powdered bitumen, excess being
carefully removed with a camel hair mop, and the plate
being warmed till the adhering bitumen powder takes
a slight shine. I mention this partly because it is the
one process of ordinary photo-engraving which seems
to be adaptable to photogravure. But since good
glazed rollers are almost as difficult to come by as auk's
eggs, and since no other kind can be depended on, few
photographers will be likely to go in for " re-etching "
weak-printing plates. Besides, it is far better to scrap
and re-make them.

There remain a few more things about plate etching
which I would like to mention. I have warned readers
in an earlier part of my discourse that different samples
of copper do not behave alike, either in their etching

colour or in the rapidity with which the ferric chloride
solution does its work upon them. Soft copper gener-
ally shows a very full deep black colouration from
start to finish of etching. Also it is acted upon strongly
with the more concentrated baths and may run ahead
of the etcher when getting toward the end. Total
etching time with such copper will probably not be
over twenty minutes, and instead of baths 38 and 37
needing to be pushed far they may need to be curtailed.
In that event 36 will likely enough become the end
bath of the series. Where the first plate of a new batch

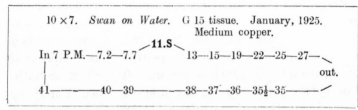

Fig. 21c.—Specimen etching log showing how grade of copper influences
etching time. This plate on medium hard copper was fully etched
in 16 minutes. Result, a good plate.

of copper shows the start of etch early on, in 41 or almost
immediately after transfer to 40, and where resist and
temperature seem to be average, soft metal should
be suspected as the cause. Copious floating off of a deep,
black stain from the surface of the resist is a sign of
equivalently deep etching going on beneath it. This
is often a premonitory sign of the etching running ahead
of you. The specimen etching log (fig. 21c) is of an
actual plate on rather soft copper which took only 16
minutes for full depth.
 Finally, we must know the distinctive characteristics
of new and much used etching solutions. A new bath

tends to etch shadow detail deeply in the greater strengths. In the lesser strengths the tendency is for it to bite through various lighter tones too closely together, so that the finished plate prints at once heavy and flat. A usual way of correcting this is to get a little copper into the etching fluid, either by allowing it to act upon an unwanted copper plate for a few minutes before it is taken into regular use, or by retaining a little of your old etching baths and adding some to the bulk of new baths intended to replace them.

Naturally we shall look for exactly the reverse characteristics in old and worn out etching solutions. With these the stronger, earlier, baths fail to bite deeply enough, while late baths have a way of stopping short suddenly at a certain tone graduation, and tending to over-emphasise it by too-deep biting before passing on to the next lighter tone. They are over-selective. My advice to the worker, at the start at any rate, is to avoid trouble from over-worked baths by making up new ones at frequent intervals, always adding to them about one-tenth part of the discarded bath of equivalent strength before taking into use. Ferric chloride is cheap. Its cost in London is something less than sixpence a pound.

Never omit to check the specific gravity of every strength of working bath with the Beaumé hydrometer the first thing on each day of etching, and correct it without fail by adding water or concentrated stock etching solution, as may be necessary. The tendency is for the contents of the etching jars to settle towards some middle concentration depending upon the time of year and climatic conditions of the locality. Strong

baths tend to weaken with standing, through absorption of water vapour from the air, while weak ones concentrate themselves by evaporation. Forgetting or neglecting this is a certain cause of erratic and out-of-control etching.

CHAPTER XIII

*Describes how to clean the etched plate and prepare it
for printing. With some hints on hand control
for those who are able and willing to make use of them.*

WHEN we have gently rubbed off the resist from the
etched plate, what do we see ? We see an awful-
looking muddle of smudge and stain (fig. 19). Were it
not that Denison had duly prepared me for this in his
excellent text-book I might easily have thought it
useless attempting to proof my first plate at all. The
reason why nothing definite appears at once is because
the whole depth of etching, even in the deepest hollows
of a photogravure plate, is not comparable with the
etching depth of even a shallow typographic half-tone
block. In the mid-tones depth is, of course, still less.
As against it, all the plate surface, barring inconsider-
able expanses here and there, has been acted upon by the
etching baths sufficiently to have taken surface stain.

The thing to do, therefore, is first of all to remove
the whole of the acid resist varnish from rim, edges, and
back of the plate. If any spotting has been done
with this varnish on the plate's surface it must be got
rid of also. A wipe over with benzine or petrol applied
on a clean, soft, grit-free rag will soon bare the copper.
Follow with a gentle application, upon another clean
linen rag, of a thin paste of double-washed whiting
and water. Personally, I find the next few moments as

exciting as any in the whole procedure, for, as the
whiting takes the general stain away, the image makes
its first appearance as a very beautiful picture upon the
bright copper background (fig. 22). After a few plates
have been made it becomes fairly easy to tell from the
appearance of the cleaned-up etched image whether
we have or have not scored at least moderate success.

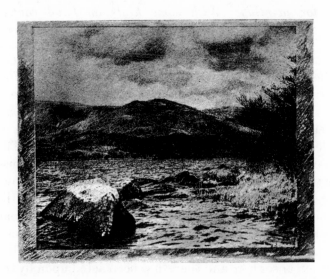

Fig. 22.—The same plate seen in Fig. 19, but now the bitumen resist
border has been cleaned off with petrol and the surface of the
copper polished with a gentle application of whiting and water.

The deepest parts of an average plate will not be
reached by the whiting, so that shadows will show
dark upon the light metal. This makes judgment
the easier, but some of the published instructions
advise removal of the deeper-seated darkening in
photogravure plates by treatment of the copper with
a very dilute chemical cleaner of the sort already

mentioned as a possible bath for removing tarnish from plates previous to making them ready for the tissue. The bath for etched plates contains one quarter of a dram each of sulphuric acid and chromic acid to the pint of water. If it is used, the plate should be put in it, and dark portions gently scrubbed with the tooth-brush, taking the plate out again and rinsing it well as soon as ever shadow-stain is gone. But I do not myself care for the treatment. Undoubtedly it removes copper from the thinner printing depths as well as taking stain out of the hollows representing shadow tones. However, the chromic bath may sometimes be used with advantage where a plate has previously been etched a shade too far.

We have still to get the edge of the plate smooth. I mean by that the *edge*, not the *rim*, which, if the resist varnish has been properly applied, will be smooth in any case. Whether the edge also is smooth will depend upon luck, perhaps, or upon whether a bevelled plate was bought in the first place. As bevelled plates cost one-quarter as much again as unbevelled ones, I have never myself afforded them. A simple way to smooth off the edge of a rough-cut plate is to moisten a slip of fine carborundum stone and rub it over the copper until the metal has been taken down smooth and slightly rounded off. Artist etchers are accustomed to bevel their hand-engraved plates for themselves by first rasping down the metal about the rim and then smoothing and polishing it with pumice powder and rouge. A good way to apply the rouge is upon a flat leather covered slip of wood. A snake-stone slip is very useful for the smoothing of plate edges.

G

If the resist we have etched was a perfect one, we shall not need to do any hand touching-up to remove blemishes. Where any spotting with varnish had previously been necessary, the plate will show small corresponding unetched areas which will print white unless they are converted to ink-holding surfaces by

Fig. 23.—Head of a roulette enlarged 12 times. The original spurs are 150 to the inch on the rim of the pivoted wheel.

touching-up with a dry-point needle or a roulette. The dry-point needle is a steel-pointed graving instrument with which a fine cross-hatching of lines may be scratched in the copper. Roulettes are little wheels fitted upon handles. Each wheel is made of hardened steel, and has upon its rim a series of raised points at intervals corresponding with the ruling of the photogravure screen (fig. 23). If the roulette is run firmly, but not over-hard, over the copper it presses its track permanently into the surface of the plate, the depressions being amply deep enough to hold a good deal of

ink when the plate comes to be proofed. The rule is (as far as my own experience goes) to put in, or to emphasise, light mid-tones with the dry-point and dark mid- and shadow-tones with the roulette.

After using either of them, the engraved part of the plate must be very gently gone over with the burnisher and a little oil or water, to take down whatever burr has been formed. Burnishing after touching-up very much lessens the ink-holding strength of whatever hand-work has been done, but if you depend upon the burr to reinforce it (as it will do), you have a plate that cannot be relied upon to print the same strength in the touched-up portions many times over. The burr gradually subsides of itself under repeated pressure in the copper plate press, and coincidentally these touched out defects become once again apparent.

There is even the possibility of exercising broad control in the printing tones of an etched photo-gravure plate by cautious local application of brass polish. When I do this I give the liquid metal polish a shake up, and let it stand a minute for the heavier grit to subside to the bottom of the tin before pouring out the polish for use. Those who are familiar with Baskett's reducer for negatives, or Bruce's " Nega-fake," will have no difficulty in seeing the similar possibilities of, say, Brasso, upon copper plates. For putting in small touches of lighter tone here and there, instead of using brass polish, a slip of wood charcoal may be moistened with water and rubbed upon the metal in the same way as a " Negafake " pencil. Anyone good at creating cloud forms has by this means a further outlet for his talent.

A five inch by one quarter inch slip of snakestone is

another invaluable help to touching up gravure plates by hand. Use it moistened with water. It grinds away the copper without sensibly roughening the surface. While wet willow charcoal lightens heavy tones without greatly disturbing light half-tones, wet snakestone does the reverse, removing light half-tones and preserving the heavier shadows.

CHAPTER XIV

*An alternative etching system—by bath dilution—of value
to the experienced worker and with more particular
application to rotary gravure. Gravure plates from
ink and pencil drawings.*

You have heard of the regular way of plate etching,
with the row of jars of ferric chloride solution ranging
in their specific gravities from 41 to 34 Beaumé,
dropping by single degrees, or even by half a degree,
in strength. You need not go to nearly so great an
elaboration unless you like, though you will certainly
work more methodically and have a far bigger chance
of learning the technique of etching well if you do.
There is a simple alternative all the same. The
present chapter shall set it forth and will add a few
hints on the reproduction in photogravure of line
drawings.

On the alternative etching system you make up
one bath strength only, which may conveniently be
40 Beaumé. Pour out into a measure enough of this
to cover the plate in its etching dish, and note care-
fully how much you pour. Bring its temperature to
whatever may be your favourite thermometer read-
ing, whether 70 deg. or 75 deg. Fahr. Have also ready
a second measure of clean water brought to the same
temperature. Pour the 40 strength bath on the
copper plate, rock gently and time with watch or
clock up to seven or eight minutes if necessary till

etching starts, and thence forward for another two or three minutes to get your shadow tone outlines, as already described. Then tip the etch back into its measure and add water in proportion of one dram water to each four ounces of etching fluid. Stir *quickly* and thoroughly and at once pour the diluted bath back on the plate for a further two or three minutes' etch. When the next step in biting the plate seems to have proceeded sufficiently far for prudence, once more return the etch to the measure, add another dram of water, stir and return to the plate again. Do this at your own discretion until the plate is fully etched, adding always the one dram of water at a time, but choosing your etching periods to please yourself.

A strong point about this technique, from the standpoint of an expert, is the fine grading of bath strengths which it admits of. Instead of jumping down degree by degree, the general principle can be so adapted that steps in the etching process are merged very completely into one another, rounding of tones and length of tone scale in the plate being improved accordingly.

For beginners, the dilution system also possesses a great advantage in its simplicity of application. You do not need a row of separate jars, each of which has to be labelled, each one warmed to correct temperature and each tested and adjusted accurately to strength whenever etching is going to be started. There is great saving of bench space. The counter-weighting disadvantage is that neither do you know exactly what specific gravity of etching fluid is responsible for each portion of the tonal scale of the finished plate,

nor does the system lend itself nearly so well to accurate logging of etching dilutions and etching times. Where successes are gained the worker has therefore but a vague knowledge of how he can repeat them. Where he makes a failure he is even more in the dark about the stage at which he went wrong.

Yet, what is one man's poison is another man's meat. It is said that the finest photographer of Alpine scenery of recent times made his best negatives by deliberately contaminating his pyro developer with hypo. We all must choose our own path.

In making photogravure plates from line subjects, such as pen or pencil drawings, theoretically, at any rate, resists from transparencies wherein the middle tones are either wholly or partially absent may be etched just the same as any other kind of resist. Actually to do so is waste of time and attention.

For instance, if our transparency is in pure black lines upon a clear ground (as it may be where it is a copy of an Indian ink original) the only etching bath required will be one which gives a rapid and sharp bite to the copper in the unprotected parts while allowing no action whatever where the gelatine-pigment layer is of even a moderate thickness. The three baths either of which should suit the circumstances almost equally well are 40, 39 and 38. Of the three, I have found 39 and 38 preferable because they get to work on the copper most promptly. Etching time for a good deep etch of a line subject at normal working temperature (70 to 75 deg. Fahr.) may vary between ten and twenty minutes, according to the grade of copper to be acted upon. You simply pour on the bath you select, rock the dish gently for the

time you favour, take out the plate and clean it for proofing. When doing line photogravure a 175 line or 200 line copy screen may be preferable to the standard 150 line screen, especially for small fine work. The perfection of photogravure reproduction of line subjects is unrivalled.

When we come to making plates from pencil drawings, the original transparency will usually not be one of deep black lines, but will have at least a little half-tone shading. It is up to the worker to decide how many changes of bath strength are necessary to do justice to whatever tonal scale there may be. For average pencil sketch reproduction, where none of the plate is required to be deeply etched, the best result may be gained by starting with a short (two or three minute) etch in bath 38 and going on to bath 37 for the final seven or eight minutes of etching time. But here, as always in the technique of plate etching, each individual worker will have to shoulder the responsibility of finding out for himself what bath strengths and etching times best suit his own disposition and ideas of what he wants. As his plates provide him bit by bit with this first-hand information his own interest is to record it clearly and simply, so that he can look up the data afterwards whenever in doubt.

In photogravure plate making from hand-drawn originals I most strongly advise that the first described arrangement of a series of ready-prepared and standardised etching bath strengths be the one made use of, and not the temptingly simple but too indefinite dilution system described at the beginning of the present chapter.

CHAPTER XV

A short theoretical interpolation to make plain the fundamental difference between a gravure print and a photo-mechanical " half-tone." This chapter proves gravure to be as truly a continuous tone printing process as any known to photography.

In my introductory chapter I said a little about intaglio copper plate printing. I explained briefly how it differed from typographic printing. Instead of the fatty ink being impressed upon the printing paper by offset from projecting portions of the metal surface, as in printing from type, the ink wherewith the picture is printed from an intaglio plate lies only in the plate's engraved or etched hollows, the high metal parts having been previously wiped clean. The same plate which would print a positive picture by typographic proofing would on this account print a negative picture by intaglio proofing, and vice versa.

Also I tried to show how—unlike a " half-tone " photo-mechanical newspaper block (fig. 24), in which there are no real half-tones at all, but only an illusion of them brought about by the microscopic inter-mingling of close-spaced areas of dead black and white—photogravure plates really print true half-tones. That is to say, they lay a varying *thickness* of ink upon the proofing paper for shadow, mid-tone and light-tone rendering, just as with, say, a self-toning or a real

97

bromide print direct off the negative. For there, also, half-tones are made by a varying *thickness* of reduced metallic silver held in the paper's gelatine coating (fig. 25).

Admitted that a screen photogravure plate has all over its etched portions a network of high copper lines corresponding to the lattice of the screen ruling, these

Fig. 24.—Half-tone photo-mechanical illustration greatly enlarged to show how in this typographic process the appearance of mid-tones is an illusion produced by varying size of black dots in proportion to their white surrounds. All dots are equally black, there being no real variation of ink depth. Also no portion of the printed area is entirely white. × 4.

lines hardly vary in width according as they cross high or shadow tones. (Refer back to fig. 3.) Thus they, of themselves, contribute very little towards high-light or shadow. If they do contribute at all to the quality of printing it is only in the same way that a layer of fine muslin or of bolting silk between negative and sensitive paper will contribute to " break

up the surface " of a photographic print and broaden its
general effect. All experienced artistic photographers
know of that dodge for rounding up and creating
" atmosphere " in a print from a finnicky or spotty

Fig. 25.—Micrograph of part of a photogravure impression on paper
showing total absence of dots in the high-lights, varying depth of
ink in mid-tones and tendency for dots to run together and so make
solid shadows. × 12 diameters.

negative. Well, photogravure performs the same
service *without loss of fine detail*. Apart from it the
screen does nothing more than fulfil the purely mechani-
cal function of preserving intact the minute array of
ink troughs from which our printing plate derives its

power to wipe up and proof. Any plain photographer
will understand this easily enough. Should a half-tone
worker happen to set eyes on it he will the more readily
understand that in photogravure the first thing to do is
to forget all about half-tone screens and their theory.
Our ideal finished printing plate is a network of ink-
pockets each surrounded by a thin copper wall and each
pocket of a *depth* corresponding with the depth of tone
of the transparency image from which the plate has

Fig. 26.—Micrograph of photogravure plate showing portion of unetched
margin and varying depths of individual ink pockets in high-light,
mid-tone, and shadow regions. The original showed a network of
fine tree branches against the sky. × 15 diameters.

been made (fig. 26). As the pockets vary in depth so
can they hold more or less depth of ink, and so will
more or less depth of ink in due time be transferred
from them to the proofing paper. All pigments show
strength of tone according to the depth of the layer
applied. Hence our photogravure proofs will be built
up of a genuinely continuous tone structure in the
accepted photographic sense of the term. Moreover,
in the deepest tones of all, if printing depth of the

plate is correct, and if printing is done with an ink of suitable consistency used at an appropriate temperature, ink dots transferred to the proofing paper from the deeper ink pockets will run together, so obliterating all, or almost all, trace of " screen pattern " or the wall network between them. That running together gives the characteristic velvety quality to deep shadows in photogravure which can be matched by no other direct or indirect process.

CHAPTER XVI

*The general method of proofing a gravure plate. Inks,
papers and wiping cloths which are most suitable.
Getting paper into condition. The relation of its
hardness to soaking time.*

LET us understand just what we have got to do for
successful plate proofing. Then we can collect our
materials and attend to minor details. First of all
the plate should usually be warmed to the point where
it can just be handled in comfort. A small amount of
copper plate ink should next be placed upon it and
gently urged into the hollows by light dabbing or
rubbing with a gritless flannel, or similar rag or dabber.
At this stage the whole plate becomes one smudge
of ink. Now take a piece of sacking, fold it into a pad,
warm it, and rub it lightly over the still warm plate's
surface, giving a polishing motion much after the style
of cleaning a brass door plate, only not nearly so heavy
or energetic. Then take a similar pad of " wiping
cloth," which is a specially coarse kind of book muslin,
and with it continue the wiping until the surface of the
plate, where unetched, appears once again free of ink
(fig. 27). By this time the etched picture should stand
out clearly as an ink inlay upon the copper.

At this point we turn to the printing press. A copper
plate press (fig. 28) consists of a roller arranged to lie
upon a flat metal bed-plate, its pressure on the

bed-plate being controlled by set-screws which put force upon the roller shaft's bearings at either end. By tightening down the set-screws almost but not quite as far as they can be made to turn an enormous pressure

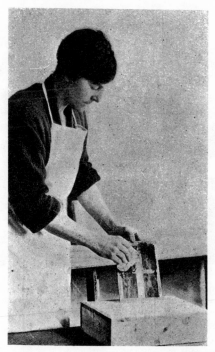

Fig. 27.—Wiping up the inked plate.

is created between the roller and the bed. The arrangement, to put it in a nutshell, is a super-mangle made of cast steel. What we are out to do is to put our inked plate and damped proofing paper through the mangle together, so adjusting pressure that the softened fibre of the paper shall be forced into the plate hollows

far enough to pick out the ink left in them and take it upon its own surface.

To ensure this happening we shall have to soak the paper first of all for sufficiently long to get the harshness out of it. Also we may, or may not, need

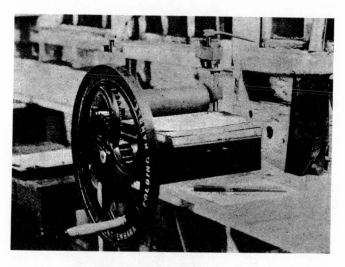

Fig. 28.—Semi-portable double-geared copper plate press. The damping dish for paper is seen on its left, and on the bench in the foreground is a simple plate-heating device made out of a piece of stove pipe with a small bunsen burner inside it.

to re-warm the printing plate so as once more to partially liquefy the ink it is holding. And again printing pressure must be sufficient, yet not more than sufficient, though in photogravure proofing I have found troubles arising through over-pressure to be slight as compared with those that come through the pressure on the roller not being enough.

You need not necessarily set apart a special room

for plate proofing, but I do think you should have at least one good long and fairly deep bench kept for this only, for it must accommodate the following :—Copper plate press (if a small bench press is worked), damping tray and brush ; storage box for damped paper ; sufficient space for spreading out freshly-made prints, and some kind of paper and card cutter, or else a zinc cutting slab for cutting printing paper to size and trimming made prints. Next to this, a separately compartmented-off portion of the bench must accommodate the supply of copper plate inks ; a small ink slab ; a storage box for dabbers and wiping cloths in use ; some kind of hot-plate for warming plates over, and a whiting box. If inks are to be compounded by the proofer, he will also need shelves or equivalent space for copper plate oils and dry-powder colours as well as for an ink-grinding stone. Then there must be bottles of paraffin and petrol for cleaning the ink slab and photogravure plates. Plates which are valued will need to be stored when out of use in some simple filing cabinet. My own (which does very well) is a small, empty soap box. In the filing box each plate is kept in an envelope having printed on the front of it a pull from the plate itself.

Some place or other will also be necessary for storing a stock of printing paper and card, as well as for reserves of wiping cloths and similar odds and ends A cupboard underneath the work bench will do, or even curtained shelves or compartments.

When first I mentioned proofing paper I said that any kind of paper or thin cardboard could be used, and this is true. But it stands to reason not every kind can be used equally simply, nor will it pick up ink

H

from the plate with equal readiness. Since the readiness and completeness with which ink is transferred to the paper decides brilliance of tonal scale in the print, we have in the selection of our proofing papers a valuable way of exercising control over the prints themselves. The rule is that the softer the texture of the paper the brighter (more contrasty) will be the print.

The softest paper I have been able to hit upon is ordinary fluffless blotting paper, such as the well-known Ford " 428 Mill " brand. On it I have often pulled successful proofs, where the plate is just a trifle dull in what should be bright high-light detail. To prepare blotting paper for the press you may sprinkle it generously with water, stack it piece upon piece, and leave the stacked-up paper under the gentle pressure of a sheet of plate-glass for sufficient time to allow damp permeating all the pieces of paper equally. Half an hour or so should do this, the degree of damping to aim at being enough to make the paper thoroughly limp, but stopping short of leaving it streaked with unabsorbed surface moisture. This is the regulation way of preparing most ordinary copper plate papers for the press. A simpler and far quicker method with blotting paper is simply to dip it into a dish of water, lay it between an outer cover of dry blotting, dab off the surface moisture, and print at once, the whole time of paper preparation being thereby shortened to something under half a minute.

Blotting paper is not a regularly accepted vehicle for proofing plates upon. The regular near approach to it in physical properties is " plate paper," an " all-but " blotting paper, if I make myself clear. Plate paper might be used as blotting paper if you took care not

to let it smudge. On damping for the printing press it absorbs water almost as rapidly and thoroughly as true blotting, so that either of the above-mentioned alternative ways of damping blotting paper will do quite well for plate paper also, though it may be soaked overnight without resolving itself to a mere pulp. Plate paper is the brightest-printing of the accepted copper plate and photogravure papers. It can be had in light weight, medium and double weight, the double weight paper being as stout as thin cardboard.

Proofing paper is, as far as my unaided observation goes, a slightly hot-pressed, soft-textured drawing paper. It is the best of the comparatively cheap-grade papers for photogravure printing, but you have to leave it damped overnight, or to soak it in water for at least six hours before use Where proofs are needed to be taken quickly on it, and none is available ready-damped, it may be prepared in a few minutes by soaking in warm water till it feels fairly limp, then laying it down upon a clean, flat surface and brushing over the side that is to come in contact with the printing plate lightly with a soft bristle brush. The idea is to raise a slight nap on the surface of the paper which on pressing into the ink pockets of the plate will send down fibrils, and so help entangle and lift out the ink.

Next in order of their facility of use come numerous soft-texture drawing, writing, and mounting papers. In general they need from one to three days' continuous soaking in water to get them into a suitable physical condition for proof printing. Last of all come the hard writing papers, bond papers, typing paper, and all those papers having a more or less parchment-like

texture and surface. At first I met with such uniform failure in attempts to get passable prints on them that I appealed to Mr. Kimber for a list of the sorts of paper which were usable. He told me definitely that any paper at all was usable if you soaked it long enough, but added that the practical soaking-time limit was three days, for by the fourth day paper often began to go stale and develop patches of mould.

As three days' soaking is not enough for a really hard paper, I solved the difficulty by adding one-half per cent. of formaldehyde to the soaking water and leaving the paper in for a week, or even for a fortnight. In that way I found I was able to prepare any paper I liked, the added germicide keeping the substance of it fresh.

Coming to cardboard, various soft-textured sheets are on the market, and can be supplied by firms catering for copper plate printers. Any cardboard can be prepared by soaking, provided it is single ; that is, not of the sort which splits into layers when kept in the wet state. If so, it will come to grief in going through the printing press.

Regular plate and proofing papers can be bought in white and also in " toned " (cream or buff) surface. Bought by the quire (24 sheets), plate paper of the best quality costs about fivepence a sheet in 30 by 20 size, the price of good proofing paper in the same size being approximately three-halfpence a sheet.

Next we come to inks. I long since said that soft Bromoil inks will do. So they will, and very nicely too. I often use for preference those made by Lechertier & Barbe, of Jermyn Street, but, compared to regular copper plate ink, they are very expensive. Kimber

has a series of soft copper plate inks ready put up in
1-lb., ¼-lb., and also smaller tubes. Bought in this way,
they cost anything from 6s. to 15s. a lb. and keep in
good condition indefinitely. A couple of ounces
of ink properly used will ink up scores of 6-in by 8-in
proofs, or even hundreds.

Alternatively, inks can be made by the worker by
grinding dry powder colours to a very stiff paste
with burnt oil, working powder and oil together
on the ink slab with an ink-grinding stone, a contraption
shaped rather like an ancient British stone hammer-
head. Copper plate oils I find to be quoted in Penrose's
latest list at something under one guinea a gallon,
strong copper plate oil being most expensive and weak
oil least expensive, the middle oil being intermediate
in cost. Copper plate oil is called " burnt " oil because
it is actually caught fire to in process of making it
from the original " Baltic " linseed oil. The burning
distinguishes it from litho varnish, which is formed
from raw linseed oil without being made to flame.

Using strong copper plate ink, a plate has usually to
be pretty thoroughly warmed both for inking and for
printing. This ink is made up with strong copper plate
oil. Ink made with weak (thin) copper plate oil is
called " dry-point ink." Plates can be inked, wiped
up, and printed cold with dry-point ink, but the result
is flatter and not so rich. Dry-point ink comes in
very handy as a means of getting a quiet print from a
plate slightly over-contrasty but otherwise satisfactory.
So here we have yet another possible line of control in
working the photogravure process.

I have mentioned that sacking may be used for inking
the plate, and also for a first rough wiping cloth.

The most suitable kind of sacking is the cheap open-mesh variety. Also, if book muslin is chosen as a second wiping cloth, it should be open-mesh muslin rinsed out in water sufficiently to take away the excessive first stiffness, but not washed enough to make it really soft. All these materials are used dry, of course, except for the ink which may get upon them. Wiping cloths are the better for being moderately inky, but each worker will grow his own preferences about the state of fattiness in which he prefers to use them. As for the plate-printer's hands, they get inky enough, whether he likes it or not. The cheapest wiping cloths of all are washed meat cloths. In practice, wiping cloths do not have to be replaced often enough to call for extreme care in making them last beyond their appointed time.

CHAPTER XVII

Pulling " toned " and " natural " proofs. How to keep them clean, with some concluding remarks upon flat plates for the benefit of original-minded workers.

YOU have soaked your paper, and selected your plate, and you intend to pull a proof from it. First of all put on a white bibbed apron. It is important. Warm the plate on the hot plate. My earliest hot plate was the top of a tin box laid on a support a little way above a small bunsen gas flame. The easiest way of getting ink on to the plate in the first place is to squeeze it out of a tube in little dabs over the etched plate while the copper heats. Remove the plate to the bench top, select a piece of sacking or flannel, press it down on the hot plate till warm and use it, as already directed, to work the ink gently over and into the ink pockets.

Next, wipe up the plate with the wiping rags, and if you want to pull a " toned " proof all that remains to be done is to polish over the surface of the plate slightly by gently rubbing with the flat of the hand. Then take a clean linen duster and go round the plate's edge till all vestage of ink has been cleaned from here. Otherwise the line of the plate mark, instead of being simply a slight depression in the paper, will be picked out by ink smudge. This is where the necessity for a bib to your working apron comes in, as while cleaning round the plate edges you will naturally press first one corner

and then another against yourself. Denison recommends damp chamois leather for plate edge wiping.

A " toned " print is one whereon the high-lights as well as the rest of the picture have a slight trace of " tone," or degradation, from residual ink. Many artistic people prefer proofs this way. Others, including myself, make for a " natural " proof, wherein the highest light is truly white, or inkless. To get it, instead of finally preparing the plate for the press by a simple light rub over with the plain hand, you first of all rub a very little double-washed whiting into the skin, so as to reinforce its power as a natural polishing pad. With practice you soon get to learn just how much whiting and how much of the polishing action upon the copper surface is enough to clean the high-lights of a plate completely, without either taking too much ink away or clogging the half-tones. If the plate is to be printed warm it has possibly to be returned to the hot plate for a few moments after wiping up. Then it should be laid squarely upon the bed of the printing press and the damped paper should be picked up and laid upon it, using a " clip " made by folding a slip of notepaper over in the middle (fig. 29). (Don't forget already your hands are very inky.) Take care to place the paper squarely in position upon the copper.

You may shift the paper upon the plate gently, if you like, after laying it down and before putting on pressure from the roller. That will not cause smudging, for the part of the copper so far in contact with the paper is only its uninked upper surface. Now cover paper and plate with a clean paper backing, next with the felt " fronting," then with the blanket, or blankets, and turn the roller evenly and with a steady hand so

that a proof is taken. The plate may be run once
through, or forth and back again. If pressure is not
sufficient to make an even impression with the single
passage under the roller it should be increased.

As you lift up the printed proof you get sight at
last of the full result of your labours (fig. 30).

Set the proof to dry, and in a day or two's time, if
you wish to flatten out the plate mark somewhat,

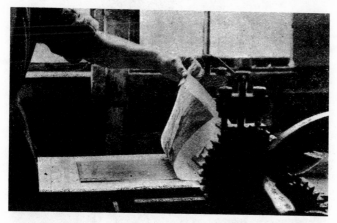

Fig. 29.—A clip made of a small doubled-over piece of dry paper, being
 used to pick up the proof to preserve it from contact with ink-
 smeared fingers.

you can do so by passing the dry print by itself through
the press, laying it simply on the clean bed-plate,
face downwards, with, of course, the blankets over it.

Make certain to keep the bed-plate of the press
always scrupulously clean by wiping it over frequently
with a linen rag slightly moistened at one part with
whiting and water.

Total time for inking and wiping up a plate and
proofing it may be five minutes.

This completes a simple and very elementary description of copper plate printing from home-made photogravure plates by the rag wiping method. Needless to say, it by no means exhausts the possibilities

Fig. 30.—The final moment. First sight of a first impression.

of simplified photogravure. For instance there is a wide field for exploration in the direction of adapting "doctor" wiping to the flat photogravure plate, as has already been successfully done in rotary photogravure (see the next chapter), thereby making possible the wonderful recent speeding up in printing fine photogravure magazine illustrations. In this latter direction I have so far tried only a few none too

successful experiments, but, probably as a measure of ignorance, my hopes remain high. At least, I believe that if not myself, then some other direct photographic worker has a good chance of simplifying and speeding flat plate proofing in the near future by adapting to " amateur " flat bed work some at least of the newer refinements of the rotary " cylinder " process.

Whether this would mean improving quality of our proofs as well as quickening their production remains to be seen. The process, as I have endeavoured to present it to my readers in the foregoing chapters, has given me so much real delight that I cannot believe it will leave everyone else quite cold if once they can ·be persuaded to give it a fair trial.

For those whose interest is rather with rapid production methods than with leisurely flat plate printing I have appended the chapter which follows, while hastening to add that it aims no higher than to give the briefest of working outlines of rotary gravure.

CHAPTER XVIII

Elements of Rotary Gravure

THOUGH photogravure worked along the lines laid down in previous chapters is capable of giving beautiful monochrome prints which compare in quality with good photographs, the speed with which they can be pulled in a copper plate press is extremely slow as judged by standards of typographic printing. A jobbing printer working with a treadle-operated machine can turn out cheap circulars (of the kind that ill-dressed gentlemen hand to you as you pass along the street) at a speed of over one thousand an hour. Large rotary newspaper presses print at rates exceeding twenty thousand an hour. In contrast to this it is a smart worker who single-handed can turn out in one hour many more than a dozen really nice " natural " gravure proofs from a moderate sized (say, seven by five inch) flat plate, rag-wiped and printed in a copper plate press. Obviously, then, plate photogravure which may be excellent from the point of view of a photographer does not fill the needs of the general printing trade. To make it do so the process must be so modified as greatly to speed it up.

Long since, a similar speeding up in typographic printing was effected by stereotyping the original type forms, bending the stereotype plates so that they could be snugly fastened round a cylinder and causing

the cylinder with its typographic facing to revolve quickly. The cylinder rim was made to come into contact with inking rollers and then to press against paper fed through the printing machine from a continuous roll. In this way modern rapid newspaper and magazine printing, up to speeds well into the tens of thousands an hour, became possible. The problem for the rapid photogravure printer was to adapt his intaglio process similarly to working from a cylinder kept continuously inked and revolved.

Introduction of the photogravure " copy screen," described in an earlier part of this book, solved one great initial difficulty. To fashion a cylinder from pure electrolytic copper, or alternatively to turn an accurate cylinder from mild steel and deposit copper electrolytically upon its face to sufficient depth to allow of subsequent etching, was again quite feasible. Added to this it was found that a screen photogravure resist could almost as easily be got down upon, and developed upon, a curved as upon a flat copper surface. It meant no more than detail modifications in the shape of troughs for hot water, spirit and water and etching solution. When it came to actual printing, the developed copper cylinder could be inked over its surface with ink rollers and the paper could be fed against it. But what about wiping it up ?

Early attempts with greasy ink and modified rag wiping by rotary pads soon showed that the process as worked out for flat plates broke down at this point. However, the situation was saved, and rapid rotary gravure made definitely commercial, by the introduction of what is known as " doctor wiping."

DOCTOR WIPING.—A rotary gravure " doctor blade "

is a flat and flexible piece of steel tempered to a yellow-
brown temper and as a general rule approximately two
inches wide. Its length must be rather greater than
that of the engraved cylinder to which it will minister,
while its thickness may vary between the one hundred
and fiftieth and the fiftieth part of an inch. One
side of the doctor is clamped firmly in a " carriage "

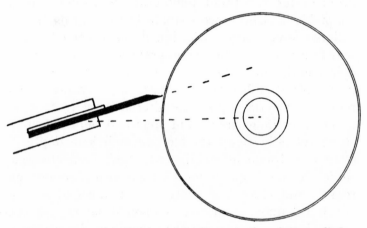

Fig. 31.—Angle of inclination of the doctor to the printing cylinder.
The cylinder rotates clockwise as shown in this diagram.

or holder, while the free, or " wiping," edge is caused
to press upon the printing cylinder at a slight angle.
This wiping edge of the doctor blade has to be pre-
pared for its work by bevelling it with a fine instrument-
sharpening stone, as though it were a miniature chisel,
and finally just blunting the edge of the bevel to pre-
vent it scratching the copper upon which it will press.
Diagram fig. 31 shows relative position and usual
angle of inclination of the doctor to the printing
cylinder. Bear in mind :—

(*a*) The thinner a doctor blade the more ink will it remove from the ink pockets forming the photogravure printing surface. Hence the lighter will printed impressions be.

(*b*) The thicker the ink used in the machine the less must be the doctor's angle of slope out of normal to the printing cylinder radius. Usually a slope of the doctor blade amounting to somewhere between ten and twenty degrees gives satisfactory all-round results. As the doctor wipes the cylinder it is given a certain amount of sideways travel. Without this the printing surface would soon be scored with fine scratches.

A simple way of envisaging the function of the doctor on a rotary gravure machine is to think of it as a thin metallic squeegee.

Now to the ink. Anyone who has experience of the stiff jelly-like consistency of copper plate (burnt oil) ink used for rag wiping upon flat plates will not need to be told that no mere squeegeeing would clean this off an intaglio surface well enough to make possible " natural " printing, or in fact any sort of passable gravure printing at all. Ink used in rotary work is entirely different and known as either " water " or " spirit " ink.

Rotary Gravure Ink.—Spirit ink gives by far the best impressions, so we will consider it first. As supplied by gravure ink makers it pours out easily from its container, being of the consistency of the raw cream served for adding to tea instead of milk. Without attempting to divulge the secret of its manufacture we should know it contains finely ground powder colour mixed with a varnish binder, the whole being held in a thin volatile liquid which may be

mineral naphtha, xylol or even turpentine according to the quality of the ink and rapidity with which it is required to dry on the printing paper. Usually, gelatine or glue rollers are arranged on the printing machine to pick the ink out of its ink well and apply it to the printing cylinder with sufficient pressure and

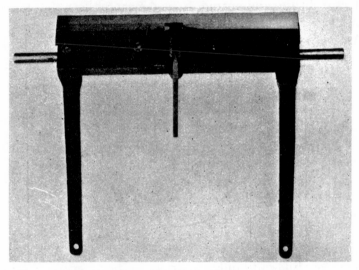

Fig. 32.—Doctor blade.

thoroughness to force the thin ink down into the etched ink pockets. At the same time it goes, of course, promiscuously over the whole copper surface. The ink-smeared copper cylinder face now passes up against the doctor blade which removes the whole of the ink from its unetched portions and causes it to drip back into the ink well again. The " doctored " printing cylinder face can now be fed with gravure paper or card, either in separate sheets, by hand

feeding, or continuously, by reel feeding, and the paper duly impressed with the contents of the still-charged ink pockets.

To get enough pressure between paper and copper a second cylinder called the impression cylinder, faced with a hard smooth rubber or similar surface, is caused to bear upon the back of the paper with considerable pressure, though not with nearly as intense a pressure as is required when pulling a similar sized rag-wiped proof in a copper plate hand press. Why ? The reason lies partly in the comparative thinness of rotary gravure ink. It is so thin that a suitable paper need not be damped for it to give a full impression.

PAPER.—That implies a special grade of paper for rotary gravure printing. And so there is regular " gravure paper." Several big British and Continental makers supply it in various weights. I have been getting what gravure paper I need from the firm of John Dickinson & Son, Ltd., 65, Old Bailey, London, E.C. Usually orders are given in minimum lots of one ton, but paper makers, like drapers, have their remnants, though the name for them in the paper making industry is " remainders." And so one can generally get a few reams when no more than this is required. Typical cheap gravure paper has a smooth shiny surface but takes pen and ink more like blotting than ordinary paper. None the less, practically any paper can be printed by rotary gravure if pressure of the impression cylinder and ink consistency are carefully enough regulated.

Water ink for gravure is rather like a thin distemper

I

colour. Dutch seedmen's catalogues are generally printed in water ink. You know it from spirit ink by the simple test of moistening a finger tip and rubbing it over the printed impression. If it smears, a water ink has been used. If not, it is spirit ink printing.

Printing speed of rotary gravure may vary between five hundred and six thousand an hour for spirit ink, according to the machine. Water ink printing speeds are said to be prodigious, up to, and even over, ten thousand an hour, but on the latter point I am merely repeating hearsay.

THE METHOD IN BRIEF.—Now that some main outstanding points of difference between the technique of hand-printed and rotary gravure have been explained, it may be helpful to run rapidly over the method of preparing and printing from a "cylinder," or rotary gravure, resist.

First steps, up to the point of squeegeeing the printed and screened gravure tissue on to the copper, are precisely as with flat plate gravure, described in preceding chapters. So in general is the method of cleaning the copper cylinder surface. It should be scrubbed with whiting-ammonia paste till bright and grease-free. Getting the wetted tissue into contact with the metal presents only those physical complications arising from the cylinder's far greater bulk and circular shape. There is no good reason why a cylinder should not be bodily immersed in a twenty-five per cent. solution of methylated spirit and water, and the tissue be got into position under the surface of the liquid. Still, as this means frequent renewal of con-

siderable quantities of spirit solution, a more general, and almost equally effective, way of going to work is to support the cylinder between uprights, place a large dish beneath it, pour the spirit and water over the cylinder and rapidly put the tissue in position before the liquid has time wholly to drain away, squeegeeing at once for good contact between the two. This makes it easy to get several printed tissues into place one by one, where, as often happens, a cylinder is required to print more than one subject at a time. Making up the positives to print together in one frame on to a single piece of gravure tissue is an even better alternative where applicable.

Development presents again only the simple problem of providing a sufficiently large tank the water within which can be kept at correct developing temperature while the cylinder is immersed. Drying the developed resist calls for some way of slowly rotating the cylinder while warm air is blown upon it by a fan. Hand rotation is quite good enough.

Having dried the developed cylinder, the next thing is to coat all uncovered copper and also any part of the cylinder which may come into contact with etching solution with a good liberal coat of acid resist varnish. Ordinary acid resist varnish is a solution of shellac in methylated spirit. Penrose also supplies a varnish called by the trade name " Mogul." I have found it far better. One great point of advantage is that it has a brown colour, so that it is impossible to omit to coat any part of the cylinder without seeing that the metal remains bare. Mogul varnish does not " shift," which means it does not run unduly while setting. Its drying is very quick and thorough.

The solvent used appears to be benzine. For ruling margin boundary lines this varnish may be stood in a saucer until it thickens up sufficiently through evaporation. An alternative is to rule lines with gravure spirit ink thinned down with benzine or xylol. In summer time a little turpentine will help the mixture not to dry unduly while in the ruling pen.

CYLINDER DEVELOPMENT.—Development of a gravure cylinder is most simply done by having the etching solution contained in a shallow trough the curvature of which is that of a portion of a circle of somewhat greater radius than the cylinder's own. Stand the trough so that the horizontally supported cylinder dips comfortably into it. Usually it will be necessary to provide some means of keeping the contents of the trough up to (but never above) etching temperature. At an earlier portion of this book I said the system of using separate baths of varying gravity, and replacing one by another, was the surest and best. So it is for a flat plate worker or a beginner. In cylinder etching, however, once some experience has been gained, the physical aspect of the problem enters in sufficiently to put the balance in favour of gravity alteration by dilution. Starting with 41 Beaumé, or more usually 40 Beaumé perchloride strength, the bath may be diluted by addition of plain water (at etching temperature) in proportion of two to four fluid drams to each pint of original etching fluid, repeating this at intervals of, perhaps, a couple of minutes (all according to circumstances) until the gravure resist has been just penetrated to the high-lights. Rinsing and cleaning are sufficiently

explained in the part of the book dealing with flat gravure plates.

Next, the cylinder has to be put in position on the machine, the ink duct filled, and paper fed. Details of machine minding vary with whatever pattern is in use, but the reader has by now a general idea of how to get to work. The rest he must fill in for himself through actual experience.

Fig. 33.—Cylinder.

TYPES OF CYLINDERS.—Four types of gravure printing cylinder come to mind. The simplest, and I suppose clumsiest, is a solid steel cylinder, integral with its shaft and gear drive. Upon its surface has been deposited a sufficient thickness of electrolytic copper to allow of etching depth. When you want to etch this cylinder it has to be removed as a whole, a heavy task considering the cylinder's weight, and one often calling for several helpers as well as for the aid of block and tackle.

The next, and very usual type of cylinder, is one where the shaft and gear wheel are permanently

attached to a slightly coned mandrel. Over this
mandrel fits a mild steel sleeve. The copper is carried
as a deposit upon this sleeve's surface.

In the third type of cylinder the gear, pinion and
mandrel are retained, but the sleeve, instead of being
formed of copper deposited upon a steel or iron base,
is made of thick copper throughout. Before going
on to describe the last and latest type of printing
cylinder let me say wherein the much thicker copper
sleeve scores. It is in this wise :—

When you have printed all the copies you want of
whatever subjects are etched upon the cylinder copper,
and wish to use the same cylinder face, or sleeve,
over again, you have to put it in a lathe, or preferably
in a special grinder, grind off enough metal to cut
away the etched image, and repolish, as far as necessary,
by buffing with emery or tripoli polishing compound.
Having done this you can use the cylinder as a fresh
blank, but, of course, your former etching has had to
be scrapped. To print another edition of any of the
old gravure pictures you would have to put down a
new resist, etch again and hope that the fresh attempt
comes out sufficiently like the last one for your
customers not to notice the difference. Except for
this last-named drawback the more often you can
re-grind and polish a cylinder face and re-use it the
less need be charged to cost of copper in pricing
gravure work. There are other reasons why a good
thick copper cylinder sleeve is likely to give all-round
better service than a skimpy deposit on steel. But
we shall also realise something else, and that quite
clearly. If it were possible to remove the etched
surface intact from a gravure cylinder after the con-

clusion of printing a first edition (like skinning the outer coat from an onion) and keep this etched skin for re-use in printing subsequent editions, it would be simpler technique and better business both arrived at together. That brings us to the fourth type of gravure printing cylinder, a wholly modern introduction, hardly yet arrived at commercial perfection, whereby the attempt is made to avoid having to destroy old work by re-grinding before putting on new.

The fourth type of printing cylinder carries no permanent deposit of copper. Nor does it take a substantial copper sleeve. Instead of this, a thin polished copper sheet is stretched tightly round the mandrel and bolted down to give as unshifting a printing surface as possible. If thin and flexible enough, the copper sheet may be etched exactly as might be a flat plate. If less thin it should first be shaped by fitting on to a dummy cylinder, etched and removed to the printing cylinder. Or it may be bolted to the printing cylinder itself and etched while fastened in place. In etching such sheet copper gravure printing surfaces, bear in mind to give the back of the sheet a coat of protective varnish before etching. Also equally bear in mind to clean off this protective coat if, and when, the sheet is removed from its dummy etching cylinder to the real printing cylinder. Most important of all, remember that the smallest speck of grit caught between the back of the sheet and its printing support will force up the copper and give rise to a metallic island surrounded by an ink-filled trough which the doctor cannot wipe clean when you come to start printing. After an edition

is printed, the thin sheet metal can be taken off its mandrel, cleaned with benzine or turps, perhaps waxed to protect its face, and stored for second edition printing without thereby locking up any considerable amount of capital. In proportion as this rotary sheet gravure becomes improved so will intaglio printing be

Fig. 34.—Small gravure machine.
(Pickup & Knowles).
A Impression cylinder ; *B* Copper cylinder ; *C* Doctor.

more and more able to stand up in competition with offset lithography which, at the moment, is, I dare say, its nearest (though far inferior) technical and commercial competitor.

JUST A HINT ON COLOUR GRAVURE.—I have not seriously touched it myself, though I have had a good deal of experience of three-colour work in what is usually called direct photography. From results

seen, I do not hesitate to name rotary gravure as the best all-round solution of two-and three-colour photo-printing. Flat plate gravure is put out of the running, it seems to me, by the necessity to soak the paper before taking an impression. Not only does that introduce serious trouble from expansion and con-traction, but, still worse, in flat plate work the capacity of the paper to pick up copper plate ink becomes so much diminished after its first pull through the press as to make accurate colour regulation impossible. (I have done enough to find that out.)

In printing rotary gravure you can use a good quality thin smooth ivory card, and use it dry. So you have a printing surface which remains the same both in size and ink-taking capacity as between colour impression and colour impression. That way lies hope.

THE LONDON AND NORWICH PRESS, LIMITED, ST. GILES' WORKS, NORWICH

PHOTO-AQUATINT;

OR,

THE GUM BICHROMATE PROCESS OF PRINTING

PHOTO-AQUATINT

OR

THE GUM-BICHROMATE PROCESS

WITH ILLUSTRATIONS

A PRACTICAL TREATISE ON A NEW PROCESS OF
PRINTING IN PIGMENT ESPECIALLY SUITABLE
FOR PICTORIAL WORKERS

BY

ALFRED MASKELL

AND

ROBERT DEMACHY

SECOND EDITION

[THE AMATEUR PHOTOGRAPHER'S LIBRARY, No. 13.]

London
HAZELL, WATSON, & VINEY, Lᴅ.
1, CREED LANE LUDGATE HILL, E.C.
1898

PHOTO-AQUATINT;

OR,

THE GUM BICHROMATE PROCESS OF PRINTING

IN PIGMENT WITHOUT TRANSFER.

CHAPTER I.

PRELIMINARY OBSERVATIONS.

A NEW method of printing which has attracted considerable attention at recent exhibitions of the Photographic Salon is destined in all probability to exercise an important influence upon the future of pictorial photography.

If not altogether new in principle it is so in its application, for the very qualities which caused it to be cast aside at the time of its original inception as worthless, or at least impracticable, are those towards which the feeling of modern art in photography is undoubtedly tending.

Inquiries concerning the method of production of the prints in bichromated pigment without transfer which have been exhibited at the last three exhibitions of the Photographic Salon have been so numerous that it has been thought that a description of the process would prove of value to those who desire to work it.

The object of these papers will be to examine briefly the historical aspects of the question, to show the distinctive qualities and value of the new method of treatment, and to give concise directions concerning the preparation of the paper, the materials employed, and the methods of using them. Some notes also will be added on the subject of similar systems, such as the *papier velours* or direct printing in carbon, known as the Artigue process.

Until quite recently, the quality desired by all photographers alike, whether for scientific or for pictorial purposes, was a printing medium which should reproduce in its minutest details, and with the greatest fidelity to the varying degrees of gradation, a counterpart or positive image of the negative. There was no distinction made between work which was intended for scientific exactness and that which aimed at artistic ends. Whatever retouching, or working upon, the negative might receive, no such liberty of modification was considered lawful in the case of the resulting print. The effect of light acting mechanically through the various densities, aided though it might be by skilful manipulation, or hand work, upon the negative, was to be alone responsible for the ultimate result. Possibly the very difficulty of altering the deposit on the printing surfaces, which in nearly all cases is the result of chemical reactions, was to some extent a reason for the continued conservatism. Besides this, there was the fast-rooted prejudice in favour of glossy and brilliant surfaces, and it was not until the fashion changed, and rough papers came in, that departures were tolerated in the direction of a less faithful reproduction in counterpart of the original image. Some of the earliest and most radical innovations in this respect were perhaps

those which permitted selective development when cold-bath platinotype was introduced. With this paper, by means of the staying action of glycerine and other devices, it may be said that any amount of modification, from absolute oblitera-tion to varying degrees of depth of half tone and shadow, is possible, and in the most skilled hands not impracticable.

That general feeling amongst those photographers who devote themselves to pictorial work is distinctly in favour of the utmost latitude in modification is hardly to be denied. The growth of such a feeling has been gradual indeed—so gradual that the transition has come about almost without our being aware of it, but it is unquestionable that methods and practices which were held in horror but a very few years back are now not only tolerated but encouraged. That the advocates of what is erroneously called pure photography may be shocked and displeased is probable, but they cannot stop the flowing tide. With the growth of pretensions towards individuality as opposed to mechanism, towards evidence of personal artistic feeling as opposed to uncontrolled machine-made pictures, it would seem that as a pictorial process pure photography no longer suffices to satisfy. It had arrived perhaps at its acme, pro-ficiency in attaining that standard had become compara-tively easy, and there was no alternative to monotonous correctness but a latitude and freedom in treatment which should set up a type of excellence to be judged on other grounds than that of mere dexterity.

The prevailing idea of photographic exhibitions in former days was that they were organised chiefly for the instruction and encouragement of the photographer. The outside public in search of the beautiful was scarcely considered a:

all. Hence it was that an important feature in the cata-
logue was the description of the processes employed, and
visitors were supposed to be greatly interested in knowing
whether the results shown were due to purely mechanical
means, or whether the personal agency of the worker had
been employed to modify them. Nowadays an exhibition
of pictorial photography is addressed in a greater degree to
the general art-loving public, which neither knows nor cares
how the various processes of photography have been applied
to produce the picture, but is interested only in the beauty
or otherwise of the result. With this change of idea the
encouragement of the inexperienced amateur by means of
medals and awards obviously also falls to the ground. It
is beginning to be understood that visitors to exhibitions
are really not in the least interested in the opinion of two
or three gentlemen, and the laurels they may bestow on a
certain number of exhibits which they may consider to be
better than others. What the visitor goes for is to find
subject for admiration, and also in many cases to buy.
The Photographic Salon was the first to encourage pur-
chases, and it is due to its exhibitions that the present high
prices are given. This is indeed a very tangible evidence
of public feeling. It is for the public to judge. If it does
not approve the results which may be produced they will
become of no value and drop out of the race. At the pre-
sent moment it is undoubtedly in sympathy with the new
order of ideas.

In reviewing the revolutionary spirit which appears to
prevail in modern pictorial photography, we are insensibly
led to the consideration how far a method which professedly
gives a great latitude to the worker may be said to be

legitimate, if we still wish to preserve the spirit of photo-graphy ; that is to say, whether the epithet *faking* may be more justly applied in an adverse sense than in the case of other practices in the production of prints and negatives which are universally allowed. A full examination of the arguments on either side, which have been so frequently debated, would lead us for the moment too far, and we pro-pose to revert to this question in our concluding chapter. But it is at least reasonable to point out that we ought to be logically consistent, and it would be illogical to condemn practices which may be used with advantage in photo-aqua-tinting, and at the same time to condone similar methods of which all photographers avail themselves.

CHAPTER II.

A BRIEF HISTORICAL RETROSPECT.

THE earliest notions of the properties of light on bichromates in contact with organic matter appear to have started with Vauquelin at the end of last century. In 1839 and 1840 Mungo Ponton and Becquerel certainly produced prints, the latter using starch, with which, in combination with iodine, he obtained a fine blue colour; and in 1853 Fox Talbot, and after him Pretsch and Poitevin, appear for the first time to have utilised the action of bichromate in rendering gelatine insoluble after exposure to light.

We get nearer to our most modern system in the results obtained by Poitevin, and in him we must recognise the first who printed by means of bichromated gum or gelatine, in which he put coloured matters. There is a long distance, however, from the discoverer of the power of steam in a boiling kettle to the inventors of the steam engine and railway system, and so we have to acknowledge the important modifications of Swan as having had the most influence on the system of carbon or autotype printing, which has obtained (in its perfection, it may be said) for now over thirty years. The name of Pouncy must also be mentioned, not only as a pioneer, but as one whose process, similar to that of Poitevin, and perhaps derived from it, is, in essentials, the system of gum-bichromate printing or *Aquatint*, which we propose to fully describe in these papers.

In connection with the general subject a brief note must suffice to allude to the kindred system known as the powder or dusting-on process, in which the colouring matter is applied to the chromated film after exposure. This method was known to Poitevin, and appears first to have been practically used in France about the year 1858.

Exhibitions were not so common in days gone by as they are now, and the results of the work of those we have mentioned and of others were shown probably at meetings of learned societies. Carbon prints produced by the Swan or transfer system reigned supreme afterwards at the leading exhibitions for many years, and it was not until attention was drawn to the error of the hitherto universally accepted teaching that the film could only be successfully attacked for purposes of development *from the back*, and the absolute proof of the error by the introduction of Artigue's *papier velours*, that pictures by the revived and perfected system began to be shown. Mr. Rouillé-Ladevèze was the first to exhibit pictures on hand-coated paper at the exhibition of the Photo Club de Paris in 1894, and at the London Salon of that year the same pictures were shown, and with them others by the writers of these papers. The beautiful results obtained on Artigue paper by Monsieur Puyo, at the same time, astonished and puzzled the *quid-nuncs*, and at the exhibitions of the two following years not only were there several other pictures by the direct method (some detected and others passing unsuspected as platinotype or ordinary carbon work), but even at the exhibition of the Royal Photographic Society very perfect examples on Artigue paper contributed to clench the demonstration of the fallacy that development by transfer was an absolute necessity if

the half tones were to be retained. The dogma will no doubt disappear in new editions of the text-books, and no longer form the opening remark at lectures. It has died hard, however, and, to the last, photographic scientific writers of eminence, or at least of prominence, have continued to deny that an error has been involved. It is perhaps, after all, only a question of terms. For ourselves we are content unhesitatingly to assert that bichromate or carbon paper can be coated and developed directly from the front, and is capable of giving in this manner the most delicate half-tones, equal in every respect and superior in some, to those which can be made by the transfer system. And this is the exact contrary to what has been taught unti. recently. The case was oddly enough a repetition of the famous problem concerning a fish in a globe of water which King Charles propounded to his philosophers, but a strange one in the present days of universal investigation.*

As we propose to go little into the theory of the subject, we need only briefly allude, for the information of those to whom it is altogether new, to the underlying principle of all systems of colloïd bichromate printing. This principle resides in the fact that if a mixture of a bichromate salt in solution and some colloid substance — such as, for instance, gum, gelatine, or starch—is prepared and applied to the surface intended to hold the impression, such parts as are allowed to be acted upon by light become insoluble in proportion to the amount of light acting upon them and are fixed on the support, the unaltered portions

* Artigue paper was first publicly demonstrated in 1889, some years previous to an American system described in the photographic journals which was copied from it. It was practically unknown in England until .894.

remaining capable of being washed or dissolved away. If we add a colouring matter to the mixture this also will, of course, remain on the support. It follows, therefore, that we may, for example, coat a piece of paper with a mixture say, of gum, bichromate of potash, and red ochre. We may then place this prepared paper under a negative through which, on exposure, the light will act in varying degrees according to the nature of the negative image. The unacted on portions being then dissolved away in water, a positive or counterpart appears, and the free bichromate being removed the colouring matter remains attached to the paper, held there by the insolubilised gum, thus forming an inalterable picture, as permanent as the paper or support on which it lies.

CHAPTER III.

MATERIALS USED IN THE PROCESS.

The Paper, the Gum and Sensitising Solutions, Colours, Brushes, etc.

IT must be borne in mind that in the preparation of the paper which we are about to describe, the characteristic at which we are aiming is not that of such a film as is deposited by Artigue's process. With the latter undoubtedly an extreme delicacy of half-tint and certain admirable, though quasi-mechanical, qualities can be obtained. Treated in the ordinary way, the reproduction from a negative is, on Artigue's papier velours, as mechanical an operation, and one which may be as rapidly carried out, as any other printing-by-development process. It is amenable certainly to various modifications, but with these we need not occupy ourselves for the moment. The charm and principal value of a printing medium prepared in the manner which we shall describe are in the adaptability by the artist himself to his moods and requirements. There will always remain with each worker a special character of his own. One may prefer to assimilate and make the most of this or that quality, another of another; and so numerous are the modifications which may be made that probably no two men will ever work exactly alike, nor is it even perhaps possible so precisely to follow a method previously used as to produce

an absolute replica. To some photographers, no doubt, this lack of automatic character and difficulty of making two prints alike is a drawback which should condemn the process entirely rather than constitute a quality to be admired. To others the freedom and personality of treatment are its essence and its beauty. It has other qualities also—a certain mellowness, and a softness of the outlines due to the behaviour during development of the constituents used— which have led us to prefer the simple method of preparation which we shall describe to any more complicated ones, or to the substitution or admixture of gelatine or other colloids instead of gum alone.

It is hardly necessary to say that prints by the gum-bichromate process are permanent—that is, they will last as long as the paper on which they are printed. The single chemical substance used in their preparation is easily eliminated, so that there is no reason for any colour-fading unless the pigment used has been chosen amongst the non-permanent ones. The surface of the print is softer and less glossy than in the usual carbon process. The pigments are chosen and mixed by the worker himself, and by changing their relative proportions an infinity of different shades of colour can be obtained. No transfer is necessary; there is no blistering of the film, for there is practically no film to blister; no chemicals are used in developing, but water alone, and that also (in normal cases) at an ordinary temperature instead of at different degrees of heat. Once developed and cleared, a gum bichromate print is composed of an irregular layer of colour held on the surface of the paper by just sufficient insoluble gum arabic. It is, in fact, a water-colour, and it is in order to give it a distinguishing

name, which shall be applicable at least to its most simple qualities, that we have called it photo-aqua tint.

THE PAPER.—Any sort of paper which is sufficiently sized to prevent the soaking of the pigmented mixture into the pores of the paper will do. It is of the first importance that the image should be kept sufficiently on the surface, and this is also the function of the gum in the mixture to assist in doing, as we shall show when treating of the method of coating. It must also have sufficient resistance to the action of the water used in developing if, as is sometimes necessary, this has to be used at a comparatively high temperature. In the choice of paper there is practically an unlimited field, and the worker has at his disposal a large range of power in the production of the effects at which he may be aiming. Japanese and Chinese-India papers cannot be easily coated. The colour sinks, and the loose fibres of the paper are detached by the friction of the brush, and cause smears. They are, more-over, so loose and soft in texture as not to be able to support the action of the water in washing up. In any case the pigment must not be allowed, while coating, to sink beneath the surface into the body of the paper. Once there it stays, and no amount of washing during develop-ment will remove it.

The final aspect of the picture is greatly modified by the different grain of various papers, in the same way as with other processes. Thus, coarse-grained, rough papers give diffusion and loss of detail, with a power of opening up the shadows; smooth papers give detail and sharpness. As a rule, perfectly smooth papers, such as Rive, are the most difficult to coat evenly. The coloured mixture finding no

asperities to cling to, and following the brush instead of settling on the paper, obliges the worker to prolong the operation, and thus assumes a semi-adhesive consistency productive of ridges, which cannot be smoothed down. It is in the highest degree necessary that the process of coating should be conducted as quickly as possible, as we shall presently show.

The easiest of all papers to coat is perhaps that known as *Michallet,* because of its parallel lines. This and the Lalanne and Ingres papers give excellent results, and, moreover, have a quality of their own which is especially suitable to the soft, diffused image which is so much appreciated. It is for this reason that we particularly recommend to beginners the papers just mentioned, both on account of the greater ease with which they may be coated, and because our object is to produce the effect of a painting on soft Sèvres porcelain, where the image is to some extent incorporated with the *pâte,* rather than that of an enamelled surface upon which the picture is kept without any sinking in at all. It must not, however, be allowed to incorporate itself into the actual unprotected fibres of the paper ; in that case, as we have already said, it is impossible to remove it.

Either the white or yellow tinted Michallet papers may be used, and probably other and deeper tints will be found of value. Then there are Allongé and other similar French papers, both the right and the wrong sides of which are very suitable. Any old-fashioned hand-made papers may be recommended, and treasures of this kind will often present themselves in old scrap albums or manuscript books. Amongst French papers those known as Canson and Montgolfier are very good and serviceable. Whatman water-

colour paper does not seem to be regularly sized; the colour sinks now and then in spots and makes indelible stains. Ordinary writing paper, such as India Mill or Imperial Treasury or Bank Post are very suitable for small subjects, the watermark, however apparent during development, disappearing totally when the sheet is dry. Excellent papers of various qualities of grain and thickness are made at the Joynson paper mills, St. Mary Cray. Of their make we can especially recommend, for a fairly rough surface of even grain, a vegetable sized paper known as P. H. Thin M. F.; for rougher surfaces the superfine drawing papers Nos. 6 and 7; and, for a very smooth paper, the superfine No. 23.

Some papers may require sizing, though, as a rule, one may be reasonably content with those which, like Michallet, already possess the desired surface. Should it be necessary to do so, it is easy to size with either gelatine or arrowroot. With the latter a good proportion to use would be about 125 gr. to the pint of water. Take then this quantity of the best Bermuda arrowroot, and mix it into a smooth paste with a little hot water. Then add, stirring the while, the remainder, and bring the whole nearly, but not quite, to the boil. The solution will become clear and of a gelatinous-like consistency. After allowing any foreign matters to settle, the paper may be floated or the sizing applied with a Buckle or Blanchard brush.

THE PIGMENTS OR COLOURS.—In treating of the colouring matters which may be used in the preparation of the sensitised coating, we by no means propose to cover the subject in an exhaustive manner. The endless variations into which we might be led in so doing may safely be left

to the individual feeling and taste of the worker when he shall be sufficiently practised in the simpler forms. For our present purpose it will be sufficient to mention a few only, and with these all the combinations of tone (using the term in its proper colour sense), which are recognised by monochrome artists, may be made. The ideal pigment would be the finest of all powders, giving, with the smallest bulk, the strongest colour. Colours may be used either dry or moist, and probably none better could be found than the well-known moist colour tubes of good manufacture. Amongst these the pigments most nearly approaching the desiderata just mentioned are, in the first place, venetian red, red chalk, indigo, and brown and red ochre. Then come prepared lampblack, umber and burnt umber, sienna and burnt sienna, Van Dyck brown, bistre, and, lastly, sepia. The last named do not give very fine division, and being transparent colours require a certain thickness of layer to give proper depth of colouring. This, of course, involves difficulties in ordinary practice. Indian ink is a good black, but requires very careful grinding and mixing. Common red ochre in the powdered state is also good, and if its crudeness is not objectionable (and it is not so to some) it may be used alone and is easy to work. On the other hand, it may be tempered with a trace of blue. On the whole, lampblack, the ochres and umbers and indigo will form, separately or combined, a palette with which, as a rule, we may be very well satisfied.

Of course all pigments are suitable, provided they are inert from a chemical point of view. It is unnecessary to do more than mention that certain colour preparations are, from some cause or another, which we do not profess to be

able to explain, absolutely unworkable. Either they cause the coating mixture to become totally insoluble, or, on the other hand, the solubility is not affected on exposure ; but those just mentioned are all of them permanent pigments, influenced, except for the desired purpose, neither by the presence of the bichromate, nor by the continuous action of light. The use of a white pigment may suggest itself with toned or dark papers. So far as our experience goes, most whites are unworkable, and it is dangerous to mix even a small proportion with another colour. The only one we are at present able to advise is sulphate of barium, known as permanent or constant white. It is scarcely necessary to add that in printing in white on a dark ground a positive instead of a negative would be used.

THE GUM OR COLLOID.—In treating this part of our subject we shall confine ourselves to the ordinary gum acacia or gum arabic of commerce. Undoubtedly other colloids may be used. There are, for instance, gelatine, fish glue, starch, albumen, ordinary glue, and so on, but we find in gum arabic qualities of mellowness and softness, on account probably of its superior solubility, which allows the insolated coating of colour to melt and run down, as it were, and form a kind of pâte. Gelatine or other colloids do not so readily give this effect. Practically, those who think they might find preferable qualities in the latter will easily devise similar methods of using them, and we may therefore leave them for the present out of consideration.

The readiest way of preparing the gum solution is to take the gum in a pulverised condition, as it requires much less time to dissolve than from the lump. It is not, however, a good thing to buy it ready pulverised, dust, dextrine or

other matters being often added to the powdered gum of commerce to give it weight or bulk. It is advisable also to confine ourselves to the best quality of gum acacia or Soudan gum. We require so little that it is hardly worth while to trouble ourselves about other kinds, the soluble qualities of which, it may be said also, vary considerably. It is easy enough to reduce the gum to coarse powder in a mortar, and then to sift it through ordinary wide-meshed muslin. Heat modifies the nature of gum; it is preferable therefore to use cold water, with which it may be worked up to regular thickness in a quarter of an hour. It will require frequent stirring, the powdered gum being apt to coagulate and to form a viscous lump, which, offering less surface, retards solution. Another way is to suspend in the water the coarsely broken up lumps enclosed in a muslin bag.

Freshly-made gum solution gives the maximum of solubility. It would therefore be an advantage to use old solution if it were possible to ascertain to what degree of acidity this had arrived. But the transformation seems to be irregular, influenced, as it is, by contact with atmospheric germs, and by weather and temperature. A solution of gum rapidly becomes sour, and it is important for us to know the degree of solubility which it possesses. Although, therefore, the addition of a preservative (such as a few drops of chloroform water) may arrest the tendency to acidity, the safest plan is to use fresh-made solution for every batch of papers to be coated, and thus be in possession of a standard quality which will save us much trouble in exposure or development. After a few trials it is easy to judge how much gum is required for the number and size of sheets to be prepared. Beginners are apt to make up about

five times the necessary quantity of sensitising mixture. Two thimbles full of gum added to the bichromate and pigment will easily cover a whole sheet of drawing paper. The gum should be filtered before use through a piece of muslin. With a funnel the filtering surface is too small. The easiest way is to pour, the solution on to a square piece of muslin and hold this by the four corners over the saucer used for mixing; the gum will drop slowly by its own weight

THICKNESS OF GUM SOLUTION.—The percentage of gum is a very important factor. Most failures in coating are due to an exaggerated thickness. This error is particularly noticeable in the coating of large-sized sheets of paper, because they take longer to cover. If the gum is too thick, the preliminary smearing process takes so long that when the softener is applied the mixture has had time to set, does not divide under the brush, and makes thick ridges which render the paper quite useless for printing.

Gum solution ought to be sufficiently thin to fall slowly in big drops through the moderately thin muslin used for filtering (ordinary cheap muslin, not poultice muslin) without any pressure of the fingers. Gum that has to be forced through by twisting or pressure is too thick and will give trouble. Generally speaking, the best proportion to use is a solution of about thirty to thirty-five per cent. strength.

PREPARATION OF THE SENSITIVE MIXTURE.—The mixture of pigment and gum should be as intimate as possible. If several colours are used it is best to mix them thoroughly first with a hard oil brush, then add the gum, mix thoroughly anew, and finally add the saturated solution of bichromate of potash and mix for the third time.

The bichromate solution is made by dissolving ten parts of the salt in a hundred parts of water. The water may be used warm, leaving a small quantity of the bichromate undissolved.

It would be possible to give a formula for the quantity of bichromate to be added to the mixture of pigment and gum, if the proportions, of pigment were in every case constant. But they are not, for great depth of colour can be got with a small proportion, say, of red chalk or lampblack, whilst a far greater bulk of colour is needed with the sepias, Van Dyck brown, bistre, or umber. On the other hand, there is a standard degree of thickness necessary for rapid and even coating. It follows, therefore, that more bichromate has to be added to a sepia mixture to dilute it to proper fluidity than would be required for lampblack, because the smaller bulk used of the latter gives a much thinner consistency. Only repeated trials can teach the beginner what degree of thickness will allow of even coating. As a guide, let him begin with common red ochre, and taking equal parts of gum and bichromate, say, one drachm of each, use with this forty grains of the pigment. A trial coating may then be made on a sheet of paper, and according to the conduct of the mixture under the strokes of the brush we can judge whether the proportions are correct or whether either gum or bichromate should be added to thicken or dilute the consistency. The sensitive compound does not keep, but the gum mixed with colour will do so under the same conditions as plain gum.

COATING THE PAPER.—For coating we shall require two different brushes; one fan-shaped, of hog's hair, about four inches wide, with rigid hairs thinly set for roughly smearing

the mixture on the paper, the other of badger hair, from four to six inches wide, of the kind known as a stainer's sweetener or softener. The latter brush is a most important tool. It is a comparatively simple matter to put an even wash of water-colour on paper, but when we have to deal with a clogging gum solution, to which is added the peculiar stickiness given by the bichromate, we should be entirely lost were it not for the badger sweetener. This brush is

SMEARING BRUSH.

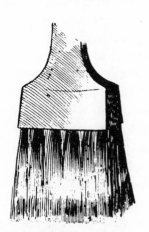

BADGER-HAIR SOFTENER.

somewhat expensive. A four-inch brush of three rows of bristles cannot be had for less than six shillings; one of six inches, with four rows, would cost a guinea, but so useful and necessary is it that it is worth while to procure one of the best quality. The fan shaped hog's-hair brush is recommended for the preliminary smearing on account of its wide-spreading area and the thin setting of the hairs. Ordinary brushes take up too much colour. A few trials will show that if too much coating has been dabbed on the paper

it is difficult to get rid of the excess, but the fan-shaped brush has to be dipped in the colour several times, and this assures, or at least facilitates, the minimum of mixture being used. With regard to the softener, goat-hair brushes, such as are sometimes sold for dusting dry plates before putting in slides, may also be used, and they are cheaper than the badger. Some workers even use a hog's-hair brush as a softener. In any case it will be, perhaps, a matter of personal preference, and the handling will depend upon the character of the brush used.

We have now our sensitive mixture ready prepared in a shallow, wide dish, such as a small porcelain developing tray, our smearing brush moistened in water, and our softener clean and dry, and are ready to proceed with the coating of the paper.

CHAPTER IV.

COATING, EXPOSURE AND DEVELOPMENT.

COATING the Paper.—The operation of coating is one which requires a little dexterity, but attention to correct proportions of the sensitised mixture, and the proper use of the invaluable tool which we possess in the badger hair softener renders it not difficult of acquirement. We may remember that the points to be aimed at are an even distribution of the coating over the surface of the sheet with the least possible quantity of the ingredients employed. We do not desire a film of such extreme tenuity and evenness as that which characterises the Artigue Papier Velours, nor, if we wished it, should we probably be able to secure these conditions without special machinery. For a paper in black pigment and for certain effects we could ask for nothing better than that of Artigue, but our aims are different.

We have, then, our paper, brushes, and coating mixture ready to hand. Take a sheet of the paper, cut about an inch larger all round than the size of the negative it is proposed to use. Pin it with two drawing pins on a flat wooden board by the two upper corners, so as to allow of even play to the stretching which results from the application of moisture. Then with the fan-shaped brush smear the sensitive mixture over the paper, taking the greatest care to use the minimum quantity necessary to cover the sheet.

Do this as rapidly as possible, and the moment the paper is rubbed all over—roughly smeared—take the softening, or sweetening, brush, which is quite dry and clean, and give three or four vertical parallel downstrokes from top to bottom, with strong, equal pressure. Then as many more from left to right with less and less pressure, and, finally, gently dust or flick with the brush in all directions, holding it vertically or perpendicular to the surface until all streaks or unevenness have disappeared. At this stage the film has set, and should not again be touched; any additional brushing will do more harm than good. The coating should be so thin that the grain of the paper may easily be distinguished through it.

To ensure good coating the whole operation—smearing and softening—ought to be performed (for a whole-plate sheet) in about forty to fifty seconds. Rapidity in coating is most important, because of the peculiar nature of the sensitive mixture, for bichromated gum does not behave like pure gum solution. - After a certain time it assumes a sort of gelatinous consistency quite different from the ordinary thickening of pure gum. If kept in a bottle it will form a quivering mass like calf's-foot jelly, moulded into the form of the bottle. This phenomenon takes place more rapidly with the thin film spread upon the paper, and when once it has taken place if the film is disturbed by additional brushing, it is impossible to smooth it down again. That is why we insist upon the necessity of smearing and softening as rapidly as possible.

Now, in order to coat the paper rapidly under the most favourable conditions the mixture must be of a certain consistency, spread thin. Practice will prove this, and after a

few trials indicate the proper proportions. It must be distinctly *gummy*, and the right thickness will easily be recognised by the peculiar clinging sensation under the strokes of the brush during the operation.

Coating may, and ought, to be done in a good light, but the paper must be dried in the dark, because, although insensitive whilst in a moist condition, it becomes sensitive immediately on dessication. Absolute darkness such as is necessary for gelatino-bromide film making is not necessary, but any direct white light should be avoided. The paper may be hung up to dry by a clip in one corner, and in half an hour or so—in ten minutes in a dry room in summer—dessication is complete. On no account must the paper be dried before a fire or stove, near enough to be heated. Insolubilisation would follow.

It is advisable to use the paper as soon as possible after preparation—say the next morning—because we then may feel assured of a certain typical condition of solubility in the gum, and we shall avoid errors in exposure. If kept, it should be stored as much as possible under pressure to avoid contact with moist air. It keeps well for two days, fairly well for five, and we have ourselves developed paper eight days old which gave excellent results for landscape work. For figures it was rather patchy in the lights.

It might be possible to prepare the paper with the mixture of colloid and colour only, and to sensitise it by immersion in bichromate solution only when required for use. This method would certainly have great advantages, but so far as our experience goes at present it is not practicable, paper sensitised in this way, if gum be the colloid used, remaining soluble even after long exposure. Such a result would, of

course, be expected when we remember that our coating is easily soluble in cold water. What image can be got after sensitising by immersion will necessarily, therefore, be weak.

THE EXPOSURE.—Correct exposure is, of course, a matter of experience, and to some extent also of personal taste. We mean that what might be over-exposure for a particular effect would be under-exposure for an opposite one. In reality an over-exposed print is one that cannot be washed up to the desired effect; an under-exposed print is one which will not retain a sufficient quantity of the pigmented gum.

Generally speaking, our aim in exposure should be to work up to certain conditions, which, as we shall show when treating of development, it is as well to keep constant: these are the condition of the gum as to solubility, and the temperature of the water used in development. We may, then, make use of a normal or of a greater or less degree of insolation according to the effect we have in our mind, and to the method in which we may use our developing appliances.

It is best for a beginner to err on the side of over-exposure, for the use of very hot water, soaking for a few hours, or developing by friction with a brush or sawdust, gives a certain latitude on this side, whilst real under-exposure means washing away of the half-tone to begin with, and the subsequent obliteration of the whole of the image.

Gum bichromate paper is decidedly slower than chloride paper, or, to compare similar things, than Artigue paper or the ordinary carbon tissue. On a bright winter's day at noon in the shade, a thin negative will require about an hour's exposure; an average negative will take two hours at least.

Correct exposure can only be arrived at by repeated trials,

and even when it has been obtained and the actinometer number registered, it does not follow that the same negative with the same exposure will give similar results, if, for instance, another batch of paper has been used; for length of exposure is proportionate to thickness of film, which often varies without the operator's knowledge according to the colour used, or to more or less heaviness in the touch of the coating brushes. A thick film demands, of course, a much longer exposure than a thin one, for insolubilisation of the shadows must work right up to the paper. If it does not do so the substratum remains in a more or less soluble state, and will dissolve during development, carrying the upper insoluble particles with it. Such cases will, however, occur only when we are working for certain unusual effects, and with the latitude to which we have already alluded, and the skilful use of our materials, we need not trouble much under ordinary circumstances.

The easiest negatives to work are, in our own opinion, very thin ones—*i.e.*, the fully-exposed negative rather under-developed. Others prefer a dense quality; what are called plucky negatives, with strong contrasts. But we must consider that richness of tone is not produced in the same way as, for instance, in silver printing. We put the depth of colour on the paper beforehand; all that we have to do in developing is to keep there the amount of weight of it which we desire, so that the thinnest negatives can give great depth and richness as well as denser ones. It is a question of more or less exposure. The whites are the first to go, so, of course, hard contrast makes development difficult even with a strong proportion of bichromate, because what is sufficient development for the high lights leaves the shadows clogged

and heavy, requiring vigorous brush development. Theoretically, different percentages of bichromate should perhaps be used according to the negative, but practically this would involve a nicety of detail which few will think justified by differences in result.

THE ACTINOMETER.—An actinometer is essential in our practice, as it is in other carbon printing methods. There are many well-known types, the best of them, perhaps, that known as Burton's. This has a number of little figure negatives of varying degrees of intensity, and is better than those with letters or numbers only. As, however, we wish our instructions to be as complete as possible in themselves, we will describe another form which is very practicable, and more akin to the materials of which our prints are made.

Cut, say a half-plate piece of glass in half lengthwise, and upon one-half gum strips of translucent paper, one on the

One thickness	Two thick.	Three thick	Four thick	Five. thick
1	2	3	4	5

THE ACTINOMENTER.

top of the other, so that the first shall be about half an inch longer than the second, the second than the third, and so on. Six or eight of these may be so arranged, thus producing a strip with as many different densities. Border the whole

with an edging of black (needle paper), and divide the different densities by strips of the same. Place the other half of the glass over the first one, and adapt a linen hinge on one of the longer sides. When ready for exposure a strip of paper coated with gum bichromate solution without any, or with very little, colour, is placed between, and the actinometer is used in the usual way.

In order to have some idea of the symptoms of gross under or over exposure, it is a good plan to expose an average negative for, say, twenty minutes in the shade in winter—ten minutes on a bright summer day. Then cover half the negative with cardboard, and continue the exposure for three hours in winter—half the time in summer—and develop with warm water.

DEVELOPMENT, OR WASHING UP. — Development is an accepted term in photography for all processes of bringing up the latent image, but in carbon printing (to use the generic name) the French have a more expressive word. This is "dépouillement." It is not easy to find a corresponding term in English. It means the despoiling, stripping, unclothing, revealing, discovering, getting rid of the superfluous—may we not say, considering the method used—the washing up? For development implies rather the heightening in character of that which already exists faintly than the removal of a veil which covers it.

PRELIMINARY EXPERIMENTS.—In order to learn by experience in what condition our paper should be before we proceed to washing up, it is well to discover what kinds of failures are caused by wrong proportions in the coating mixtures or by defects in the process of coating. By so doing we shall be able, later on, to localise the causes, and

not to ascribe, for example, the result of a defect in coating to a lack or excess of exposure.

Take a coated sheet of paper which has not been exposed to light, and develop it, using cold water or water at about 50 deg. F. If the bichromated pigment has been properly mixed and properly spread, it will dissolve gradually and equally, showing a flow of minute particles of colour, coming, at first, from the surface only, so that the lightening of the general aspect ought to be very gradual, passing from black to dark grey, then to grey, light grey, and white. Layer after layer of colour has been successively dissolved, up to the paper support.

If, on washing up, the paper shows a colour stain all over which cannot be removed by hot water but demands friction with brush or sponge, the proportion of gum in the mixture has been too small, the paper has absorbed the pure colour and is useless for ordinary work, though it may be of service for certain effects where no high lights are wanted. It is to be remembered that paper is always more or less stained by pure water colour, and that it is the presence of gelatinous gum which prevents the colour from sinking and allows the total removal of the pigmented surface, leaving white, unstained paper beneath. This stain will therefore appear when colour is in excess in relation to proportion of gum, or when the proportion of colour is adequate to the desired depth of tone, but the quantity of bichromate is too great and has diluted the gum to an undesirable consistency.

Take, again, a sheet of paper and coat it with a mixture of bichromate and pigment without adding any gum. Expose and develop. Scarcely any colour will wash away, but on rubbing the paper with a pad of cotton wool the

picture will appear, the whites being totally and indelibly stained with the pigment.

If, on developing an unexposed sheet of coated paper, the film, instead of dissolving equally, breaks up into a quantity of minute scales, it is a sign of extra thick coating. This is easy to prove also, for on developing an exposed print one often notices this scaly breaking up on the outside edges of the paper where the excess of mixture, brought by every stroke of the brush, has accumulated during the coating process, the print itself developing gradually and correctly in the centre part where the film has been thinned down by greater pressure of the brush.

If the unexposed film refuses to wash away, or washes partially away, leaving patches and black stains of pigmented gum, the paper is of no use whatever. Old gum which has become acid by fermentation has been used, or the paper— good when fresh—has been kept too long, or it has been dried close to the fire and heated too much, or has been exposed to direct, hot sun rays; in fact, insolubilisation, not due to light, has occurred.

The above experiments will prove extremely useful in practice, for if a piece of paper coated with the same film which has thus been tested and found satisfactory gives a bad result on washing up after exposure, there will be every reason to ascribe the failure to incorrect exposure and not to false proportions of mixture or imperfect coating.

WASHING UP.—Some workers develop under water, immersing the print face upwards, and gently rocking the tray until the soluble parts of the film are dissolved. Others immerse the print and let it float face downwards, leaving it to soak and develop of itself. This is pure mechanical

development, and though we may make a beginning in this manner, if we were satisfied with it entirely we should be taking no advantage of the great selective facilities we have at our disposal and should be reducing our work to the level of other mechanical processes.

In any kind of chemical development the reducing agent, brought into contact with an exposed sensitive film will exercise its action equally over the whole of it because it is a chemical action. All that can be done to control its power is to apply more of it in some places than in others. In gum-bichromate development there is no chemical reaction. The film is first of all softened, then partially dissolved and washed away by water ; so if a stream of water is allowed to run over half the print while the other half is simply moistened, the first part only will be affected. In chemical development the agent used has a power of its own independent of its quantity. In fact, the developing power of the water is proportionate to the frequency of its application, to the quantity of its flow, and to the force of its stream.

The method of development which we recommend is that in which a stream of water is used flowing over the print from a sponge, and is practised in the following manner : The prepared paper is taken from the printing frame after having been placed there film to film with the negative, a depth of about an inch turned down on one edge to prevent the action of light on that portion. It will be found useful to do this, because some judgment of the quality of the paper may be formed from the behaviour, during washing up, of this protected strip. On removal from the frame the print is first

3

immersed in cold water, or in water at no higher tempera-
ture than 65 deg. F., and is then placed on a glass plate
about a third larger than itself. This plate is placed in an
inclined position in a large developing tray half filled with
cold water, one end immersed in the water and resting on
the bottom of the tray, the other tilted up and supported by
a little wooden stand about three inches high, or in some
other convenient manner which shall permit the angle of
inclination of the plate to be altered, and so cause a flow
of water over it to be more or less rapid. Two sponges are

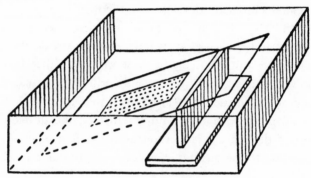

DEVELOPING TRAY AND SUPPORT.

used, one small enough to be held in the palm of the hand,
the other somewhat larger ; and a can of hot water. The
large sponge is filled with cold water and gently pressed at a
few inches distant from the glass plate, upon which it falls
and flows over the print, which is held in position with one
finger. It is important that the stream of water should not fall
on the print itself until we know that the film is sufficiently
insoluble to stand the shock. After a few minutes of repeated
floodings with cold water, the image, if capable of being
brought up at a low temperature, ought to have appeared.

If not, the sponge is dipped into the hotter water (which should not exceed 100 deg. F.), and the print flooded several times. Very careful watching is necessary at this stage of the proceedings, for often a simple application of the warm water is sufficient to loosen the film and to start development; and if too hot, mischief is at once done which it is impossible to repair. If, however, the print resists the first warm floodings, hotter may be cautiously used until the outlines of the picture are visible. It is then that selective development begins.

The worker will have done well to provide himself with a silver print from the negative (it will help him if this print stands before him during development). He knows already what are the errors to be remedied, what values require to be strengthened, or to be brought down to their true importance. He has noticed where the deepest shadows are (and here water may be freely applied), and where the most delicate half tones lie and are to be treated with the utmost precaution. Little by little he will determine the general scale to which he will have to work up, and the key in which his picture is to be set. He has found, perhaps, how effectively a high light may be placed here, a shadow left there in all its depth, or opened up to the light, or where some white patch disturbs the equilibrium of the picture, and must be lowered or counteracted. Local development will enable him to approach as near as possible to the ideal composition which he has built up in his imagination on the imperfect document furnished by his silver print.

Local development may be carried out in numerous ways. We may, for instance, take the smallest sponge and press it gently as close as possible to the particular part of the print

which may require clearing, taking care by shifting the
position on the glass plate that the water does not run off
too forcibly over some other delicate portion. Now and
then a more copious flooding of cold water will tone down
the edges of the locally developed portions ; the general pro-
gress is watched from time to time from a little distance, and
development renewed until the desired effect is brought out.
Very hot water from the can will be used for the darkest
shadows; lukewarm, obtained by dipping the sponge into
cold and hot water alternately, for the intermediate values ;
cold water for the delicate half tones. Or the work may
be carried on by means of a minute flow of water directed
through a glass pipette or nozzle with a tube communi-
cating with a small reservoir placed high enough to give a
certain force ; or through an ebonite tube with flexible ball
held in the hand such as is used for blowing magnesium
through a flame for flash-light ; or by squeezing the
sponge as it lies in the open part of a funnel ; and in
numberless other ways whereby control upon exact spots
may be maintained. Throughout the whole there need be no
hurry ; the work may be left and resumed as one pleases,
and one has time to think, and look with another eye upon
the growing picture. *La nuit*, even, *portera conseil*, if our
impatience and greed of work will permit us to avail our-
selves of it.

Development with the brush is carried on on similar
principles, but it can only be used if the exposure has
been long enough to ensure a sufficient firmness of film.
Every worker will find out the different conditions for
himself ; how far, for instance, it is safe to allow the
loosening action of the first warm water to go, and the

temperature at which this may be applied. It will vary according to circumstances, and our experience of the behaviour of the film under our first cautious beginnings will show us in what directions our next steps may be taken. There is, of course, infinite variety in the brushes or other implements which we may now bring into play, and the way in which we may use them. In some cases we may, while so doing, keep the print under the surface of the water, which thus forms a kind of elastic cushion between the head of the brush and the film, and allows of comparatively greater force being used. At times we shall employ gentle smoothing strokes beneath the water of wide and soft camel's-hair brushes; at others we may use the tapping action of the sparsely set stiff hairs of a badger hair pencil held vertically, or even a stiffer hog's-hair brush.

At other times the print may be placed face up on a glass and worked upon the bare surface, but this requires extreme caution; the slightest and minutest touch may ruin the picture, while on the [other hand a brilliant inspiration will, with the production of a single point of light, skilfully placed, achieve in a moment the wished for effect.

We have not yet learnt how to discover half the possibilities, but what our experience has been able to show plainly is that the varying conditions of prolonged exposure, the manner in which the film is first loosened, and the subsequent treatment of it by various brush methods combine to place in our hands a variety of effect, the gaining of which it is well worth while to master.

Great care and delicacy are necessary in this mode of development. Hand and brain must work together, and every stroke of the brush must be actuated by deliberate

intention, and made in the right place with a firm yet delicate touch. Hurry is fatal. When once the pigmented surface has been disintegrated by friction, water development should not again be taken up. It would tend to wash away the layer where it has been touched, and therefore if during water development brush friction is necessary to clear heavy shadows this should be done when the print is complete in other parts.

There remains yet another useful method for commencing development and clearing the print for the more delicate after-treatment. This is the use of the sawdust soup of the Artigue process which we shall describe presently in its place. The action is, however, tolerably strong even with a very thin mixture and can only be used after prolonged exposure.

RETOUCHING.—Retouching is a delicate operation with which it would be impossible to deal here other than in a summary manner, and may be left to the individual skill of the artist. It must, of course, be carried out so as to harmonise with the general character of the work, and be in no way conspicuous. We should in a general way use the colour employed for the groundwork of the print, but we must remember that this has been mixed with bichromate and afterwards acted upon by light. A good plan is to take the bichromated mixture and applying it where required (this may be done roughly), immediately or shortly afterwards pour water along the top of the print, allowing it to flow downwards and carry off what is superfluous. In this way, were it desirable to do so, it is possible even to make additions to the work. The limitations to such additions, and their legitimacy, must be left to the honesty of the artist.

CLEARING.—When the print is thoroughly dry it is neces-
sary, for its future permanence, to rid it of the chromic salts
imprisoned in the layer of gum and pigment. This can be
done by soaking in an alum solution,.but it takes some time
and the print also loses something of its soft, delicate effect.
A better and quicker way is to immerse the dry print for one
or two minutes in water to which has been added sufficient
bisulphite of soda to produce a distinctly sulphurous smell.
The yellow stain left on the paper by the bichromate dis-
appears immediately, and a minute or two of subsequent
washing is all that is required, for bisulphite of soda is
extremely soluble.

ACTION OF HEAT AND ACID ON THE SENSITIVE
MIXTURE.—A strong proportion of citric acid or a smaller
proportion of more active acid added to the mixture of gum
and bichromate will utterly destroy its sensitive properties ;
that is, will render it insoluble without exposure to light to
such an extent that repeated friction with a sponge and hot
water will scarcely affect it. We may, therefore, take advan-
tage of this property to counteract the excessive solubility
of freshly prepared paper and lessen exposure, giving more
stability to the half-tones. A small quantity of a weak (say
5 per cent.) solution of citric acid, or simply a few drops of
lemon juice added to the sensitive mixture, will start
insolubilisation and allow of slower and surer development.
It is better, however, to master the ordinary process before
resorting to this expedient.

Heat also produces insolubility, and care must be taken
not to dry the paper too near the fire, or to expose in the
direct rays of the summer sun.

It will be gathered from the instructions which we have

now given that in order successfully to prepare and develop hand-coated paper, it is necessary to pay great attention first to correct proportions of the sensitive mixture, next to an even, thin, and rapidly applied coating, and lastly to the degree of exposure to light.

The power of insolubilisation, or, as it may otherwise be called, of sensitiveness, of the paper ought, one would imagine, to be in direct proportion to the strength of the chromate solution. We know that chromic acid hardens colloid matters : quickly in the presence of light, slowly in darkness. It would follow that insolubilisation should take place more or less rapidly according to the greater or less concentrated strength of the agent. If, therefore, the proportion of bichromate is reduced to a mininium, longer exposure will be necessary, and *vice versa*.

Upon this point, however, differences of opinion have been expressed. In an article on the subject in a Viennese photographic journal, Mr. Watsek (whose admirable pictures by this method were so prominent at the London Salon of 1896) appears to hold that the proportion of bichromate has but a very feeble influence upon the character of the image, and that exposure is proportionately longer according to the greater or less quantity of gum in the coating mixture. But it is worth while noticing that, of necessity, the more gum there may be in a given quantity of the sensitive solution the less will be the strength of the bichromate, reduced in volume and weakened by the water in the gum.

Amongst the factors governing our work probably that which determines the duration of exposure is the most important of all, and as this is affected by the composition of the sensitive coating, and by its thickness, it presents, of

course, some difficulties which will vary according to circumstances.

There are, therefore, many questions upon which the worker who wishes to make himself acquainted with all the capabilities of his medium will do well to satisfy himself. Amongst them the effect upon the image of different relative proportions of gum, colour, and chromic salt, and the thickness or otherwise of the coating, are worth his careful study. For all these matters it is impossible to formulate direct instruction. In the preparation of the coating mixture and its application to the paper, a certain amount of practice will teach a good deal. For instance, the right consistency for coating will be instinctively recognised without the necessity of weighing and measuring. One finishes by *feeling* what is the right proportion. It cannot be explained. It is like the knack of an engraver wiping the plate with the palm of his hand—he *feels* that it is right—while another man doing the same thing would do it wrong.

In the details of the practice of photo-aquatinting which we have given we have endeavoured to be as precise as possible, so that this method of printing in pigment should be available even to those who know nothing whatever about other processes in photography. For those who do, and are able to perform for themselves the very simple operation of developing a negative, we have, we hope, assisted to still further simplify the details of photographic procedure.

A few words may now be said upon the method of working a kindred process, viz., the very beautiful paper known as Artigue Papier Velours, and in adding some considerations and reflections upon the subject in general our task will be done.

CHAPTER V.

ARTIGUE PAPER.

FOR some who may desire different qualities from those for which the hand-coated paper we have described is suitable, and who wish to use a direct carbon paper, without transfer, capable of giving as faithful a counterproof from a negative as can be obtained by any other photographic process, certainly none could be recommended more than the " Papier Velours," generally known as Artigue paper.

We have already alluded to the incredulity of those who maintained, in the face of evidence to the contrary, that carbon development must of necessity take place from the back of the coating. The prints by Artigue's process shown in 1894 at the Photographic Salon, and the admirable examples exhibited at that Exhibition, in 1895 and 1896, by Monsieur Puyo, are sufficient proof, in themselves, of a long-established error.

We know no method of coating paper with bichromated gelatine and pigment which is capable of giving the texture which we find on this paper, except perhaps the use of such an instrument as the air-brush. We have used this machine, and certainly with it an extremely fine and even coating can be applied. What the pigment may be, which Monsieur Artigue employs, what the colloids, what the substratum, and how the coating is effected, are still the maker's own secrets.

The paper has a surface of extraordinary fineness and homogeneity—a pigment of some peculiar black mixed with a little gum and possibly some gelatine and fish-glue also. Viewed by reflected light, it is a dead velvety black, and so soft that a moist finger easily removes it. By transmitted light the paper is almost transparent, with a quite light greenish - grey appearance, very regular indeed, with no apparent surface faults. The secret of its quality, in fact, the whole secret of preparing paper for development from the front so that it shall give the most delicate gradations of half-tone, is in the extreme tenuity of coating and the perfection of evenness in which the pigment is held in suspension, allowing of absolute regularity in distribution. At present it is only made in black, and there appears to be some difficulty in using other colours; at any rate, those which have, till now, been put on the market, have not proved to be satisfactory.

In 1878 Monsieur Frédéric Artigue produced a paper covered with a thin layer of some colloid substance with which was incorporated a very fine black powder. This was intended for the reproduction of architectural plans and other line work, and was developed by friction with a soft wet sponge. On one of the plans sent (in negative form) to Artigue for reproduction there happened to be in one corner a small water-colour sketch. On development he found, to his surprise, reproduced, in all its half-tones, the original drawing. This put him on the track. He made experiments, but unfortunately died before he had perfected the system. His son, Victor Artigue, took the matter up, and in 1889 showed, for the first time, perfect prints at the International Exhibition of that year. He then demon-

strated his method of development before the Société Française de Photographie, but as he would neither supply his paper nor communicate the method of preparation, that Society was incredulous and awarded him a medal for *results* only. The paper as now supplied was first placed upon the market in 1893. It will be admitted that we have in it a carbon paper of a very high degree of excellence. The .blacks are intense, and, if desired, the whites may be retained with great purity and brilliancy. The surface is delightfully soft in texture and the scale and gradation of tone unusually extended.

The paper is supplied unsensitised and in that state will, of course, keep indefinitely. It appears however to vary in quality. The emulsions used do not seem to have always a constant power of resistance to the temperature of the water used in developing. They may, in fact, be divided into two categories : that (and this is unusual) in which development may be effected at a temperature of 60 to 65 F., and that which requires to be attacked at a temperature of F. 80 or higher.

The earlier method of sensitising was a tedious and uncertain one through the back of the paper, but as was shown at the Photographic Salon Conference in 1894, a simpler way that by immersion, is quite as efficacious. At first, also, development was effected with baths of comparatively high temperature. Now, it is practically cold throughout, at least at a temperature no higher than that of water in summer.

To sensitise, prepare a two per cent. solution of bichromate of potash in a flat dish. In summer the strength of this solution should be reduced to one and a half per cent. Immerse the paper in this gently to avoid air-bubbles, and hang

up by one corner to dry in the dark. As the pigmented surface is very tender and easily rubbed off, it is convenient to put a little metal clip at each corner of the paper, to lay it on the bed of the dish, flow the solution over and handle by the clips only.

Exposure is made with an actinometer in the usual way, and the paper when freshly sensitised may be said to be about three times as rapid as silver paper, say about the same as

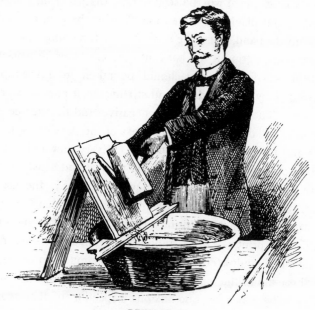

DEVELOPING.

platinotype. For development, very finely pulverised saw-dust (a special preparation, to be obtained with the paper) is generally used.

Of course this is of no necessity. A brush, rocking, laving, flowing from a sponge, plain water, and other ways would

develop in time ; but the sawdust, by its soft rubbing action and adaptability to different conditions of exposure, is very useful.

Make, therefore, in a large, very deep earthenware pan, a thick soup of this sawdust and cold water, and have ready a coffee pot or similar utensil with a very wide (about an inch wide) spout. After exposure take the paper and place it in water at as near as possible 65 deg. (not more). In a minute or so a faint image will be seen. Lay the paper on a sheet of glass, and placing this on an easel over the pan, or holding it in the hand, pour the sawdust mixture along the top of the print, letting it run back into the earthenware pan. At first the sawdust mixture should be taken from the top ; afterwards, by dipping down and stirring up, it may be taken thicker. The character of the negative and the degree of exposure will determine the thickness of the developing mixture and the manner of applying it. Every now and again a dash of cold water will reveal the picture and satisfy us as to the progress of the development, and finally, the usual alum bath to discharge the bichromate and harden the pigment, will complete the print. Development must continue until the print is considerably lighter than it is desired to be when completed, as it darkens very much on drying.

Throughout, the operations have been with cold water only. There has been no anxious inspection of thermometers, no squeegeeing, no transfer from one support to another, no pressure between blotting boards ; we can suspend and take up development where we will ; there is no film to blister and leave the paper, no safe edge to make to the negative and, finally, there is no reversal, end for end, of the picture, but a true positive from a negative.

The whole process of development, in the case of a cor-
rectly exposed print ought to be complete in a minute or
less. If it takes longer the exposure has been wrongly timed.
In cases where we deliberately seek for particular effects,
very prolonged exposure and subsequent special treatment
give a power of altering the general character of the print
and of modifying the rich velvety black to a more delicate
engraving or pencil-like effect. But we prefer at present to
consider the paper in its more automatic character.

CHAPTER VI.

CONCLUDING REMARKS.

IT is not to be imagined that the system of printing which we have described is one which will meet the taste of all who occupy themselves with photography, or that it will be in consonance with the views of those whose preferences are, for the most part, towards mechanical and automatic procedures. Neither can it be pretended to be a simple or an easy process : there is little of the " press the button " character about it.

Whether or no photo aqua-tinting may strictly be termed pure photography may perhaps be matter of opinion. It is at any rate photography, and for those who judge with discrimination will always preserve a distinctly photographic character. It is true that the results differ from the earlier type, and a very few years back might easily have been taken, at first sight, for chalk or water-colour drawings. This, in fact, they are, for there is nothing left on the paper but pure water-colour, with just sufficient gum to hold it in permanence.

At a recent exhibition, referring to one of these pictures, a painter was asked, "Supposing such a photograph had been sent in to an ordinary exhibition of pictures—of course, nowadays with your knowledge of our methods you would recognise it as a photograph—but what would you have

said a few years back if it had been sent without any indication?" He replied, "Well, I should have said, what's the man about ; why is he working in this photographic sort of way?" And so, of course, it is. The photographic way appears to those trained in other systems to be wrong, but we have no desire to hide it, or to admit that it is wrong. On the contrary, we wish to uphold it, and to say emphatically that these results must be in essence photographic ; at least, as much so as in other photographs where licence is permitted.

We must fully recognise the limitations of our medium. There is no necessity to alter its characteristics ; our avowed purpose is to accept them, and our endeavour to express ourselves by frankly making use of the means at our disposal. We may set up our own standard without reference, of necessity, to the conventions and principles established by other methods. The photographic character will always remain, for those who are capable of discovering it. If, in the phase of transition through which we are, perhaps, now passing there may appear to be an ill-defined purpose, it is the natural result of the struggle to be free from the trammels imposed by those who, inspired by feelings of an entirely different character, sought to govern by the same laws two opposite and distinct applications of photography.

It is necessary to say here a few words concerning the legitimacy of the licence in practice to which we just now referred. We are entitled to ask from those who may oppose it that they should be consistent and logical in their condemnation ; that is to say, that they cannot be permitted to approve here and to condemn there according to individual inclination or the reverse. Now practices in photography which

appear to be universally condoned are vignetting, sunning down, adding clouding, matt varnishing and scraping off, shading with the hand, a cloth, or in other ways while printing, with many others. How often do we see a figure posed against a background, on which all sorts of accessories —furniture, steps, balustrades, windows with rays of light streaming in, landscapes even—have been painted, and if nothing more remains, purely photographic, than the principal figure, still no objection is made to the photographic character of the whole. Suppose it were possible to apply selective development to negative making, would it not be practised?

It would, of course, be easy to multiply examples and parallel cases. The whole gist of the question lies in this : Is a photograph to be rigidly produced by mechanism, or are assistance and modification by the skill and craft of the artist to be allowed?

It is not to be contended that we advocate such practices as, for instance, the addition of any absolutely new matter to the print ; that we are in favour of such liberty as would allow the painting in, say of a tree or flower where none would be produced through the medium of the negative. But it is impossible to draw any hard and fast line. The conscience of the artist will alone accuse or absolve him. Neither is there any essential difference in this respect between the method of photo-aquatinting and others ; such, for example, as platinum printing and the use of glycerine in the modification of tone by keeping back portions of the print. In itself the development *may* be carried out in an absolutely mechanical manner, say by soaking in water until the soluble parts are washed away.

Few, however, will deny that the latitude at our disposal, if intelligently used, is of infinite value. It constitutes the beauty and the essence of the system, and it would be drawing a very fine distinction indeed to say that here there is no art.

An objection to be anticipated is that in using the methods we have described, the result does not truly represent the original negative. But what has the beholder of a picture to do with a negative? The true test is that an intelligent and artistic observer shall see no incongruities forcibly apparent. The public does not want a scientific expert's opinion, for it does not come to a picture gallery to be instructed in chemistry and optics.

We must be prepared to hear these results qualified as imitations, but the charge is scarcely justifiable. The resemblance, which is called imitation, cannot or need not be avoided. We work in photography upon similar principles to those which govern other monochrome systems. There is nothing contrary to the art of painting by light when we produce an enamel which is like a miniature painting, a platinum print which recalls a mezzotint, a photogravure which is truly an etching, or a carbon print which is truly a drawing by light in pure carbon and therefore may be like a charcoal drawing. None of these arts has a monopoly which is disturbed in the same way as when water colour trenches upon the technique of an oil painting.

There is one point of view which is important. It is that we must submit to have our pictures judged upon other grounds than those which govern our appreciation of the mechanically produced photographic print. We have but

lately begun to practise these more personal methods, and faults of arrangement, of harmony, and of light and shade have been tolerated with perhaps too much lenience at our exhibitions. But a greater discrimination will doubtless before long be applied. Efforts admittedly crude, and glaring in falsity, will not deserve acceptance merely on account of difficulties overcome, and of the novelty of the system. Less and less will credit be given for qualities due to the machine, or the model, or to nature's own arrangement.

POSTSCRIPT.

SINCE the above pages have been in type, a modification of some importance in the method of coating the paper has suggested itself.

Certain difficulties will sometimes occur, of which the causes are not always apparent. For instance, using perhaps precisely the same procedure as we may have done before with success, a print will develop itself clear and brilliant, but, shortly before becoming dry, the film will melt and run and presently leave nothing more than a smudgy mass. On the other hand, the paper when freshly coated with the proper proportion of the coloured mixture will sometimes be found to be stained with colour to such a degree, even without any exposure to light, as seriously to interfere with the subsequent development.

Now the principal charm of the method of printing which we have described lies in the peculiarly soft and delicate character of the image produced by a certain amount of melting and running down or mingling together during development, or drying, of the sensitised and exposed pigment. But if this condition takes place in excess of requirements, the result is, as we have said, a confused and smudgy mass. On the other hand, if it does not occur at all we may have a hard image, a picture, in fact, of the sort and whitewash type. We require, therefore, to be able to restrain these tendencies within limits and to control and guide them according to our wishes.

It was while casting about for remedies against the melting propensities of the film under certain conditions, and the colour-staining of the paper under others, that an entirely new principle

upon which to work suggested itself to us. This newer method appears in several ways to facilitate the actual preparation of the paper, and to possess distinctive advantages from the point of view of results.

It consists in sensitising the paper in the first place and then applying the gum and colour, instead of coating with a mixture of gum, colour, and sensitising agents. Very simple indeed—as simple a matter as the balancing of Columbus' egg—but we think that it has not been noted before, or at any rate published with regard to any form of carbon printing.

The paper, then, is to be first of all soaked in a ten per cent. solution of bichromate of potash for about two minutes, rocking the dish the while, to avoid air bubbles. It is then dried (bone dry), and is ready for coating in the manner previously described, the coating mixture consisting of gum at twenty per cent. and a sufficiency of colour. We reduce the strength of the gum by one-half because it is not now so reduced by the bichromate solution.

The sensitiveness of the paper is increased to an enormous extent. Instead of being, as in the earlier system, three or four times slower than chloride or platinum paper, it is now quite as rapid as either, or as ordinary carbon tissue : even more sensitive perhaps. Unexposed, the film dissolves and leaves the paper pure, so that the edges of a print protected by the rebates of the frame are quite white, and the high lights of the picture, also, are more amenable to control. This is especially marked with black and brown pigments, which formerly were very apt to stain.

The rationale of this system would appear to be that each molecule of the pigmented gum with which the dried bichromate paper is coated absorbs, or is in contact with, just its molecule of bichromate and no more. The rest of the bichromate, protected by the coating of colour, is probably very little acted upon.

In our earliest essays on the newer system we found that the images were apt to be hard ; the high lights dissolved away too

quickly and cleanly. This, however, clearly resulted from wrong proportions of the materials used, and so again, as we laid down in a preceding chapter, we shall not attempt to give an empirical formula. A very little patience and practice will teach each worker what is best for his own requirements.

The general practice is, we think, rendered more easy. We may now sensitise as many sheets of paper as we like in advance, we can keep our colours mixed with water in any quantity, and have only to add, as required, in equal proportions, gum solution of the desired strength (i.e., at about 40 per cent.) There is in this way also, far less waste. The results appear to be much more certain, and if we remember how very sensitive the film is and that where formerly, perhaps, four actinometer tints were required, less than one will suffice, failures will not so often occur.

THE

OIL AND BROMOIL
PROCESSES.

THE

OIL AND BROMOIL PROCESSES.

BY

F. J. MORTIMER, F.R.P.S.

Editor of "The Amateur Photographer and Photographic News,"

AND

S. L. COULTHURST.

["THE AMATEUR PHOTOGRAPHER" LIBRARY, NO. 31.]

LONDON:

HAZELL, WATSON & VINEY, LD.,

52, LONG ACRE, W.C.

1909

PREFATORY

THE oil-pigment process, as practised to-day by a very considerable number of workers in pictorial photography, differs only in its method of application and general use from the process invented by Poitevin in 1855.* Poitevin's specification dealt with the production of an image in greasy ink on chromated gelatine, but his description of the method was too vague to be regarded as instructional. A later patent by Asser (No. 543 of the year 1860) contains a specification that distinctly sets forth a description of the production of proofs in printing ink, for use as primary or direct prints. In *The Amateur Photographer* for December 20, 1904, Thomas Bolas, F.C.S., F.I.C., deals at length with Asser's process, and describes his own production of prints by this method before the Society of Arts in 1878.

The oil process is essentially collotype on paper, but it has been due to Mr. G. E. H. Rawlins that a practical revival of oil printing has been

* Poitevin's English Patent, No. 2815 of 1855.

3

made. Its application in the production of
photographic pictures is now firmly established,
and the need for a complete handbook on
the process and its offshoot—the Bromoil pro-
cess, will be met by this volume. Mr. Rawlins
described the results of his first experiments in
The Amateur Photographer for October 18, 1904,
and his procedure at that time was to apply the
pigment for the formation of the picture by
means of a composition roller. Later experi-
ments demonstrated that greater control was
to be obtained in the application of the ink
if special brushes, similar in design to stencil
brushes, were used, and the pigment applied
with a dabbing action. By this means the pro-
duction of the image becomes entirely subservient
to the desires of the operator.

Oil printing, therefore, in its present practice,
gives to the photographer the power of absolute
control over his result, as any part of the picture
may be strengthened, subdued, or even elimi-
nated altogether, at will. The materials are
both simple and inexpensive, and the results are
absolutely permanent. No other printing process
at present known to the pictorial photographer
places such enormous control in the hands of the
skilful and artistic worker.

The Bromoil Process utilises the power of

bromide paper for enlarging purposes, and by
employing chemical action the silver image of
the bromide paper can be converted into an
image that is analogous to the chromated image
in the oil process. Bromoil gives the oil worker
still greater possibilities, as it places no restriction
upon the size of the final print, which can be
produced entirely by artificial light, either by
contact, or in the enlarging apparatus. To Mr.
C. Welborne Piper is due the original method
of producing oil prints from bromides. His
description of it appeared in *The Photographic
News* for August 16, 1907, and the method of
procedure is equally as simple as the direct oil-
pigment process. The latest and most practical
instructions for working both processes will be
found in the following pages.

CONTENTS

7

THE OIL AND BROMOIL PROCESSES

I

THE OIL-PIGMENT PROCESS

The Process in Brief

THE reader who has not tried the oil process for the production of his photographic prints, and who takes up this book for the first time, may ask, "What is the Oil Process?" In the prefatory note a brief historical reference is made to the inventors and original experimenters, but without dipping further into this side of the subject (*i.e.* the birth and early history of the process) we feel that a short explanation as to the basis of our subject is necessary. The following brief outline

9

will therefore serve to describe the process generally :—

Paper thinly and evenly coated with gelatine, such as the double-transfer paper used in the carbon process, or the special oil-pigment paper prepared for the purpose, is sensitised with an aqueous solution of bichromate of potassium or ammonium, and allowed to dry in the dark. The paper is insensitive when wet, but becomes about three to four times as sensitive to light as ordinary P.O.P. as soon as it is dry. When quite dry the paper, which is now stained yellow by the bichromate, is ready for printing from a negative.

Printing is conducted in daylight just as with P.O.P. or platinotype, but it is here the beginner may go wrong, and it will repay him to devote some little attention to the question of correct exposure, because much of the success of the after manipulations depends upon it.

A faint brown image is formed on the surface of the paper, and this affords a guide to the correctness of the exposure. The image should be clearly visible in all parts, and printing is complete when detail is just perceptible in the highest lights. After exposure, the printed paper is washed in plain cold water until the whole of the yellow

bichromate stain has been removed. During this period of washing, which should occupy about half an hour, the picture will appear in relief on the gelatine surface. The parts which have been protected from light by the dense portions of the negative (*i.e.* the high lights), absorb more water than those which have been printed deeply (*i.e.* the shadows), and the image swells up in proportion to the different gradations of the negative.

The best negative for the process is one that has a good scale of gradations from high lights to shadows, and is fairly " plucky."

When the swollen gelatine image has been obtained, the print is in condition for " inking up " or pigmenting.

This is accomplished by placing the print upon a pad of wet blotting-paper. This is necessary because if the surface becomes dry during pigmenting the pigment will adhere equally all over the surface. By keeping it damp and the image in a swollen state, the portion which has absorbed the greatest amount of water (*i.e.* the high lights) will repel the pigment more than the parts which have been fully exposed (*i.e.* the shadows). The latter attract the ink in proportion to the amount of exposure.

The pigment is applied by means of specially

prepared brushes. These brushes are made of fine hog-hair or fitch, and are so constructed that they present an even, flat butt-end, which allows the pigment to be spread evenly on the surface of the print with a light " dabbing " action. The pigment, which is of fairly stiff consistency, is spread on a piece of glass or china palette, the brush is dabbed on the pigment and then lightly dabbed on the surface of the print, which should not be actually wet, but in a tacky, moist condition. Lithographic inks are suitable for the process, but the special pigments now prepared, and easily obtainable, are recommended.

The image will now grow under the action of the brush, and the more pigment that is applied to the shadows the darker these portions will become. At the same time, the high lights repel the application of the pigment, and by continuing the dabbing action the whole picture is gradually built up, and can be modified to any extent to suit the worker.

The application of very stiff pigment tends to produce a hard result, while thinning the pigment with a medium such as boiled oil or Roberson's Medium makes it possible to obtain a much flatter result. A soft smudging action of the brush will distribute the pigment evenly over the surface, and assist in toning down high lights, while a

vigorous " hopping " action of the brush will take away pigment and accentuate high lights.

Materials Required

1. A good strong negative is the best for initial experiments—say one that will give a good P.O.P. print.

2. A good paper, fairly tough, and of smooth surface, coated with gelatine—such as the double transfer papers used in the carbon process. (Suitable papers for the oil process are fully described on pages 14 to 20.)

3. Sensitising solution of bichromate, as described later.

4. Blotting-paper.

5. Piece of old glass, or thick sheet zinc, larger than the sizes of prints likely to be worked, also a few old ½ or 1/1 plate negatives as ink palettes.

6. A palette knife or old household knife to spread ink on palette.

7. Specially prepared oil pigment or lithographic ink of fine quality. (The pigments are described on pages 47 to 52.)

8. Brushes for pigmenting the picture. (*See* pages 40 to 45.)

The following materials may also be used with advantage :—

1. Blanchard brush as described—later (p. 33).
2. Soft rubber for clearing high lights, etc.
3. Blind pen or lance points for picking up spots of ink, hairs, etc., on print during or after pigmenting.
4. Spring handle for brushes when " hopping."
5. Tracing-paper to fold over prints whilst drying, to prevent dust from settling upon the surface.

Suitable Papers for the Oil Process

The question of papers for oil-pigment prints is one of importance, and should receive full consideration by all oil workers ; for this reason a few may be described which we have found from recent practical trials to be worthy of consideration. It must not, however, be assumed that they are the only ones that are good, or that better may not be found or made, but the papers mentioned are at present undoubtedly the best for the purpose.

There are many workers who are only using one make of paper, and are quite in the dark as to the possibilities of others that may be used.

It may be said at the outset that all the papers mentioned below are quite ready for sensitising, and that each and every one of them should be treated alike in this respect.

Rawlins' Oil-Pigment Paper and " Pigmoil "

First (in justice to Mr. Rawlins, who has done so much for the revival of the process) should be mentioned the paper known as " Rawlins " Oil-pigment Paper," placed on the market by Messrs. Griffin, of Kingsway, London. It is a very excellent paper, and eminently suitable for the process for which it is intended. A later variety of the Rawlins paper is made by the same firm under the name of " Pigmoil " paper. This is an improvement on the original Rawlins paper, and is probably the best for the beginner to use, and indeed for advanced workers also. The pigment is taken up readily in the shadows and repelled in the high lights. The operation of pigmenting can be conducted very rapidly with " Pigmoil " paper, and the tendency is to get strong vigorous results. It is made in two grades, "smooth" and " rough," and is sold in cut sizes from quarter-plate to 18 by 16 inches, also in rolls 35 inches wide. Whole-plate size, to name a medium one, costs 2s. per packet of 12 pieces.

The " smooth " surface papers have no special indication as to which is the coated side, and this is where the beginner may go wrong. Careful inspection will, however, show that the two sides are slightly different in texture, the very smooth side being the coated one. If any difficulty is experienced in finding this, the tip of the tongue applied to the corner of the paper will readily disclose which side is coated with gelatine.

This paper is admirable in every respect for the process. In many early workers' hands, progress towards success with the oil process was slow, owing to difficulties that occasionally arose in pigmenting. " Pigmoil " paper has been specially made for the purpose of obviating these difficulties. With it the oil pigment " takes " with great readiness, and the process is much simplified, so that with very little practice straightforward prints can be obtained by the novice.

When using it, however, one feels that one is using an expensive article in comparison with other gelatine-coated papers obtainable, and which may be successfully used for the process. This is the only complaint that can be levelled against this admirable production, and if the price is not considered it may be regarded as the ideal paper for the process.

The Autotype Company's Papers

The Autotype Company have also recently introduced a special double-coated paper for the oil-pigment process. This is made in two varieties. Special No. 1 is a thickly coated white paper of fine grain. It pigments easily and stands a considerable amount of hard brush-work. No. 2 has also a fine grain, but is a toned paper, and is highly suitable for certain effects where a toned paper may be used.

The Autotype Company's final support for double transfer carbon work is frequently used by the leading workers in oil. " No. 76 " is one that has given great satisfaction. It is pure white and has a beautiful matt surface.

The coating is even and thick, so that good relief is obtained when the printed paper is soaked in water and blotted off. The same paper with a toned or cream-colour surface is known as " No. 77." These both take the ink well and stand rough usage. The Autotype Special No. 1 and No. 2 are the same as Nos. 76 and 77, but are double-coated and therefore somewhat easier to work. " No. 90," known

as "smooth-toned 'Reynolds,'" is also a good paper that works well in our hands. If very rich "juicy" prints, with a decided gloss, are required, the Autotype Litho-Transfer paper is recommended. This is very thickly coated and gives great relief.

Illingworth's Papers

Messrs. Illingworth's Double Transfer Papers are very popular for the process, and are recommended by several well-known oil workers, particularly Monsieur Demachy.

No. 125 "Thick Smooth" is a very useful paper for almost all purposes. It is very strong, and its colour may be termed "opal tint." It takes the ink easily. The image swells up well when wet, and the pigment does not "sink in" even when a thin ink is used.

No. 117 is a thick, strong, rough-surface paper, not too rough by any means, but a most useful surface for large work or broad masses of light and shade. It is toned paper, but not so deep in colour as No. 77 Autotype.

In No. 119 Illingworth's we have a thick white Whatman paper of a distinct character, and it may be used in a similar manner to the last named (117). It must be noted that these

thick papers should be soaked longer than the thin papers, in order to obtain relief before pigmenting.

No. 151, "Gravure White" or Toned, is also a good paper made by Illingworth and recommended by Monsieur Demachy.

If a toned smooth-surface paper is desired, Illingworth No. 118 is to be recommended. It is almost like a vellum paper. It is stout and fairly heavy, is well coated, and takes and holds pigment readily. If printed with wide margins and the print plate marked, etching-like productions may easily be secured.

Other Makers

Messrs Elliott & Sons of Barnet, and Wellington & Ward, of Elstree, who are also makers of carbon tissues and supports, have several excellent final supports that can be employed successfully for the oil process.

The Rotary Company have two papers. No. 1, "Thin White Smooth," is similar to P.O.P., but with much less gloss for small work. It is admirable, and for fine portrait work it will be found useful, but its scope is not so wide as the others we have mentioned. No. 2, "Matt Medium," is a useful paper, especially if stiff or

hard inks are being used. It is of the "egg-shell" surface kind, but not quite so heavy as No. 76 Autotype. It is well coated, and one has no difficulty in finding the right side. For work up to whole-plate size it can be recommended.

It is hard, takes the ink well, dries without the ink sinking in too much, and will stand more than ordinary usage.

Sizes of Paper

All the double transfer papers mentioned above are obtainable in rolls 12 ft. by 30 inches, in addition to packets of the usual cut sizes from $\frac{1}{4}$ plate to 15 × 12.

It is advisable when printing the sensitised paper for oil prints to place the negative on a glass support in a frame larger than the negative and use a piece of paper also larger than the negative.

Most of the makers of the papers described issue them slightly larger on account of this requirement in carbon work : thus, for a whole-plate it is sold 9 × 7. If the larger piece of paper be used it leaves a margin all round, and this will keep the brush from picking up dampness from the wet blotting-paper when working near the edge of the print. After printing is finished,

any colour may be removed from the white margin, and this margin may be made use of for mounting-up purposes if trimming is not required.

To Coat Paper with Gelatine

There is no reason why the oil worker should coat his own paper : when there is such a splendid range of eminently suitable papers at his disposal, we think he is fastidious indeed if one or the other does not suit his purpose. There may, however, be times when he wishes to coat a very special kind of paper to secure certain effects and results, and should therefore know how best to do it. We cannot do better than quote Dr. A. R. F. Evershed, who has done a considerable amount of successful experimental work in connection with the process.

" To coat the paper with gelatine, take 6 grains of thymol, rub it in a mortar with 30 to 60 minims of alcohol (spirits of wine), and add this to 20 oz. of water in a wide-mouthed vessel ; then 1 oz. of Heinrich's or Nelson's gelatine is cut into shreds and put into the alcohol and water, the whole is allowed to stand for an hour or more, and then dissolved by the aid of a

water-bath, the temperature of which should not exceed 120° F., as otherwise the gelatine will be killed. When completely dissolved, the mixture should be filtered through a couple of thicknesses of Indian muslin, and the paper can then be coated ; and this is the most troublesome process. It should be conducted as follows : Have ready a piece of plate-glass, levelled by means of four screws screwed into the table, or by wedges, and test with spirit level ; another piece of glass (an old cleaned negative will answer) ; both these must be larger than the piece of paper it is desired to coat ; a dish larger than the glass, a 2-oz. measure, glass rod, and plenty of very hot water.

The papers recommended by Dr. Evershed were Smith's Royal Cartridge, at 1*d.* a sheet, or Steinbach's Water-colour paper or Turkey Mill H.P. (the latter two can be obtained at Reeve's depots at 2*d.* or 3*d.* a sheet) ; or Rives' Photographic, to be obtained at Fallowfield's at 4*s.* a quire.

Having cut the paper to size required, mark a " B " on the back of each corner, immerse it face downward in hot water in the dish, and remove all airbells, but under it first place the thin piece of glass, fill the measure with hot water, and in it put the glass rod ; now proceed

to warm through the plate glass, and then re-
place on the four screws ; empty the water out
of the measure, and in it pour some of the melted
gelatine (a sheet 12 in. by 10 in. requires about
6 drachms for a thick coating), and stand by the
fire ; then take the thin glass and lift it out of
the water with the paper on it, and put it on
the warmed plate-glass, both being allowed to
drain for a minute, being sure there is no air
imprisoned between the paper and glass ; now
take the measure and pour the gelatine in a
pool in the centre of the paper, and by means
of the glass rod guide it to the edges, at the
same time removing any air-bells or bits of
dust.

Let the gelatine set, and in about 15 minutes
the coated paper can be removed from the thin
glass and put on a level surface to dry ; now if
any gelatine has overflowed on the glass, in-
sinuate a palette-knife or similar article under
the paper all round to free it, and this may
require attention again ; in about three or four
hours the paper can be hung up to dry, but the
Rives' paper must be left lying flat on blotting-
paper, which is known by the paper curling in-
wards, and it can then be cut up if required
and stored ; it will keep indefinitely, the thymol
acting as a preservative.

Sensitisers and Sensitising

The best results are certainly not obtained by jumping about from one condition of things to another, and for this reason we suggest that Sensitisers and Sensitising be as simple as possible, and that the work be conducted upon a definite basis, especially for initial experiments. The sensitising of paper for the " Oil Process " with various strengths of bichromate of potassium or ammonium is not advocated; it is better to begin with one standard strength. The paper coated with gelatine may be sensitised, as in the carbon process, according to the quality of the negative; but by far the best plan, and one to be recommended, is,—Choose a reliable standard sensitiser and use it always, bearing in mind that very thin, weak negatives are bad for the production of good oil prints, no matter what sensitiser is used. Further remarks on the best type of negative to use appear on page 35.

A Standard Sensitiser

The following sensitiser can be regarded as the best for all-round work, and should be adopted as a standard for the oil-pigment process :

Take 1 oz. bichromate of ammonium, powder it well, and add to it 10 oz. of water. This makes a saturated solution. Always keep a few crystals of the salt at the bottom of the bottle, and add water as the bulk is reduced.

For use take 1 part of stock bichromate solution, and mix with 2 parts of methylated spirit, or, preferably, pure alcohol.

The method of application is described later, but care should be taken, when spirit is mixed with the sensitiser, that the two are well blended.

It is well to point out here that *potassium* bichromate is precipitated by alcohol, so cannot be used in a spirit sensitiser. In the case of the ammonium salt, the alcohol mixture does not keep well, therefore only just as much as is likely to be used should be mixed and applied as soon as possible.

Other Reliable Sensitisers

The following sensitisers are given as examples of the variations that are permissible in this part of the process, but the beginner is advised to adopt the standard formula above.

Mr. G. E. H. Rawlins recommends for the original Rawlins paper :

Potassium bichromate	. .	1 oz.
Water	20 ,,

For the " Pigmoil " paper, each piece is immersed in the following :

Potassium bichromate	. .	80 gr.
Potassium citrate	. . .	1 oz.
Citric acid	40 gr.
Water	10 oz.

The potassium citrate and the citric acid are dissolved together in part of the water, and added to the potassium bichromate which has been previously dissolved in the remainder of the water. The mixed solution keeps, provided the " used " solution is not returned to the bottle. The paper should be completely immersed in the solution for not less than two minutes, then hung up to dry in the dark.

M. Puyo insists upon a comparatively weak solution of bichromate of potassium or ammonium, not more than 2 or 3 per cent., for the floating method of sensitising, and a 6 per cent. solution

of ammonium bichromate with spirit for the brush method.

M. Demachy gives the following formula in the little booklet on the subject published by James A. Sinclair & Co., Haymarket:

"To cover six whole-plate sheets of double transfer paper, take 5 cubic centimetres ($1\frac{1}{2}$ drams) of ammonium bichromate 6 per cent. solution, and add 10 cubic centimetres (3 drams) of alcohol (90°). Pin a sheet of paper on your drawing-board by its four corners, dip the extremity of your flat hog's-hair brush in the alcoholic mixture, draw it once horizontally along the upper part of the sheet, and with rapid downward strokes gather the solution from the top streak and cover the whole sheet."

Dr. Evershed advocates a 5 per cent. solution of potassium bichromate for average negatives, and also the following:

A 10 per cent. solution of potassium bichromate is taken, and to each part one part of acetone is added; this is brushed over the paper quickly with a well-charged, wide camel-hair brush. No part should be gone over twice, as the solution dries very quickly. It may then be smoothed by stippling with a badger softener.

James A. Sinclair, F.R.P.S., finds the Bennett

sensitiser for carbon tissue answer well. The formula is :

Potassium bichromate	.	.	4 dr.
Citric acid 1 dr.
Water 25 oz.
Ammonia ·880	.	.	about 3 dr.

The potassium bichromate and citric acid are dissolved separately in hot water, the solutions mixed, and sufficient ammonia ·880 added to change the colour from red to lemon-yellow. It is imperative that the ammonia be added immediately after mixing the two solutions. The solution, if mixed as described, will keep indefinitely.

John H. Gear, F.R.P.S., advocates floating the paper for sensitising or brushing the mixture on. His sensitising solution consists of :

Bichromate of ammonium	.	100 gr.	
Carbonate of soda	.	.	10 ,,
Water	4 oz.

One part of this solution is mixed with two parts 90 per cent. alcohol. Care should be taken in sensitising not to allow the solution to get underneath or at the back of the paper. He advises a good margin, at least

one inch each way outside the border-line of the negative.

Messrs. Burroughs, Wellcome & Co. issue amongst their excellent series of " Tabloid " chemicals, one for sensitising carbon tissue : viz.—

" Tabloid " potassium ammonium chromate,
 gr. 24.

This is a preparation of the double chromate of potassium ammonium which simplifies the operation by obviating the necessity of using ammonia solution. It is a great convenience for those who only require it for occasional use. The makers issue the following instructions :—

" Tabloid " Potassium ammonium chromate,
 gr. 24 one
 Water 1 oz.

If printing from soft negatives, dissolve one " Tabloid " product in 2 oz. of water ; or if from very hard negatives, 1 in 6 dr. of water.

Sensitising the Paper

There are two methods of sensitising :
 (1) By immersion.
 (2) By coating or brushing on.

The latter method is certainly preferable. It is quicker, cleaner, and more certain, but paper sensitised by this method will not keep more than twenty-four to forty-eight hours, and it is advisable to use it as soon as possible. Paper that has been immersed keeps for three or four days, but in either case the best results are obtained with freshly sensitised paper— *i.e.* paper that is used as soon as it is dry after sensitising.

Sensitising may be conducted in weak daylight, but the wet sensitised paper should be immediately removed to a perfectly dark place to dry. Light and gas fumes should be avoided during the drying processes, and to avoid possibility of fogging the paper the beginner should conduct his sensitising operations in artificial light at first.

Sensitising by Immersion

A dish slightly larger than the print is filled to the depth of about an inch with the sensitising solution.

The paper is immersed face upwards, and kept under the solution, and free from air-bells, for two or three minutes; this will soften the gelatine and allow it to take up the sensitiser.

Drain the paper over the edge of the dish, or a glass rod, and pin up to dry. The drying takes several hours in an ordinary dark-room unless a spirit sensitiser is used.

Paper that has been sensitised by immersion may be assisted to more rapid drying by squeegeeing it on a plate of glass or zinc, to remove all surface moisture before hanging up to dry. It should be squeegeed film downwards. It is wise to make a pencil-mark on the *back* of the paper before sensitising by immersion, so as to easily distinguish one side from the other.

Sensitising by Coating

This method of sensitising is strongly advocated because the process is quicker; it is more satisfactory and economical, and also, after printing, the bichromate is easily and thoroughly washed out: this is an important point.

Sensitising by coating is performed by brushing the sensitiser over the surface of the paper, and for this purpose the formula containing alcohol is much the best, because of its rapid drying properties.

M. Puyo recommends a brush for this purpose, and the use afterwards of a goat's-hair

brush for softening; this equalises the coating. The following process, however, is strongly recommended:

Make up the standard spirit formula given above, or buy a 1s. bottle of the Autotype Company's "New Spirit Sensitiser." It is perfectly satisfactory for the purpose, and can be strongly recommended, as it keeps well, The beginner

FIG. 1.—THE BLANCHARD BRUSH.

needs the hands and mind to be as free as possible, and for this purpose alone it is worthy of consideration; even the experienced worker will find this ready-made solution invaluable to have at hand, especially if he is a " carbon " worker also, for he may then with the same solution prepare an odd sheet or two of tissue, if he so desires.

With each bottle of " Spirit Sensitiser " the Autotype Company send out a coating brush, which, although a good old-fashioned tool, may be new to many present-day pictorial workers. It is what is known as a " Blanchard Brush." It consists of a piece of glass, about $6\frac{1}{2}$ in. × $2\frac{1}{4}$ in. (an old half-plate negative cut down the centre would provide two), a piece of swandown calico or fluffless flannelette is wrapped over one end of it, and held in position by a rubber band. It is one of the best brushes that can be used for the purpose.

To coat paper for " oil " work, go into the dark-room, or a room illuminated by subdued daylight or artificial light, and take a clean quarter-plate dish which is quite dry. Pour into it a small quantity of the "Spirit Sensitiser," according to the quantity of paper you require to coat—say about 1 oz. for four 12 × 10 pieces.

Now take a piece of blotting-paper and put this on a drawing-board, or other such support, and with the aid of two " dark-room pins," fasten the piece of paper to be sensitised at the top. Now tilt up the dish of sensitiser so that the liquid is all at one end, dip the Blanchard brush into the solution, and taking up as much as the brush will carry, go rapidly over the paper

from top to bottom. The brush will coat it quite smoothly and evenly, and drying will commence almost before you can take the sensitised paper off the board. The illustration will indicate the method.

It is convenient to have a large cardboard box lined with blotting-paper, top to bottom. When the first piece is done, put it into the box

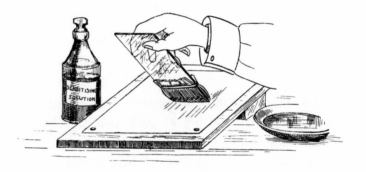

Fig. 2.—Sensitising Paper with the Blanchard Brush.

and go on with the second, and so on until all are ready; then pin some of them on the inside of the lid and others on the bottom of the box, and close it up. Or, the pieces of paper can be pinned up to dry in the dark-room or a dark cupboard.

The paper will dry in about ten minutes or less. In order to ensure it being " bone dry," place the pieces in a cardboard box for a little while

in a warm place—for instance, if convenient, on the oven-top of the cooking range—they are then in fine condition for work. At some periods of the year the dried paper will have a limp feel unless the room is warm, and if limp it does not work so satisfactorily.

By the drying method given above, paper has been sensitised, dried, printed, and the print placed in the washing water within an hour, even during the damp months of winter.

Printing

Printing from the negative on the bichromated paper is very similar to any other daylight process. A fairly strong negative should be chosen for initial experiments—such a negative as would give a good, bright P.O.P. print.

Almost any negative may be used if one fully understands the process, and various degrees of inks may be used to obtain hard or soft results at will; but this cannot be taught—it is the outcome of experience and practice with the brush.

The negative is placed in the frame, and paper ready sensitised and *bone-dry* is then placed in contact with it, as in ordinary printing. The

frame should be filled in artificial lights or very weak daylight. We must at once realise that the operation of printing is a fairly quick one. A bright diffused light is the best for the purpose, and in most months of the year an average negative may be printed in 5 to 10 minutes. An actinometer may, of course, be used, but is not absolutely necessary. The image is a " print-out " one, just as in Platinotype : a slight brown image appears on the yellow paper, and this image strengthens as the printing proceeds. How far to carry the printing is a matter that a few trial exposures will quickly teach, but the image should be printed well out, and details should be visible in the high lights before taking the paper out of the frame. Care should be taken not to expose the paper too much to daylight while inspecting the print, as it must be remembered that the paper is about four times as sensitive as ordinary P.O.P., and if slightly fogged, renders clean pigmenting difficult later.

It is recommended that a printing-frame larger than the negative be employed, so that printing-paper an inch larger each way may be used ; this excess of paper all round the print will be of great value when inking-up the print. When working on a piece of paper printed close

up to the edge, there is danger of the brush picking up moisture from the wet pad on which it is placed during the process of inking. This can be avoided by using paper larger than the negative.

If quite identical exposures are required, a print meter may be used, and the number of tints it colours be carefully registered. There is a slight continuing action of light, but it may not possibly alter the results of such an easily-controlled method as the oil process very much.

The prints should, however, be washed as soon after exposure as possible, and the continuing action is thus stopped. The endeavour should be made to secure the correct exposure if possible, and deal with the print as quickly as possible.

Washing the Print

Printing being finished, the print is removed from the frame and placed in water—preferably running water—the object being to remove all bichromate. The bulk of the yellow bichromate will be quickly washed out, and it is then necessary to leave the print in several changes of water for 30 minutes to 2 hours. It will be found that

brush-sensitised paper does not require so much time to wash, as the bichromate is chiefly in the gelatine, and but very little in the paper fibres.

Care must be taken that the paper is kept well under the water, and no air-bells form ; the bichromate must dissolve out evenly, and the gelatine image of the print must receive a generous soaking to give the desired relief.

The object of this soaking is to swell the gelatine image. The use of warm water for this purpose, although it does it very effectively, is not recommended, because the gelatine is affected and some of the delicate half-tones may be lost. Tepid water—about 75°—may, however, be used to hasten elimination of the bichromate, and the first washing should be conducted as quickly as possible. M. Demachy suggests the rapid bleaching of the image by the addition of a small quantity of bisulphide of soda to the third washing bath and rinsing thoroughly afterwards.

In hot weather a 3 per cent. or 5 per cent. bath of alum for 5 minutes will be of advantage. This should be soon after all traces of bichromate have been washed out, and the print should have, say, 20 minutes' soaking afterwards.

After removing the print from the washing-water, lay it face upwards on a pad of three or four thicknesses of saturated blotting-paper, or a pad of thick, well-washed butter-cloth, which holds the water well, and with a piece of clean, dry, fluffless blotting-paper or butter-muslin that has been boiled and well dried, remove the surface moisture from the print very quickly; or better still, take a pad of cotton-wool, enclosed in a clean, soft piece of linen or silk hand-kerchief, and form it into a ball, and with this take off the excess of water from the surface of the print. It will be seen that the image now stands out in clear relief, and this gives the print its foundation for the purpose of pigmenting.

Much of the image may appear to have been washed away, only the deepest shadows retaining their brown colour.

After washing, the prints may be dried and stored away, to be pigmented at some future time if desired. In this case the prints must be well and evenly soaked before proceeding with the pigmenting. This soaking should be for at least an hour in cold water. In very cold weather two hours will not be too much to bring the print into good condition for inking-up, and raising the temperature to 75° is recommended. The

application of warm water to the gelatine
image is, however, always attended with risk
in view of its softening effect, and the
vigorous brush action that follows when pig-
menting.

The temperature of the water in which the
print is washed, and the temperature of the
atmosphere of the room in which the damp
print is pigmented, are matters which undoubtedly
need attention. It has been found that prints
made in extremely cold weather, or washed in
very cold water, or pigmented in a room of low
temperature, give results that are much flatter
and lacking in contrast, when compared with
prints from the same negatives made under
warmer conditions of temperature. This point
should be remembered, and the operations of
washing and pigmenting should be conducted
with an average temperature of 65° if possible.
The effect of temperature may also be made
some use of as another factor in the control of
the print from certain negatives.

Brushes

The type of pigmenting brush best suited to the
oil and bromoil processes is that which is usually

described as the "stag-foot" brush. It has acquired this name, we assume, from its apparent similarity to the pedal extremity of the quadruped mentioned. This brush is illustrated in Fig. 3 (Nos. 1 and 2). They are mostly made in France, and are of fitch-hair ("the polecat" or "fitchet"). They were originally recommended by Messieurs Demachy and Puyo, and have now been universally adopted by all workers in oil.

M. Bullier, 5, Rue Charlot, Paris, supplies these brushes; but they are now obtainable in England from Messrs. Griffin of Kingsway, London, James A. Sinclair & Co., Haymarket, and Robersons, Long Acre, W.C.

Messrs. Griffin also supply "Rawlins" brushes, which are very well made and of first-class quality. They are made on the straight or flat-top principle, as in the illustration, No. 3.

Another form of this brush is the "Gradator." This is fitted with a sliding collar of metal, which adjusts the hardness or softness of the brush at will by permitting more or less of the hairs to be free for pigmenting. It is obtainable with either flat or askew top.

The "Prima" brush—a useful brush of soft hog-hair—is made by Griffins, and for starting pigmenting is very useful.

A very large brush, made of long and fine " Lyons " hair, shaped like the Fitch brushes, is supplied by both Sinclair and Robersons. It is specially designed for dealing with broad masses of colour and for inking up large prints expedi-

No. 1 No. 2 No. 3 No.4

FIG. 3.—BRUSHES.

tiously. At the same time it is capable of giving the finest texture. It has been named the " Mortimer " brush by Mr. Sinclair, and listed by him under that title.

Messrs. John B. Smith, of Hampstead Road, London, supply several useful brushes specially

designed for the oil-pigment processes; and Messrs. Miller & Co. of St. Thomas' Road, London, N., have also placed on the market a set of excellent brushes for the work. These are known as the " Salon " set, and include every useful shape.

The quality of the brushes employed for pigmenting is an important factor in the success of the results obtained. There is no doubt that the use of brushes of the best quality assists in the production of the finest prints. Good " Fitch " brushes of the type described are quite the best for all purposes. The hair is beautifully arranged in the manufacture, so that a firm dome-shaped surface is presented to the print when the pigment is dabbed on. It is also possible to do small and fine work with quite a large brush, provided that the brush is of good quality.

For a beginner, therefore, one or two of these Fitch brushes of fairly large size will amply equip him for most work. It is to the earnest worker's advantage, however, that he should possess a number of brushes, as it is easier and better to use a fresh clean brush as needed during the progress of pigmenting than to stop and clean the brush that has become fully charged with ink.

The "stag-foot" form of brush, being made with an oblique top, is much more suitable for working on an inclined surface as in the illustration on page 57 ; the hairs of the brush are then in the best position for work upon the paper, and the hand can take up a very natural and easy position ; it therefore facilitates the inking, and is much more satisfactory—in fact, most prominent workers would not think of attempting to make an oil print without it.

The following brushes are recommended, and should be obtained, if possible, if the worker is making prints at frequent intervals every week :

Two Stag-foot Fitch Brushes .	No. 14
Two ,, ,, ,, .	No. 10
Two ,, ,, ,, .	No. 7
One ,, ,, ,, .	No. 5

In addition to these one or two straight-top brushes, Nos. 10 and 5 ; a " Gradator " brush, and one or two small sizes in Fitch for detail work. For preliminary pigmenting and big work a " Prima " brush and a No. 3 " Mortimer " brush will be useful.

This set of brushes should equip the worker thoroughly for all types of prints, and will enable

him to lay down a brush if it has become too heavily charged for the effect he desires, and take up a clean one.

If, however, only one or two brushes can be afforded at the start, the best to get are the Fitch No. 14 and No. 10, with a smaller one for detail work.

A very fine and useful brush for " working " in fine high lights is what is known in the " process " world as a " Chinaman's pen." (See Fig. 3, No. 4.) Messrs. Penrose & Co. sell them under the title of the " Chinco " brush at 3*d*. and 4*d*. each ; they are drawn out to a fine point and are firm, yet the tip is most soft ; and they are the cheapest and best brush we know for stopping out defects, taking off small spaces of pigment, etc. They are set in bamboo, and have a protector of the same material. Sinclair and Griffins also supply this brush.

To Clean Brushes

Too much care cannot be taken with the brushes, not only because they are expensive, but because it very materially affects the quality of the work to be done with them.

After pigmenting they should not be left to become dry, but be immediately cleaned of all

ink and dirt. The best method of cleaning to be adopted is to pour a little petrol on a clean rag and rub the hairs of the brush on the rag. This will clean them admirably. If, however, the brushes have been allowed to get clogged, they need a thorough cleaning before use again. The petrol should be applied first and then the brushes washed in soap and water.

Take the brush in the hand and soap it well under the tap with a little water running upon it ; work it between the fingers, and then let the water wash away the dirty mass which is the result of soap and ink ; then re-soap again and leave a few moments whilst you clean up another brush, and so on until all have been roughly cleaned ; then go over each one and wash until all trace of ink is gone, and the washing water remains clear, surface-dry them on a clean towel, and hang up hair downwards in a warm room to dry.

Do not roughly handle the brushes whilst washing or put them out of shape ; when perfectly dry make a cone of white writing-paper and slip it over the brush, over this place a small elastic band—it will help the brush to go back to its original shape.

Mr. G. E. H. Rawlins, writing in *The Amateur Photographer* on the subject, says :—

" So much depends upon the condition of the brushes that it pays well to take care of them. Although they last a long time, they naturally deteriorate with use, and the washing " takes it out of them," even more than hopping and dabbing. It is therefore advisable to avoid washing them if possible. My plan is to wash my hands instead of my brushes ! I keep two or three old brushes for the heavy pigmenting and rough preliminary work, and these I wash as usual after use. To distinguish them from the rest I have stained their handles black. Their condition is not very vital, as they are never wanted for fine work, so washing does not affect them much. But for the gentle ' hopping ' work I keep all my best brushes ; and, as they never become heavily loaded with pigment, I find careful rubbing on an old print, and then on the palm of my hand, generally cleans them quite enough to make washing only an occasional necessity."

Inks and Pigments

The choice of inks or pigments is a most important one. Upon this subject there is a great difference of opinion. This to some extent is based upon the fact that the personal equation

in the process is so considerable that a general rule cannot be laid down. Some workers can produce a brilliant print with a soft ink, yet an equally good worker will produce a flat and lifeless result, and in spite of all endeavours cannot give the brilliance of the other worker from the same negative. This is brought about by the personal touch, as there are probably no two oil workers who pigment a print in the same manner.

The chief points about the selection of ink are that it should be of extra good quality, finely ground, and one that will dry in a reasonable time.

There is not much doubt that the practical pictorial worker in the oil process studies his inks very keenly; he makes no hard-and-fast rule as to their thickness, but uses his judgment as to what he requires in his final result.

It may be taken as a general rule that hard or thick inks give contrasts, and soft inks flatness. Warm-coloured inks give less contrasts than blacks.

The special inks made by Mr. Rawlins, and now sold commercially by Griffins of Kingsway, may be taken as excellent examples of the best consistency for general all-round work. These

THE CHALET.

Straight print. (See next page.)

p. 48]

THE SNOWSTORM.

Oil print from same negative as print on preceding page ; showing effect obtainable with slightly wet brush.

pigments are supplied in fine colours in tubes. The " engraving black " will be found to give print of fine tone and quality, and the ink is in the right condition for immediate use. Black is the best " colour " for most work, and generally suits every subject.

Robersons of Long Acre have recently put a series of special pigments on the market in handy form for the oil process, and their range of colours and undoubted high quality recommend them at once.

James A. Sinclair & Co. have also introduced " Sinclair's Permanent Inks " for the oil and Bromoil processes. These are made in a variety of colours, dry quickly, and are very brilliant in results. Both Sinclair's and Roberson's inks are supplied in a very stiff consistency, and have to be thinned for use by the addition of a very little " Roberson's Medium."

M. Demachy says on the subject of inks :

" My first experiments were made with Mr. Rawlins' Special Ink—a thick tacky sepia, that works very well ; but subsequent trials have convinced me that complete liberty of interpretation can only be reached by having at one's disposal several samples of ink of different thicknesses

4

and composition. I have often found it necessary to use locally, on the same print, two or three different inks of the same colour, but of various degrees of tackiness, according to the degree of stickiness of the different portions of the gelatine relief. One must have actually seen the contradictory effects of two samples of different ink on the same print in the proportions between oil and pigment. The general rule is as follows : Thick, tacky ink causes contrast ; fluid ink, such as ordinary oils, flatness. It follows that an over-exposed print will give a good image with thick ink, and no image at all with fluid ink, for it will ink all over—and *vice versa,* of course.

" This is why I insist on the necessity of having samples of ink handy for use on the same print, for it may happen—and it does often happen— that a false value, for which the negative is responsible, has to be toned down ; in other words, that some portion of the picture has been, from an artist's point of view, under-exposed. It must be treated accordingly, and dabbed with fluid or extra fluid ink, just as thick and tacky ink will have to be applied locally to portions that take too much pigment, and lose their modelling. Patient working with the same sort of ink chosen for the rest of the picture will not

produce equivalent results, as experience has proved. For extreme cases I can recommend a tube of ordinary oil colour to be used sparingly.

" I have come to the conclusion that all sorts of inks, except the non-dying lithographic transfer ink, can be of use—but that only two samples will meet the everyday requirements of the oil printer. These, for France, are represented by the " Encre Machine " and the " Encre Taille Douce "* of Valette's, both of which are quite free from turpentine. I use several other kinds of home and commercial manufacture, but only for special and rare occurrences. With an ink of the thickness of " Encre Machine " for fully exposed, and of " Taille Douce " for under-exposed portions of a picture, one can work for months without feeling the want of any other ink. The day that want makes itself apparent, a simple addition of cooked or pure linseed oil will be sufficient to convince the oil painter that he had better print another picture with the right exposure."

Other inks that can be employed for the process are " Photo Litho Black," made by Messrs.

* Both the " Encre Machine " and " Encre Taille Douce " can be obtained from J. A. Sinclair & Co., Haymarket, London, S.W.

Penrose ; and Litho Black and Sepia, Shades 1, 2 and 3, by Flemings. These are all good and ready for use.

The best collotype inks made by Messrs. Penrose can also be recommended, and if a very soft and smooth working pigment is wanted, Windsor & Newton's " Stiff " oil colours in tubes are useful. They are excellent for negatives giving very hard prints and if a picture in a low key, lacking in contrast, is wanted.

The beginner is advised to stick to one ink, such as Rawlins' or Sinclair's , and do all work with it until he has acquired a knowledge of the process and a " touch " that enables him to get the results he wants.

Pigmenting or Inking up the Print

We now arrive at the most important stage of the oil process, that of inking-up the print already prepared for the purpose. It is a stage that may be written down as purely individual and which really requires a practical lesson to demonstrate thoroughly.

We have all our own particular methods of controlling a negative in the developing dish— working on the film or glass side, as well as con-

trolling the print by various means to produce what is in our judgment a harmonious pictorial result. Now this indicates a wish to produce something that contains our own pictorial ideas apart from what mechanical means will give us, but we use photography as the main basis of the production.

The personal element is given greater opportunity in " oil " than in any other controllable process, and in pigmenting the print we have absolutely free control of our subject, bearing in mind the power of the consistency of the inks we are using.

To be practical and as brief as possible : After the print has been soaking for at least an hour it is taken and placed upon a pad of wet smooth blotting-paper. The best method of preparing this pigmenting pad is to take a sheet of plate-glass and use this as an easel upon the working desk. Upon the sheet of glass place three or four thicknesses of 80-lb. demy white blotting-paper or " Robosal " well soaked with water. Upon this spread a pad of two thicknesses of butter-muslin (that has been well boiled previously). This makes a good firm working surface.* Upon the muslin place the print,

* Messrs. Griffin of Kingsway now supply a pigmenting pad specially made in an enclosed metal case ready for use.

face upwards ; now take a piece of the blotting-paper and take off the excess of wet from the surface of the print. Do not make the surface too dry ; only take off the superfluous wet.

The print is now in a condition for receiving the ink. It will be noticed that the image stands out well in relief upon the surface of the wet gelatine, and many workers judge the character of their success from the appearance of the print at this stage. The greater the relief the more readily the ink will " take " in the preliminary pigmenting.

Now take a piece of clean glass or Bristol board (an old negative answers well), and at one side place some of the ink to be used ; a small quantity, about the size of a pea, will suffice for several 1/1 plate prints. Spread this out on the surface to about 1 to 2 inches square. The ink should be in a condition that can be worked about with the knife on the palette without much pressure.

For mixing up the ink, a stiff palette knife or old household knife should be used. Having spread the ink on the glass, a brush is taken and dabbed once or twice on it, so as to pick up some of the ink ; but before applying it to the print it is dabbed twice or three times on a clean

part of the palette to distribute the ink evenly over the brush.

The brush should be lightly held, and not gripped, between the thumb and the second finger, the first finger supporting the second and helping to guide the brush ; the third finger should be separated, and the fourth in the air,

FIG. 4.—INK AND PALETTE.

in the painter's method. The wrist should be bent, but quite free. The brush should not be held too near the hairs—a very general mistake with those who are not used to handling brushes. Any ink will seem harsh and unmanageable, if the print has not the sufficient exposure for that ink ; while if it has been properly exposed, however hard the ink, it will seem soft in use. The worker can thus feel at his finger ends, from the

very first, whether the composition of the ink is suitable.

It is always wise to start inking up with " hard ink," bearing in mind that we can always introduce any lower consistency of ink into our work as occasion requires, but it will be found very difficult to introduce a " hard " ink on a " soft " one, the tendency being to pick up the ink already deposited.

In our practice it is usual for us to have two consistencies of ink on the glass or ink palette, one of thick or normal consistency and the other thinned down somewhat with Roberson's Medium, linseed oil, or Meglip.

We have found that the colour of the blacks is much finer with linseed oil than with any other reducer we have tried, and the " oiliness " of the print is retained much better ; but Roberson's medium, supplied in tubes, is cleaner to use, and dries very rapidly.

The brush action of most workers varies considerably. Many take a slow kind of tickling or dragging action on the paper, whilst others just dab the brush lightly all over the print and build up the image in their own particular manner. A small amount of ink only is required at the commencement. When once the ink begins to " take "

and the image forms, go boldly to work and ink-up as quickly as possible, taking up more ink on the brush from the palette as the print requires. The best results are obtained by working boldly and finishing off the results quickly.

The beginner will now realise that the action of

the ink is to adhere to those parts of the picture which have been acted upon by the light, while other parts of the picture—the high lights— repel the ink on account of the gelatine being filled with moisture, to which the ink will not adhere.

The print must be kept moist from under- neath all the time pigmenting is proceeding.

If it becomes surface-dry, the pigment will adhere all over. (This at times may be taken advantage of when certain effects are desired.)

The beginner should start pigmenting with a light tapping action evenly all over the print, depositing the ink carefully and surely, and taking up more from the palette as required. It will be readily seen when more ink is wanted on the brush, as the empty brush will start lifting pigment instead of depositing it. Always re-start upon the print in the shadow part and gradually work towards the high lights.

If pigment is required to be removed or reduced, it will be found that quick light tapping or " hopping " with the brush will do what is required. A slower action, by which the brush is softly pressed on to the surface of the print, will deposit pigment, even in the high lights. If this action is continued with a soft ink it is possible to completely ink over the entire surface of the print to a uniform tint. A quick bouncing or hopping action of the brush will then " clean " up the high lights and shadows and bring out the picture again. One is to use gentleness rather than violence when pigmenting a print. Under the influence of a gentle perseverance the print will take up the ink ; if one is violent it refuses

to do so. Most of the beginner's difficulties are brought about by too much vigour and roughness in handling the brush, or by impatience at not getting a finished and perfect result immediately.

A sweeping or dragging action of the brush upon the almost finished print gives a touch of brightness very often to the lights, and at the same time the shadows are helped. This " sweeping " action can be effectively employed to " intensify " a somewhat flat or weak print—one that has been made from a flat negative or has been over-exposed. The best method of " sweeping " is to hold the brush by the end of the handle almost vertically over the print and gently " swish " or " sweep " lightly across the surface. It must be the merest touch—just a flick and no more. The high lights will be cleaned up in a remarkable way by this method and the shadows gain in strength by contrast.

The brush needs cleaning immediately after, as it will frequently evince a tendency to deposit the colour it has swept up in ugly patches on undesirable places.

The outline and general form of the picture having been built up by carefully going all over the print with gentle dabbing and hard ink, the broader shadows are inked in with a well-charged

brush—still using the hard ink. This ink can
be used until the picture is fairly well developed
and most of the shadows as strong as desired.
If to the ink on the palette a *very* little Roberson's
Medium or linseed oil is added, and the mixture
well kneaded and spread about with the palette
knife, it will be found that when the brush
applies the softer variety the print will take
the ink more evenly all over its surface. Care
must now be taken not to entirely close up
the finer details, which may well occur if the
ink is too soft.

Vigorous " hopping " will then have to be
resorted to, to clear the print again.

The hopping action with the brush is one that
comes instinctively to many workers. It consists
in gently dropping the brush square on to the
pigmented portion that requires clearing, and
catching the brush as it " bounces " up again.
The brush is never dropped or " thrown " from
a greater distance than about 2 in. from the
paper, and after a little practice it is possible
to repeat the action with great rapidity and
certainty. It is a method of treatment, how-
ever, that should be avoided, as the desired effect
should be obtained, if possible, by building
up, and the hopping action only used as a
corrective.

Experience shows that a print with reserved whites looks infinitely better than one the whites of which have been produced by removal. But in the darker portions of the print the use of the hopping action often becomes a necessity. There are half tones and shadow details that

FIG. 6.—POSITION OF BRUSH FOR "HOPPING."

it may not be possible to reserve. They will have to be inked over and picked out by "hopping."

The less a print is worked on, the better it will be.

As the picture is but slightly visible at first, it will be found of service to have at hand an

ordinary " straight " bromide or P.O.P. print—
the latter need be only lightly printed—fixed
and rinsed. Such a straight print not only
is a great help in showing one all the drawing
of one picture, but also it is a useful aid
as a restrainer, preventing one dabbing about
indiscriminately.

We have found that the average worker in oil
generally succeeds in obtaining prints at first
that do not do the process justice. The results
are dirty, and the picture has a spottiness that
appears difficult to obviate in some workers'
hands. The smooth, velvety texture that should
be the standard of a good oil print is generally
missing, although the pigmenting has been other-
wise conducted perfectly. We have heard the
expression " creamy " applied to the appearance
of a really good oil print that has been produced
with due regard to the possibilities of the pigment,
and with less regard for the " grainy " texture
that appears to be inevitable when some workers
use a brush.

The fine texture can only be secured by
practice, and the beginner need not despair
because he fails to get a perfect print at the
first attempt.

One of the chief causes for uneven or degraded
texture that occurs with the beginner is the

drying of the print during pigmenting. The paper *must* be kept in the right condition of moisture for pigmenting, or the results will be unsatisfactory.

A corner of the print should be lifted occasionally during pigmenting, and the under side should appear quite wet. If this is not so, the print should be lifted entirely from the pad, placed on a sheet of clean blotting-paper, and the pad should be well wetted again by pouring a little water all over it. Sometimes the print is allowed to get so dry that it curls up from the pad. In this case the best plan is to float it for a minute or two on the surface of a developing-dish full of water. The paper will quickly absorb sufficient moisture to put it in working condition again, when it can be replaced on the pad—which should also be re-wetted, and pigmenting can be continued.

Brush action can be assisted somewhat by the use of a spring handle for holding the brush. Messrs. Griffin supply an arrangement of stiff wire that holds the brush in a vertical position at one end and allows the other end—the wire is about 10 in. long—to be held in the fingers, and the " play " of the stiff wire handle gives a " tapping " action to the brush. Similar holders can easily be constructed by ingenious

workers, and are principally designed to save fatigue to the muscles of the forearm.*

The control that the oil-pigment process places in the hands of the pictorial worker enables a pleasing result to be frequently obtained from the most unpromising negative, and in a manner that probably no other process could attempt.

With the " pilot print " before him, the worker should make his mind up as to the parts that require accentuating, and the high lights that need suppressing. The first general inking up then gives a working outline, and progress should then be quite straightforward.

It is useful, sometimes, to make a matt surface pilot print—say on bromide or gaslight paper—and with a soft pencil or charcoal and stump go over the composition, subduing portions here and there, strengthening shadows where needed, and generally pulling the masses together.

If it is a portrait, the background may be treated, or the high lights of the collar or hands may be reduced, but in any case it becomes much easier to make a satisfactory oil print with

* Since writing the above, James A. Sinclair & Co. have introduced an improved form of brush-holder to facilitate pigmenting.

AWAY ALOFT.

The straight print. (See next page for controlled oil print from same negative.)

p. 64]

AWAY ALOFT.

Bromoil print from same negative (see preceding page). *Note alterations in tones and accentuation of masses.*

greater decision with the pilot print treated in this fashion before one, than when working at the print without a guide of any sort beyond a sustained idea of the result as you think it ought to be.

It has been said that the clouds of many oil prints are either conspicuous by their absence, or bear strong evidence of being hand-made, and we must say there is much truth in the statement. Yet there is no reason for this : clouds may be " printed in " just as in any other process, and can be inked-up just as delicately or as vigorously as may be desired ; and they 'are certainly more truthful and artistic than any " home-made " clouds we have seen.

Over-Exposure, Correct Exposure, Under-Exposure

These three conditions are likely to be encountered, and they can be easily recognised and treated accordingly.

In the first, under the influence of a light tapping the ink takes everywhere ; with every touch of the brush the shadows take on more ink and darken very rapidly, losing all gradation. At the same time the high lights darken to a

5

half-tone. Dabbing in the way described has
no effect ; instead of removing ink, it seems to
make it adhere more strongly. These signs
indicate that the print is over-exposed. Hard
ink must be used for the pigmenting, and
hopping resorted to, to keep the lights clear.
The " sweeping " action already described
must also be attempted, and as much of
the pigment on the high lights brushed off
as possible.

In the second case, we may find that under
the tapping strokes the part selected for the
test progressively inks-up and the normal con-
trasts make their appearance. This shows that
the print is correctly exposed for the hard ink,
and all one has to do is to go on inking-up
with that. This is certainly the best result
to get, as it gives the greatest freedom to
the photographer for modifying his treat-
ment in different parts. One should always
try for the exposure that will give this
result.

In the third case (under-exposure), the print
only " takes " the ink with difficulty. In spite
of repeated tapping and dabbing, the shadows
will not darken, and the highest lights and lighter
half-tones make no appearance. If the tapping
is a little harder, the shadows lighten and the

half-tones become granular. The appearance of
a coarse grain under the brush, which cannot
be made finer, is always an indication that the
print is insufficiently exposed for the particular
ink in use. Dabbing immediately weakens the
tone.

These signs show that the print has not had
enough exposure for the hard ink, and this must
therefore be thinned with a little Roberson's
Medium or oil. The addition should be done little
by little, so as not to exceed the exact degree of
softness that suits the exposure. In fact, it
is better to use an ink a little too hard rather
than one too soft, as the latter has the effect
of over-exposure and tends to flatten the result.
Besides, the softening action is very marked.
A mere spot of medium or oil, such as can be
taken up on the end of a match, quite trans-
forms the hard ink. If the first addition is
insufficient for the purpose, add some more.
After one or two such additions we shall
feel that the resistance of the ink ceases. The
shadows under a light tapping stroke gradually
darken in tone, and the half-tones gradually
take on a delicate modelling. This shows
that the ink is suitable, and work with it is
continued.

One general principle has already been enun-

ciated—viz., that the tones should be gradually built up by successive additions, rather than that we should have to remove an excess of ink. Another is that it is advisable, after bringing out any particular part, to build up its gradations almost as far as necessary before passing on to a fresh part.

The whole picture may be divided into the centre of interest and the subordinate parts. It is in the first-named always that the strongest accents and the clearest details are to be found ; in the second, the different elements are subordinated or sacrificed. Hence the importance of the rule. In the progress of inking, the centre of interest should always be a stage in advance of the rest.

Removing the Pigment

A soft sponge and cold or slightly tepid water will remove the whole of the pigment from the print if a mistake has been made that cannot be easily corrected without starting afresh. This, of course, only applies if the pigment has not had time to dry. If the pigment has been applied thickly, petrol will be necessary to remove it. The surface of the print can then be finally

cleaned with plain water and a soft sponge, taking great care not to abrade the surface. The print should of course be well soaked again before starting to re-pigment, and it is safer to let it dry totally before soaking it anew—to avoid unequal swelling of the gelatine.

The points to remember when pigmenting are :

Much ink will be deposited if (1) the image is nearly dry ; (2) the dabbing is heavy and slow ; (3) the pigment is fine and the brush well charged ; (4) the temperature of the air is high ; (5) the print has been over-exposed.

Little ink will be deposited if (1) the image is very moist ; (2) the dabbing is light and quick ; (3) the pigment is stiff and the brush comparatively clean ; (4) the temperature of the air is low ; (5) the print has been under-exposed.

After Treatment

When the pigmenting has been satisfactorily accomplished the print must be hung up to dry in a place free from dust, or it may be laid on a sheet of clean blotting-paper in the bottom of a box or drawer, or pinned by the four corners on

a board and placed near a stove, when it will dry
very rapidly. In the ordinary way the paper
and gelatine will dry in 1 to 3 hours according
to the hygroscopic condition of the surrounding
atmosphere, and the ink in about 24 hours, or less
in warm weather. Heavily pigmented prints, of
course, take longer to dry than those in which
the pigment is very slight.

When dry, the first thing to do is to clean up
the surface of the print. It will be found that in
spite of every precaution a certain amount of fluff,
small hairs and other foreign matter, has found
its way on to the surface of the print while
pigmenting or drying. No attempt should
be made to remove this until the surface is
dry.

When quite dry, it will frequently be found that
lightly " dusting " the surface with a clean brush
—a pigmenting brush answers admirably—will
entirely remove the specks and bits of fluff, etc.,
that were adhering. A soft cloth may even be
applied, and gentle rubbing resorted to. In the
case of hairs embedded in the pigment, a small
lancet, or fine-pointed knife will generally
serve to lift these out. Care must be taken,
and a steady hand is needed so that no mark
remains.

A needle mounted in a wooden penholder

makes a handy tool for picking off these atoms of foreign matter. Another method that has been suggested is to place the dry print face downwards in water at a temperature not exceeding 70° in a deep dish. In about half an hour, after occasionally rocking the dish, the fluff and dirt will wash off and drop to the bottom of the dish. The print can then be pinned up to dry again. When the fluff and specks have been removed, and the print is perfectly dry, it can be straightened out flat by passing a flat-edged ruler over the back. This should be done on a sheet of clean glass, and the ruler should be drawn over the back of the print—*not* the print pulled under the ruler—or the surface may get damaged.

High lights can now be touched up with a pointed piece of rubber, or very fine points of light can be accentuated with a sharp scalpel or penknife. The sharpened nibs sold for print trimming make excellent retouching knives. (*See* Fig. 7.) A piece of soft rubber will work wonders in capable hands at this stage of the print's life, and many of the tone

Fig. 7.

values can be greatly assisted if it is found necessary. The retouching should not be overdone, as the tendency to introduce many points of light will probably disturb the concentration

of the subject which has been achieved in the pigmenting.

Spots may be touched out carefully with a little of the original pigment; but large spaces should be touched in this manner very carefully indeed, or the newly applied pigment will dry with a different texture and betray itself at once.

The appearance of oil prints—especially those in which heavy shadows appear—may be enhanced by varnishing. "Vernis Retoucher," supplied by Robersons or Sinclair, is the best for the purpose. This is an exceedingly fluid petroleum varnish. It is applied rapidly to the print with a broad camel-hair varnish brush, and dries almost immediately.

Mounting the oil print is easily conducted, but it is always wise to keep a sheet of tissue paper in front of it to avoid abrasion.

The best method of mounting is to trim the dry print and affix it by the corners only or the top edge to the required position on the mount. It may, however, be pasted all over the back, but is difficult to rub down satisfactorily, as there is always the risk of injury unless the pigment is some weeks old and absolutely hard.

Dry mounting can be recommended also if the

pigment is quite hard, but do *not* attempt this form of mounting with a print pigmented within 24 hours. The heat of the mounting process will probably remove the greater portion of the pigment.

FAILURES IN THE OIL PROCESS

For the benefit of beginners a useful Table of Points in connection with the Oil-pigment Process is appended. The various points have been tabulated by Dr. A. R. F. Evershed. Many of the points also apply to the Bromoil process.

FAULTS.	CAUSES.	REMEDIES.
1. Pigment refuses to adhere ..	(a) Underprinted image . . . (b) Too stiff a pigment . . . (c) Too rapid a brush action . .	(a) Print deeper. (b) Thin pigment with megilp. (c) Obvious.
2. The pigment, after first adhering, comes away in small irregular spots.	(a) Too rapid and uneven a brush action. (b) The gelatine has blistered . (c) Some foreign body on brush . (d) Some defect in the gelatine coating.	(a) Obvious. (b) Burn the print. (c) Clean the brush. (d) Generally met with in papers not specially prepared for the process. Use different.
3. The pigment adheres all over, both high lights and shadows.	(a) Printing on the non-gelatine surface (b) Unsuitable negative, viz. too thin (c) Washing water too hard . (d) Overprinted image . . (e) Insufficient soaking . (f) Too thin a pigment . .	(a) Obvious. (b) Intensify the negative (c) Boil the water and allow to cool. (d) Do not print so deeply. (e) Soak two or three times as long, up to six hours. (f) Spread a thin film out, and allow the excipient to evaporate.

3 The pigment adheres all over, both high lights and shadows.	(g) Brush too heavily charged with pigment.	(g) Obvious.
	(h) Brush action too slow	(h) Obvious.
	(k) Deterioration of gelatine, due to (i) too long a soaking, (ii) the use of hot water, or (iii) formation of bacteria.	(k) (i) Throw print away; (ii) ditto; (iii) ditto.
	(l) Drying of print whilst pigmenting	(l) Re-soak or re-damp blotting-paper pad.
4. Circular spots, refusing to take pigment.	(a) Formation of air-bells in sensitising bath.	(a) Brush paper whilst in bath.
	(b) The brush has picked up some moisture.	(b) Press brush on clean dry blotting-paper, and press another piece on the spots.
5. Circular spots, taking pigment more freely than other parts of image.	(a) Formation of air-bells between surface of gelatine and water whilst soaking.	(a) Turn prints two or three times over and remove air-bells when first put into water.
	(b) Puncturing of gelatine	(b) Destroy print.
6. Pigment adheres in streaks	Unskilled sensitising with brush	Sensitise in future by immersion.
7. Pigment is deposited as if "peppered" on to the image.	Brush has become clogged	Clean brush by rubbing on a piece of clean old P.O.P. or bromide paper.
8. Pigment deposited in irregular areas after soaking during pigmenting.	Print has not been put into the water face downward and all the imprisoned air between the surface of the print and water displaced.	Obvious.
9. Image pigments up as a negative instead of a positive.	Unknown	Continue pigmenting, and the reversal may disappear.

THE BROMOIL PROCESS

As briefly mentioned in the introduction to this book, the Bromoil process is analogous to the oil-pigment process inasmuch as it depends upon the distinctive action of swollen gelatine towards greasy ink ; but in this case, instead of being brought about by the action of light on a bichromate salt in the gelatine, the selective image that repels or attracts the ink has been produced by chemical action on a silver image already formed in bromide paper. The selective action is in direct ratio to the original image; and in the final Bromoil print— provided the pigmenting has been straightforward —the result is a picture in oil pigment that has replaced the silver image of the bromide print. The enormous advantages that the Bromoil process places in the hands of the worker who desires to make large prints, but who has not the time or inclination to make the enlarged negatives which are necessary for the direct oil process, are obvious.

What can be more simple than the production of a bromide enlargement, drying it and treating it with three simple baths, when it becomes practically the basis for an oil print ready for pigmenting? It is the ideal winter or evening process, as the entire procedure can be carried out by artificial light, and quite as much control is placed in our hands as with " oil " printing.

The Bromide Print

The quality of the bromide print which is to be converted into the Bromoil print is deserving of careful attention. The best print for the purpose is the one that is specially prepared for Bromoil work, but as this means as good a bromide print as the negative will give, there is no reason why good prints or enlargements should not always be made.

The print should receive *correct* exposure, and should be fully developed in a dilute amidol or metol-hydroquinone developer. The dilution of the normal developer with an equal amount of water slows the action, and allows an apparent evenness and richness of deposit to build up that does not appear to obtain when a quick-acting concentrated developer is employed. The character of

the print appears different, even when made from the same negative and given the same exposure. There is no doubt, however, that a bromide print made in this way and fully developed to obtain a full, rich, and plucky image, is ideal for making a Bromoil print.

The tone of the print for Bromoil work should be blacker than would be quite correct for a good bromide print, but the shadows should not be flattened by over-exposure. The fixing bath should be a neutral one. The acid fixing bath appears to harden the film to such an extent that uneven bleaching or inability to properly pigment results.

It is also possible to entirely omit the fixing bath at this stage, and considerable time is saved. The developer must be well washed out, however, before bleaching. This method is not so certain as when the developed print is fixed, washed, and dried in the usual manner.

Smooth matt papers are the best for pigmenting. Rough-surface papers are never altogether successful. Any of the best-known brands of bromide paper will yield good Bromoil prints, but a bromide paper with a specially prepared emulsion calculated to withstand the rough treatment of vigorous pigmenting and also to give bright prints has now been prepared by Messrs. Griffin of Kingsway,

under the title of " Bromoil " paper. This costs no more than the ordinary bromide paper, and is an excellent paper in every way.

The prints should be freshly made. Prints that have been made for some time, and allowed to get hard, are difficult to deal with. The best method of treating such a print, provided another cannot be made to replace it, is to soak it in water not lower in temperature than 65° for 4 or 5 hours. It is then taken out and hung up to dry. When dry it may be treated in the same manner as a freshly made print, and may give the same result.

Bleaching the Print

The original bleaching solution for Bromoils suggested in *The Photographic News* by Mr. C. Welborne Piper was as follows :

" Ozobrome " stock solution . . 4 parts
10 per cent. potash alum solution 4 ,,
10 per cent. citric acid solution . 1 part
Water to make 20 parts

The print was placed in this until the image bleached out or turned a faint brown colour. The action of this bath is somewhat rapid, and the solution becomes exhausted fairly soon. The

best results are obtained when the *dry* print is placed straight into the bleaching bath and allowed to soak until evenly bleached and quite limp. Messrs. Griffin have placed upon the market a special " Bromoil " solution that needs only the addition of water for immediate use. The formula is :

Bromoil solution (No. 1 and No. 2)　　1 part of each
Water　　.　　.　　.　　.　　.　　2 parts

This diluted solution should be kept in a well-corked amber bottle or in the dark, and replenished from time to time with a little fresh stock Bromoil solution mixed in the above proportion. It may then be used repeatedly until exhausted.

In this solution the image takes about three minutes to completely bleach out. The effect of this becomes apparent when pigmenting. The constituents of the solution enable a very strong and vigorous image to be built up with great rapidity. The slow action of the solution appears to increase the relief and bring the image into a more receptive condition for pigmenting.

In a little booklet on the oil and bromoil processes previously referred to, and published by James A. Sinclair & Co., C. H. Hewitt, F.R.P.S.,

gives the following formula for a bleacher for Bromoil prints :—

Potass. bichromate . . .	2 dr.
Potass. bromide . . .	1 ,,
Potass. ferricyanide . . .	1 ,,
Alum	4 ,,
Citric acid	1 ,,
Water, distilled, up to . .	10 oz.

This solution should be mixed fairly freshly.

Mr. Hewitt suggests that with this formula the bromide print should be soaked in cold water until limp, the water being carefully drained off again and the solution applied so that the action commences evenly. Bleaching is complete in a minute or two.

The Acid Bath

A brief rinse in running water or a couple of changes in clean water should follow the bleaching, and the print, now practically free from yellow stain, is immersed in an acid bath composed as follows :

Water	1 pint
Pure sulphuric acid . . .	1 oz.

When making up this solution add the acid to the water, and not *vice versa*, or sufficient heat will

6

be generated to break the bottle or measure. In any case do not use the acid bath until it is of normal temperature—*i.e.* 65°. It may be readily cooled by allowing cold water to run on to the bottle containing the solution. The print should be allowed to stay in the acid bath for about six minutes—longer in cold weather, or for less time in warm weather. By passing the finger-tips over the surface of the print while in this bath, a distinct relief will be felt. This will be particularly the case at the margins of the print if there is a clear mark of the printing-frame rabbet.

At the expiration of six minutes the print should be removed, and the image should be visible in faint relief if the subject is one containing contrasts.

The acid bath rapidly becomes inoperative, and should be thrown away as soon as it becomes decidedly yellow in colour.

The Fixing Bath

The print is again washed for two or three minutes, and then fixed for one minute in—

Hyposulphite of soda .	.	. 2 oz.
Sodium sulphite $\frac{1}{2}$,,
Water 20 ,,

This bath practically removes all trace of the silver image and leaves the paper almost blank. The proportions of hypo given above should not be exceeded, or blistering may occur. Blistering may also occur if the fixing bath is too freshly made, and is in consequence very cold. All solutions for the Bromoil process should be of about an equal temperature—say 65°—if the best results are wanted. If this bath is not used the pigmenting may still be done, but there is a danger of the silver image remaining in the film blackening on exposure to light, and the tones of the final print would be affected. If necessary, however, the unfixed image can be redeveloped with amidol or sodium sulphite and the pigment applied on top of the redeveloped image.

The whole of the bleaching and fixing operation can be conducted in broad daylight.

After fixing, the print is washed for five minutes, and is then ready for pigmenting, or it can be dried and put away for future use. In this case it will need to be soaked for at least an hour before the image will be in the best condition for pigmenting.

In cold weather care must be taken to ensure that the washing waters and also the fixing bath are not below about 65° temperature, or there will be difficulty in pigmenting and " flat "

prints will be obtained. Cold water applied after the acid bath is a common cause of failure, while other causes are the use of the bleaching bath and of the acid bath for too many prints in succession.

An inspection of the print when it is ready for pigmenting will enable one to tell very accurately whether it is in proper condition or not.

If correct, the image will be slightly coloured and also glossy, while the rest of the print will be white and matt. The effect varies slightly with the kind of paper used.

If the print shows too much matt surface, or a want of detail, the bleaching bath is exhausted, but if the print is glossy all over the acid bath is overworked.

Generally the image will be seen to be in sunk relief, or intaglio, but the degree of relief is not of any consequence. It appears to depend mainly on the thickness of the paper and smoothness of the surface. With a thin rough paper little or no relief is produced, but the image will pigment just as readily as one in strong intaglio.

In hot weather, or if a sample of bromide paper is used of which the gelatine is too soft to stand much brush-work, a method of hardening the film, suggested by Mr. T. H. Greenall in

The Amateur Photographer, should prove useful. The bromide paper is bathed in a hardening solution *before* exposure.

The bath, which will keep and may be used repeatedly, consists of 50 minims of 40 per cent. formalin dissolved in 5 ounces of ordinary mineralised (methylated) spirit. The time of immersion is half a minute, and the paper is then pinned up to dry. Of course several sheets may be hardened at one operation, and the work must, of course, be done in the dark-room. It appears necessary to use the formalin *before* making the silver print, and not at later stages.

Pigmenting

The print, after leaving the washing water, is placed on a wet pad of blotting-paper in the same manner as a direct oil print. The surface of the print is mopped with blotting-paper or butter-muslin in the same manner, and the pigment is applied with the same action.

The method of inking is, however, a little different in the case of Bromoil prints. Here the best procedure is to apply the ink at first in a fairly stiff condition in all cases. This will pigment up the general outline and form of the

picture in solid colour. The ink can be applied boldly, but not roughly, with a large brush, and the surface covered as expeditiously as possible. When the image is thus well pigmented, the second part of the treatment commences with a more fluid ink.

The first ink can be softened with Roberson's Medium, or an ink of a different shade can be applied ; but this latter must be done carefully, or results not altogether satisfactory will appear. A thin sepia coating may be, for instance, applied over a black or blue-black colour, or burnt sienna over sepia or burnt umber. The second application is made with a quiet " smudging " action of the brush, and the colour applied very sparingly. Only just sufficient is necessary to soften down the hardness of the first application and to produce a velvet-like texture.

Half-tones can be readily lightened by dabbing with a nearly dry brush, but shadows can only be softened slightly, and turpentine or benzole is necessary for their removal. Detailed high lights, if over-pigmented, should be cleaned right off with wet cotton wool or a wet brush, and can then be re-pigmented. A dry brush will lighten them, but at the expense of their brilliancy.

The texture of the paper should be chosen to

suit the subject, and glossy papers avoided always, but very rough bromide papers do not appear to take the pigment well.

The after treatment of Bromoil prints is practically the same as that described for oil prints.

For spotting purposes it is a good plan, when pigmenting in a " made " colour, to dab a fairly thick patch of it on to the margin of the print. This is cut off when the print is trimmed and cleaned up, and if any portion needs retouching a little medium applied to the patch of colour will soften it sufficiently to give a small supply and afford an exact match for the print.

Some Experiments in Bromoil

A process of utilising the redeveloped image of the bromide print in which the rationale of the Bromoil process is followed in order to varnish the shadows of the picture was described in *The Amateur Photographer* for December 10, 1907.

The print is bleached by the method previously described, well washed, and then either treated with sulphide solution, as in ordinary sulphide toning, or redeveloped, in which case the final

image will be black. The sulphiding solution
consists of—

 10 per cent. sodium sulphide . 25 mm.
 Hydrochloric acid (1 in 5) . 5 ,,
 Water 2 oz.

Note.—The hydrochloric acid must be added at
the last moment before using, and fresh solution
mixed each time.

The alternative redeveloping solution must be
fresh, and consist of—

 Amidol 2 gr.
 Sodium sulphite . . . 20 ,,
 Water 1 oz.

After either sulphiding or redeveloping, the print
is just rinsed and then placed in sulphuric acid,
diluted, 1 oz. in 20 oz. of water, as in the Bromoil
process. In this bath the print is allowed to
soak for twenty minutes or longer, and is then
washed for ten or twenty minutes and dried ;
or it may be taken at once for varnishing.

To Apply the Varnish.—Have ready a moist
pad, consisting of several layers of wet paper
placed on a sheet of glass, and on this place the
print previously soaked in water. The varnish
consists of a few drops of Japan gold size and
a touch (about one-fifth the quantity) of raw

linseed oil, and should be mixed with an old
table-knife on a piece of glass. Now take a china
painter's dabber, which is a soft camel-hair
brush, closer and more velvety than a mop, and
press it on the layer of varnish, afterwards
dabbing it once or twice on a clean part of the
glass, and proceed to apply the varnish to the
print.

It will be found that the highest lights resist
the varnish and remain perfectly matt, whilst
the shadows take on extra richness in proportion
to their depth. In a large print a part only may
be worked on at once. The operation must
be complete before the varnish dries, but should
this occur before the high lights are clear, it is
only necessary to gently wash the print with
soap and water, or with a soft rag moistened
with paraffin, followed by soap and water.

Further notes by Mr. Greenall in a subsequent
issue of *The Amateur Photographer* described a
method of adding pigment to the gold size and
so obtaining an oil print on top of the redeveloped
bromide print.

The bromide print is bleached in the usual
manner, and is then just rinsed and put straight
into the sulphuric acid bath, where it remains
twenty minutes or longer, and then into a fixing
bath composed of hypo 4 oz., sulphite of soda

1 oz., water 20 oz. A few minutes' fixing is
sufficient, and after half an hour's washing the
print is ready, or it may be dried and used at any
future time after soaking in water. No washing
is required between the bleaching and sulphuric
acid, because in this case any reduction due to
chromic acid is of no importance, but if the
print were a toned bromide intended for glazing,
it must be washed an hour before putting in the
sulphuric acid, which must also be fresh, or there
will be loss of half-tone.

The process of pigmenting is similar to the
direct oil process.

Any powder colour may be used for preparing
the pigment, but it must be fine. Paint-shop
colours are too gritty except for large work.
The smoke from a small lamp burning turpentine,
if caught on the palette, or better on a 12 by 10
enamelled iron developing tray, will give a very
pleasing black. The powder is made into a stiff
paste with the least possible quantity of Japan
gold size, and is then placed in a small covered
tin. For use a little about half the size of a pea
(for a 10 by 8 print) is spread out on the palette,
with one drop of a mixture of one part raw lin-
seed oil and two parts common benzoline. The
benzoline quickly evaporates when the paste is
spread out, and is only used to dilute the oil.

If the paste was originally stiff, it may mean another drop of the medium before it will touch even the shadows, but it is best to keep on the hard side and soften very cautiously. At a certain moment you will get a pigment which will give all the tones and leave the whites clear, which is what you require. Should extra brilliancy or more vigour be necessary, add one drop of the gold size and less of the oil; but the brush should remain clean, and if you make a mistake, simply wipe off the picture with a rag moistened with benzoline, wash the print with soap and water, and start afresh. This may be done even after the print is dry.

Winsor & Newton's powder colours can be used with success. A mixture of about equal parts of vandyke brown and black with a little Indian red works satisfactorily, as also does black and burnt sienna. Black alone takes the least size, and is the easiest to work. With the browns it may be necessary to " sweep " the print once or twice with a badger softener to get contrast before finally putting in the half-tone.

The Ozobrome-Oil Process

This process, which should prove of considerable advantage to workers in the oil-pigment

and Bromoil processes, enables the operator to obtain any number of oil prints from a single bromide (or gaslight) print. It was first described by J. Parrack, in *The Amateur Photographer* for May 12, 1908.

In practice it is a combination of the ozobrome process and oil printing. The bromide print is prepared in the same way as for ozobrome.

Place the bromide print in clean, cold water. Next take a piece of oil-pigment paper (or any other paper suitable for oil printing) and wet it in cold water. Then place it in dilute ozobrome solution, made by adding four parts of water to one part of concentrated solution. Allow the paper to remain in the solution two minutes. Lift it out and drain off the superfluous solution. Now draw the paper through clean water and bring it into contact with the bromide print. Take the two papers out and squeegee them into close contact. Leave for about twenty minutes. When this time has elapsed place the prints in cold water and separate.

So far the working has been the same as in the ozobrome process, except that instead of pigment plaster oil-pigment paper has been used. The rest of the operation is the same as in oil printing.

Wash the paper to get rid of the ozobrome solution. Place the paper on the wet blotting-pad, surface-dry, and pigment as in oil printing.

The bromide print should be washed, and then may be developed up with any suitable developer. It is then dried and kept for further use.

The oil print will, of course, be reversed, but, as this process would be used principally in the case of enlargements, this is no drawback. If the operator, in making the bromide enlargement intended for this process, reverses his negative, he will obtain from it any number of oil prints the right way round. There appears to be no limit to the number of prints obtainable.

Bromoil Prints in Colours

In *The Amateur Photographer and Photographic News* for September 29, 1908, Mr. E. Warner published a short note on his method of producing multi-coloured Bromoil prints. Mr. Warner was the first to make oil prints in colours, and his procedure is as follows :

" The bromide print must be fully exposed, and FULLY DEVELOPED (this last important), use amidol developer, rather more than usual quantity

bromide potassium advisable—put by to dry ;
soak, then bleach in ozobrome sol. 4 parts, alum
(1 in 20) 8 parts, citric acid (1 in 20) 1 part,
water 2 parts ; rinse, transfer to sulphuric acid,
dilute, 1 in 20, leave in bath 25 min. ; rinse, fix
in hypo 4 oz., soda sul. $\frac{1}{2}$ oz., water 20 oz. ; wash
carefully, as gelatine is now very tender, in running
water half an hour ; dry, bone hard ; resoak for
20 min. for pigmenting ; charge brushes FULL
of colour for pigmenting, and work rapidly.
Finish print in one sitting.

" The colours are made by grinding artists'
quality colours, and mixing with thin lithographic
varnish and a spot or two of pure olive oil.
Quantities are best ascertained by experiment,
as proportions must be adjusted to weather
conditions. (Rowney's will grind any colour—
very fine—in spirit at a nominal charge. Some
colours are very troublesome—all blues, some
browns, and some reds.) I am experimenting
with litho. colours, but find them messy and
unsatisfactory in many ways.

" Put out all colours to be used (use old negatives),
start always with blacks, browns, or reds, never
with blues or yellows (supposing that a full range
of colour is to be used). If colours are used in
the order named as little trouble as is possible
will result. If a large surface is to be covered

with a tint colour—pink, light yellow, or light blue, etc.—and detail is not required, thin down colour with lard, which gives some stiffness (more than oils), and does not degrade the colour.

" After working over a portion of the surface (both in oil and Bromoil) do not leave it too long before finishing, or freshness of print will be spoilt."

Recapitulation

(1) The bromide print from which the Bromoil is made should be full of contrast, not altogether lacking in detail, but above all must be fully developed, and the shadows a rich black, not grey, nor with a tinge of brown or green, but black.

For the beginner, therefore, a good " plucky " negative is useful if he desires to make such a bromide print.

(2) Always develop, if possible, with Amidol, and avoid using an acid fixing bath.

Other developers may be used, and the acid fixing bath also, but they introduce elements of uncertainty that their avoidance removes.

(3) Pour the bleaching solution on to the *dry* print. Wetting the print before bleaching may prove to be a source of uneven markings, and many troubles that arise when pigmenting.

(4) The bleaching should not be too rapid. Too rapid bleaching primarily indicates that an unsuitable bromide print is being used, and pigmenting becomes correspondingly difficult.

(5) The bleached print may be placed straight into the acid bath without washing. The acid bath should be freshly made, but cool—about 65°. The print should remain in this for at least five minutes. Longer in cold weather.

(6) After the acid bath the print should be washed in clean water for about five minutes or in half a dozen changes, and then placed in the fixing bath for two or three minutes.

(7) The final washing may be from five minutes to a quarter of an hour. The print may then be hung up to dry, or placed upon the wet pigmenting pad, blotted, and pigmented at once. If the print is allowed to dry it should be resoaked for at least one hour in water at 65° before pigmenting. If *not* soaked enough the picture will ink up as a negative instead of positive and only vigorous brush-work will save it.

(8) The entire picture, if unsatisfactory, can be cleaned off with a little petrol on a rag, and after the surface has been gently wiped with a wet cloth a fresh start can be made.

Printed by Hazell, Watson & Viney, Ld., London and Aylesbury.

PLATINOTYPE

PLATINOTYPE,

BY

CAPTAIN PIZZIGHELLI AND BARON A. HUBL.

TRANSLATED BY THE LATE

J. F. ISELIN, M.A.,

AND EDITED BY

CAPTAIN W. DE W. ABNEY, R.E., F.R.S.,

Vice-President of the Photographic Society.

[*Reprinted from the " Photographic Journal,"* 1883.]

LONDON :

HARRISON AND SONS, 59, PALL MALL,

BOOKSELLERS TO THE QUEEN AND H.R.H. THE PRINCE OF WALES.

1886.

Price Two Shillings.

HARRISON AND SONS,

PRINTERS IN ORDINARY TO HER MAJESTY,

ST. MARTIN'S LANE, LONDON.

PREFACE.

———

THE growing popularity of the Platinotype process has induced the Council of the Photographic Society of Great Britain to authorize a reprint of the translation of the brochure by Captain Pizzighelli and Baron Hubl, which appeared in the *Photographic Journal* in 1883. My friend and special colleague, the late Mr. J. F. Iselin, who made the bulk of the translation, and left me but small labour in editing it, has, alas! passed away before the work reached its present stage. Had I now the benefit of his great linguistic knowledge, perhaps some slight modifications in the text might have been introduced; as it is, I have left it nearly in the same state as that to which we both agreed three years ago.

W. DE W. ABNEY

May 1, 1886.

CONTENTS.

PLATINOTYPE.

INTRODUCTION.

AT the meeting of the British Association at Oxford, in 1832, Sir John Herschel[1] gave an account of some remarkable experiments on the action of light upon a salt of platinum. He prepared a solution of platinum in aqua regia, and neutralized it with lime; after carefully filtering this solution, he placed it in the dark and added limewater to it. At first no change took place; but after the lapse of some time a light flocculent precipitate was formed, no further reaction being observed so long as the solution remained in the dark. On such a solution, however (either the same which had been kept in the dark with the precipitate removed, or one freshly prepared in the same way as above), being exposed to sunlight it became at once clouded, and a white—or, with an excess of platinum, a yellow—precipitate was thrown down. The same reaction will occur, but less rapidly, on exposure to diffused light.

This precipitate was considered by Herschel to be a platino-calcic oxide; but according to Döbereiner[2] it consists of platinic chloride, platinic oxide, and lime. Judging from Johannsen's experiments,[3] however, Herschel's view seems to be the more correct: a solution of soda and baryta-water were found by Johannsen to behave in this reaction in the same way as lime.

Herschel observed that the platino-calcic solution is only affected by the violet end of the spectrum; when exposed to the light for days behind screens of liquids coloured yellow (solution of potassium bichromate) or red (tincture of rose-leaves with sulphuric acid), no alteration was observed.

According to Hunt (1844) a piece of paper dipped in a

[1] R. Hunt—" Researches on Light," 2nd edition, 1854, p. 152.
[2] Landgrebe—" On Light," 1834, p. 95.
[3] " Annalen der Chemie und Pharmacie," vol. 55, p. 204.

solution of platino-cyanide of potassium,[1] and hung up in the sun, undergoes a scarcely perceptible change even after a long exposure; but if the paper, after only a short exposure, is treated with mercurous nitrate, a weak positive image is produced, which can be fixed by means of a hot and dilute solution of carbonate of soda. Instead of a solution of mercury, one of nitrate of silver may be used equally well for developing the image.

The platino-cyanide of potassium paper, treated before exposure with the solution of mercurous nitrate, turns of a yellowish-brown colour, which in the light often becomes a beautiful scarlet-red; by a longer exposure this colour will be paler, and by continued exposure finally a weak reddish-brown. So that according as the duration of the action of light is greater or less, either a negative or a positive image will be the result.

Hunt observed that all the pictures prepared in this way are liable to fade; and it may happen that after some years such pictures will become inverted, so that what was originally a negative is converted into a positive.[2] The action of single parts of the spectrum on platino-cyanide of potassium paper appears to take place simultaneously in the extreme yellow and in the blue. In the more refrangible rays the action extends from the beginning of the blue well into the violet, but does not seem to overstep the visible spectrum. In the yellow the action is shown at first by the paper turning of a darker colour, but later on a gradual fading is observed.

Paper prepared with solutions of platino-cyanide of potassium and nitrate of silver becomes a deep violet colour under the action of light; and if a little mercuric chloride is added the colour will be developed by ammonia to a deep black. By dipping the developed image in a solution of mercuric chloride, the positive will be converted into a negative.

All these phenomena point, in our opinion, to the fact that by the exposure of platino-cyanide of potassium a reduction is effected, and that the compound thus produced possesses

[1] Prepared by mixing a solution of platinic chloride with one of potassium cyanide.

[2] This change was noticed by Hunt in the case of pictures which had been kept for ten years in a portfolio.

the property of reducing the salts of silver and mercury. This explains the possibility of developing such pictures by means of these salts, since on those parts which have been affected by the light metallic silver or mercury, as the case may be, will be deposited.

Reasoning in the same way, we are also able to explain why paper containing mercuric chloride, in addition to the salt of platinum, will blacken on being treated with ammonia after exposure ; the mercuric chloride is reduced to mercurous-chloride. Similarly may be explained the observation of Hunt, that platinum pictures which had been kept in a portfolio in contact with silver paper were completely transferred to the latter ; the parts which had been affected by light disappeared from the platinum paper, but were reproduced on the silver paper.[1] This remarkable fact induced Hunt to believe that it might be possible to employ the non-permanent platinum images for the production of pictures on other kinds of photographic paper. But this non-permanence, on which Hunt lays so much stress, may partly be due to the fact that these images are not really platinum, but more probably consist of imperfectly fixed mercury or silver.

A solution of platinic-chloride in ether when exposed to the light, according to Gehlen,[2] first turns a straw-yellow colour, and then the reduced platinum separates in the form of a thin film on the sides of the glass vessel containing the solution. The same reduction process was observed by Döbereiner[3] in the case of mixtures of chloride of platinum with solutions of sodium tartrate, tartaric acid, formic acid, and oxalic acid, and also of chloro-platinite of potassium with potassic hydrate and alcohol. Hunt found that the same thing took place, if paper dipped in any of the above mixtures is dried and then exposed to the light. In these cases he observed that the parts which had been affected by light sometimes grew lighter and sometimes darker ; and he was able to make the action visible, when the exposure had been short, by treating the image with a solution of mercurous nitrate.

[1] For similar observations of the transfer of photographs by contact, see Dr. Eder's " Manual of Photography," 1st part, p. 33.
[2] Landgrebe—" On Light," 1834, p. 92.
[3] Schweigger's " Year Book," vol. 17, p. 122.

Platinic iodide and bromide, which are both closely related
to the chloride, behave, according to Hunt and Herschel,[1] in
exactly the same way. Herschel found that images obtained
with the iodide fade away, and the paper recovers its previous
copying power; the same is true, according to Hunt, for
platinic bromide. The latter observer remarked also that
the alteration produced by the action of light is a very
uncertain one, in that the affected parts sometimes became
lighter, sometimes darker. According to Hunt, a mixture of
platinic chloride and potassium ferricyanide is also sensitive to
light, and gives blue images on paper through decomposition
of the latter salt.

Starting with the above historical data, we have made it
our task to investigate very carefully and closely the prepara-
tion of pictures by photography with the salts of platinum.
By our researches we hope to have brought within the reach
both of the amateur and the professional photographer a pro-
cess of reproduction which, in our opinion, as regards the
permanence as well as the artistic effect of the results, is a
most important one.

[1] Hunt—"Researches on Light," 2nd edition, 1854, p. 154.

I.—THE THEORY OF THE PROCESS.

Preliminary.

In the presence of organic substances we find that the action of light causes in every case a reduction of the platinum salt ; that is to say, the salt corresponding to the higher oxide (platinic chloride or bromide) is reduced to that corresponding to the lower oxide (platinous chloride or bromide), and by still further exposure metallic platinum is separated. If, for example, a piece of paper dipped in solution of platinic chloride is exposed to the light, it will at first begin to fade in colour ; this is owing to the dark-coloured platinic salt being converted into the light pink coloured platinous salt ; and if the exposure is continued, the parts affected by the light will become black, owing to the separation of metallic platinum. The more easily oxidizable is the organic substance employed, the quicker will this reduction process be accomplished ; for instance, in the presence of oxalic or formic acid the blackening will take place much sooner than if the cellulose of the fibres of the paper alone be used. This reduction seems to explain the difference in the results obtained, as already mentioned, by Hunt in his experiments.

When the platinous salts are used, of course there will be no fading at first, but the exposed parts will at once turn black from the direct reduction of the salt to metallic platinum. It appears, however, certain to us that, previous to any blackening becoming visible—that is to say, with a short exposure of from ten to fifteen minutes in shadow—some change must have occurred in the platinous salt, since the parts that have been acted on by light have acquired the property of being more readily reduced by organic ferrous salts than would have been the case in their unexposed condition. An experiment of ours, which we made in the following way, illustrates this.

A sheet of paper was dipped in a solution of chloro-platinite

of potassium and oxalic acid, placed underneath a paper scale, and exposed to the light for fifteen minutes in a shady place. The paper, on which not the slightest effect of light could be seen, was then treated with a cold solution of ferrous oxalate and oxalate of potassium in water, so dilute as not to be capable of affecting in the slightest degree non-exposed chloro-platinite of potassium, and at once a well-defined image of the paper scale made its appearance. To what this change is due we were unable to determine; but the phenomenon reminds one of an analogous reaction in the case of slightly exposed silver chloride, in which the invisible image can be made to appear by means of the proper reducing agents.

In this respect the observation of Gehlen [1] is very remark-able, that a solution of platinic chloride in ether, after being exposed to the light, will be decomposed by ferrous sulphate, metallic platinum being separated. Gehlen supposes the cause of this change to be, either that platinic chloride suffers some alteration by the action of light, and is then more readily and completely reduced by the ferrous sulphate, or that the ether in the solution also produces an effect. It is well known that neither platinic nor platinous chloride alone can be precipitated by ferrous sulphate, but that when they are accompanied by some of the more readily oxidizable organic compounds (for instance, organic acids) the decomposition at once takes place. Now, as exposure of the ether solution of platinum induces the reduction of the platinic to the corre-sponding platinous salt, and therefore also promotes the forma-tion of organic acids, it is possible that both the reactions given by Gehlen as the cause of the decomposition of the salt may come into play.

The question can, however, be solved indirectly by produ-cing, by means of some sensitive substance, what may be called a provisional image, and then by an effective method con-verting this into one of platinum. The sensitive substance must, in the first place, answer the conditions on the one hand of being capable of being so altered by light as to acquire the property of reducing, under further treatment, the salts of platinum to the metal itself, and, on the other hand, of not possessing this property previous to exposure to the light.

[1] Landgrebe—"On Light," 1834, p. 93.

Further conditions required by this substance are a sufficiently high sensitiveness to light, and the power of showing distinctly the alteration induced by the action of light; in other words, the provisional image must make its appearance quickly and clearly.

Of all the better known sensitive substances the salts of the heavy metals, for instance, those of silver, uranium, and iron, seem to be more especially well adapted to this purpose. These salts in the presence of organic substances undergo complete or partial reduction on exposure to the light, and in this state they possess the power of reducing salts of the precious metals.

THE INDIRECT PRODUCTION OF THE PLATINUM IMAGE BY MEANS OF THE SALTS OF SILVER AND URANIUM.

1. *By means of Silver Salts.*—This process, which is occasionally practised, consists in treating with solutions of platinum a silver print obtained in the ordinary way, whereby (just as in toning with a salt of gold) platinum is partially or, with a longer continuation of the action, completely substituted for silver. So far as we know, Caranza[1] was one of the first to publish a definite method of toning silver prints with platinum ; he used for the purpose a very dilute solution of platinum chloride in water, (1 : 2,000), acidulated with hydrochloric acid. This method is exactly like those afterwards recommended by Haackmann,[2] Watt,[3] Gwenthlian,[4] Sellon,[5] Maugham,[6] Kay,[7] and others.

Haackmann observed that prints on dull paper could be much more readily toned than those on albumenized paper ; also that generally platinum baths are not so powerful as gold baths. Watt found that platinum prints produced in this way

[1] "Lumière," Feb., 1856, and "Photo. News," vol. 1, 1859, p. 251.
[2] "Photo. News," vol. 1, 1859, p. 251.
[3] *Ibid.*, vol. 2, 1859, p. 204.
[4] *Ibid.*, vol. 2, 1859, p. 263.
[5] *Ibid.*, vol. 8, 1864, p. 182.
[6] *Ibid.*, vol. 8, 1864, p. 184.
[7] *Ibid.*, vol. 14, 1870, p. 26.

were not liable to fade, although exposed to the light continuously for several years. According to Gwenthlian, acid solutions of platinum give black tones; alkaline solutions, brown ones.

Platinum toning-baths for paper prints have not, up to the present, met with general acceptance, in competition with those of gold, partly because the former are less active, and partly because the tones obtained by means of the platinum baths are inferior in point of variety to those obtained by the aid of gold. The reason why the platinum works less energetically than the gold bath is doubtless due to the fact that platinum salts are not so readily reduced as those of gold.

These platinum prints produced by means of silver images have been used in encaustic photography on glass and porcelain. In applying this process, Grüne[1] first converted a silver image on collodion into one of platinum, and then transferred the latter to the glass or porcelain, afterwards fixing it with a flux containing lead.

The method of intensifying negatives by means of salts of platinum is in principle analogous to that of toning paper prints. In this case the action of the platinum on the silver image is clearly of a chemical character, inasmuch as silver chloride is formed and metallic platinum is separated. For this reason intensification with platinum cannot, like that with pyrogallol or iron, nor like that with gallic acid in the gelatine emulsion process, be carried on to any desired extent, but has very definite limits.

Eder and Tóth[2] made some searching experiments on the action of platinic chloride on negatives produced by the wet process and developed with iron, and compared the action of platinum solutions acidulated up to different points and of different degrees of concentration. The best standard of dilution (although, according to their experience, much does not depend on the point) they found to be 1 part of platinic chloride in from 800 to 1,000 parts of water. More concentrated solutions act more quickly, whilst more dilute act less rapidly; but, if the action be continued for the proper length of time, the final result will always be the same. Hydro-

[1] "Photo. Archiv," vol. 11, 1870, p. 230.
[2] "Photo. Correspondenz," vol. 12, 1875, p. 237.

chloric, nitric, or acetic acids added to the platinum bath[1] produced about the same effect : the silver image becomes black more rapidly,[2] but only by reflected light; by transmitted light it can scarcely be distinguished from the non-intensified negative. Neutral baths, according to these authors, give no advantage; they only work more slowly than acid baths.

To increase the density of the negative, Eder and Tóth converted the silver chloride which forms during the action of the platinum chloride into metallic silver, by flowing over the intensified negative, but without washing, a solution of ferrous sulphate (the iron developer); and they repeated the operation of platinizing and developing several times, as often as might be necessary. They found, however, that this process can only be repeated a limited number of times, since at the third or fourth repetition the platinum black will no longer adhere, and is washed away.

Eder and Tóth also tried whether the same reduction and precipitation as above described could not be effected by adding directly 20 grammes of ferrous sulphate to 500 cubic centimetres of the platinum solution acidulated with acetic acid; they found the result to be very much the same as if the platinum and iron solutions had been employed separately. This modification of the intensifying process, however, was not recommended by the experimenters, for the reason that a solution of platinum, containing ferrous sulphate, after standing some weeks, decomposes with the separation of metallic platinum. In the wet process intensifying with platinum alone will not, as a rule, give sufficient density, unless some other method be also employed; for this reason platinum as an intensifier is not much resorted to in practice.

Very recently Willis[3] has adopted the plan of intensifying gelatine-emulsion plates with platinum. For this end he converts a dark silver image into a white one of silver oxalate by treating it with ferric oxalate; he then washes it with

[1] To every 500 cubic centimetres of the solution of platinum chloride (1 : 800) were added 20 drops of nitric, or 30 drops of glacial acetic, or 20 drops of hydrochloric acid.

[2] The bath in which nitric acid is used works quickest; that acidulated with acetic acid is the slowest.

[3] "Photo. News," vol. 26, 1882, p. 183.

distilled or rain water, and flows over it a dilute solution of chloro-platinite of potassium. The latter salt decomposes the silver oxalate, forming chloro-platinite of silver :—

| Silver Oxalate. | Chloro-platinite of potassium. | Chloro-platinite of silver. | Potassium oxalate. |

$$Ag_2C_2O_4 + K_2PtCl_4 = Ag_2PtCl_4 + K_2C_2O_4$$

Now when this chloro-platinite of silver image is treated with the ferrous-oxalate developer, the whole of the silver, together with a portion of the platinum, is reduced to the metallic state.

The value of this intensifying process is, however, much affected by the property which the platinum salts have of rendering gelatine completely insoluble and impermeable, thus causing irregularities in the course of the intensification. Owing to this defect, the employment of platinum intensi-fication for gelatine plates appears scarcely to be reliable.

Willis further found that the density of a gelatine negative can be increased by means of the ferric oxalate alone, without using any platinum salt. He submitted a negative to the action of ferric oxalate until it had turned quite white, washed it for two or three minutes in water, and then treated it with the ferrous-oxalate developer, which reduces the silver oxalate again to metallic silver. By this means he pro-duced a greater density of the dark parts (which occasionally turn brown), and obtained the additional advantage that he avoids altogether any chance of the negative becoming tinted yellow, as happens when the pyrogallic developer is used. How Willis really attains a denser negative by thus working in a circle, as it were, is not clear to us ; unless, indeed, that by the basic salts of iron depositing on the parts affected by the light, the density of those parts is increased.

2. *By means of Uranium Salts.*—Of the indirect production of platinum images by means of the salts of uranium we have been able to find only very meagre notices in photographic works and journals. According to Van Monkhoven,[1] Nièpce de St. Victor was the first to make any attempts in this direc-tion ; he exposed a sheet of paper dipped in uranium nitrate to the light, and developed the scarcely visible image which

[1] " Bull. de l'Assoc. Belge de Phot.," vol. 6, p. 335.

was formed of the uranous salt, by treating it with a solution of gold or platinum. Bollmann[1] also employed the salts of platinum for the production of uranium images; he did this in two ways :—1st, by applying a mixture of the uranium salt and the platinum salt directly to paper, afterwards intensifying with a solution of some other metal, such as gold; 2nd (which is also Krone's[2] method), by converting the uranium into a silver image, and then into one of platinum.

None of these processes have been adopted in general practice. The defect which qualifies every urano-platinum process is that the image obtained after exposure is almost invisible, as the action of light produces only a slight change of colour from light yellow to light green; hence the time necessary for exposure could only be estimated by using a properly arranged photometer. From our own experiments we are of opinion that the process can be carried out much in the same way as the platino-ferric process which will be found described further on. But we believe that the above difficulty of copying on uranium paper, added to the high price of the uranium salts, will render the adoption of this process impossible in practice.

THE INDIRECT PRODUCTION OF THE PLATINUM IMAGE BY

MEANS OF THE SALTS OF IRON.

THE facility with which the organic salts of iron can be reduced by light is capable of manifold application in photography. Both Hunt and Herschel[3] were aware of the reaction, and took advantage of it in their photographic experiments. They used paper dipped in solutions of ferric citrate or oxalate, or of the double salts of ammonium, and having exposed it to the action of light, they converted the ferrous image thus obtained into one of gold, silver, mercury, or prussian blue, by developing with solutions of gold, silver, mercury, or ferricyanide of potassium, as the case might be.

[1] Bollmann's "Phot. Monatshefte," 1862, p. 37.
[2] "Bulletin de la Soc. Française de l'Photo.," vol. 28, April, 1882.
[3] R. Hunt, "Researches on Light," 2nd edition, 1854, p. 163.

Van Monckhoven[1] repeated these experiments in 1863, and published directions for carrying out the process.

These experimenters do not appear to have tried the effect with the salts of platinum; at least, we can find no mention of any researches on the subject in their publications. As, however, the salts of platinum are readily reduced by the ferrous salts, the latter seem to be peculiarly fitted for the production of platinotypes. Hunt[2] believed that he could turn this reaction to advantage in photography by dipping paper in a mixed solution of ferric oxalate and platinic chloride, and when dry exposing it to the light. After an exposure of a few minutes he found that the part of the paper which had been acted on by light was considerably darker than the part which had been protected from the light; but when the exposure was continued for a longer time, he noticed that the dark parts faded again. His hopes of obtaining in this way more vigorous images than by applying the salts of platinum alone were therefore disappointed. But the true explanation of the phenomenon lies in the fact that the salts of platinum are only reducible by solutions of the ferrous oxalate formed during the exposure; the change in colour observed by Hunt must be attributed virtually to the salt of iron. It is true, as was stated in the Introduction, that the salt of platinum also undergoes a change of colour after an extended exposure; but this is so trifling in comparison with that of the ferrous oxalate that it is neglected in the observation.

Merget[3] also, in 1873, attempted to take photographs in platinum indirectly by means of the iron salts. He used in his experiments a solution of platinum chloride mixed with one of ferric-chloride and tartaric acid. Paper dipped in this mixture and exposed to the action of light under a negative gave a white image in ferrous chloride on a yellow ground. The deliquescent ferrous chloride absorbed moisture from the atmosphere, and in this state it was said, in conjunction with the simultaneous exhibition of mercurial vapour, to complete the reduction of the platinum. Pictures taken in this

1 "Bulletin Belge de la Photographie," vol. 2, 1863, p. 29.
2 R. Hunt, "Researches on Light," 2nd edition, 1854, p. 157.
3 "Photo. Correspondenz," 1873, vol. 10, p. 105.

way were then washed with weakly acidulated water, in order
to remove the remaining salts of iron. Besides those of
mercury, Merget also employed the vapours of hydrogen,
sulphuretted hydrogen, and iodine. In his opinion, the con-
ditions of success in working this method depend not only
on the more or less appropriate choice of sensitive substances,
but also on the proper preparation and physical properties
of the sensitive films. When prints are produced by the
direct or indirect reduction of the salts of the precious metals,
the vigour of tone produced depends, according to Merget,
materially on the grain of the sensitive film. This may be
obtained by the happy selection of the proper kind of paper,
or by the addition of certain substances which, though in a
state of fine crystals or of powder, are yet insoluble, so that
their particles nestle in between those of the sensitive sub-
stance. This process for the indirect production of the
platinum image, as described by Merget, never seems to have
got beyond the experimental stage ; at least, we were unable
to find in the literature of the subject any further account
of it.

At all events, whenever the salts of platinum are used for
the production of images in the same way as those obtained
with the salts of gold and silver, more energetic reducing
agents are required than in the case of these latter. For
instance, the platinum will not be entirely precipitated from
a solution of platinic chloride by means of ferrous oxalate
alone; it can only be effected by increasing the reducing
action by exhibiting at the same time potassium oxalate. In
order, therefore, to convert an image obtained by the action
of light on ferric-oxalate paper into one of platinum, it is
necessary to have present, besides the salts of platinum, sub-
stances which, like the soluble oxalates, tartrates, citrates, &c.,
will increase the action of the ferrous salt. This seems to
have been known to Willis, for he bases on it the platinum
printing process called after his name.[1] This process, for
which he took out a patent in England in 1873, is essentially
as follows :—A solution of a salt of platinum, iridium, or
gold, or also of a mixture of these salts, is applied to the
surface of paper, wood, or some other suitable material, and

[1] Specification of W. Willis, jun., No. 2011, 5th June, 1873.

B

dried; it is then coated with ferric oxalate or tartrate, again dried, and exposed to the light under a negative. A faint brown image will appear, which, after being brushed over with a solution of potassium oxalate, turns a strong, intense black.

The following instructions were given by Willis :—

1. Coat a piece of paper with a solution of 1 part chloro-platinate of potassium in 48 parts of water. When it has been dried, dip the paper in a solution of 1 part nitrate of lead in 48 parts of water. Dry once more, and brush over with a solution of 1 part ferric oxalate in 8 parts of water, to which, in order to render the oxalate more soluble, a little oxalic acid has been added. After again drying, the paper must be exposed under a negative, and then put to float on a hot solution of potassium oxalate. Finally, it must be washed in a weak solution of oxalic acid in water, then in sodium hyposulphite, and lastly again in water.

2. Proceed as in the previous case, only substituting for the lead solution one of 1 part silver nitrate in 60 parts water. When the prints are taken up from the weak solution of oxalic acid. they must be dipped either in a strong solution of ammonium chloride or in a weak solution of the same salt, and then in a weak one of ammonia. Finally rinse well in water.

3. The paper is first dipped in a solution of 1 part platinic bromide in 40 parts water, then dried, then again dipped in a strong solution of ferric tartrate, and afterwards once more dried. It is now exposed beneath a negative, and the image thus obtained is developed by floating on a hot solution of potassium oxalate. Afterwards it is immersed in a weak solution of oxalic acid, finally rinsed in water, and dried.

For the platinum process described above, with which Willis, according to his own statement, produced excellent results, he substituted, in 1878, a modification, by means of which he was enabled to take, with more ease and security, prints showing much greater uniformity, and possessing a higher degree of permanence. This improvement was made the subject of a second patent,[1] according to which the prin-

[1] Specification of W. Willis, jun., No. 2800, 12th July, 1878.

cipal points were the entire. elimination of the silver salt, and the addition to the developer of chloro-platinite of potassium. The following short extract from the specification will give an idea of the nature of the process :—

Paper, or some other suitable support, is dipped in a solution of

Water...	30	parts.
Chloro-platinite of potassium	1	,,
Ferric oxalate	4·5	,,
Lead chloride	0·13	,,

Having been dried, the paper is then exposed beneath a negative, and the image is developed by floating on, or dipping in, a hot solution of

Water...	30	parts.
Potassium chloro-platinite ...	0·5	,,
Potassium oxalate	8	,,

The further manipulations remain precisely the same as in the previous process. In this specification Willis further states that, in place of the above-mentioned platinum salts, he can also use other salts of platinum, as well as the salts of other metals, such as gold, iridium, or palladium; also, that he is able to dispense altogether with the chloride of lead, or can substitute for it chloride of mercury; lastly, that he can add to the developer other salts of platinum or the salts of other metals instead of the chloro-platinite of potassium, but that in general he prefers the latter.

In 1880 Willis took out a third patent[1] for a still further improvement of the platinum process; in this he proposed to increase materially the amount of platinum salt in the sensitizing bath, but, on the other hand, to omit the use of silver or lead salt, and in the developing bath that of platinum salt. By this arrangement, not only is the process much simplified, and the expense reduced, but also any fear of discolouring the white parts of the image—which so often happens when lead or silver salts are employed—is altogether avoided.

[1] Specification of W. Willis, jun., No. 1117, 15th March, 1880.

Willis, according to this specification, gives the following instructions for preparing the sensitizing bath :—[1]

Water	30	parts.
Potassium chloro-platinite		...		4.2	,,
Ferric oxalate...		4.2	,,

and he further mentions that in this improved process he applies a minimum of 0.12 gramme, generally, however, 0.27 gramme, and even more of potassium chloro-platinite per 1,000 square centimetres of surface. He also speaks of improved developing-solutions which may contain the citrate or tartrate of sodium, potassium, or ammonium, or mixtures of these salts, as well as the acetates of the above-named metals, and the mono- or diphosphate of ammonium or the mono-phosphate of sodium. Of the properties and action of these developing solutions nothing is said in the specification : the salts are merely enumerated.

Since the above-named dates several attempts have been made to imitate or modify this process for taking platinotypes, but without satisfactory results. For instance, Dr. Koninck published[2] a process very much like the one of Willis, only using platinum chloride instead of platinous chloride. Dr. Koninck, however, only succeeded in obtaining a grey tone in his pictures ; and this is due to the circumstance that chloride of platinum is generally very acid, which would prevent the reduction from being thoroughly carried out. That this is the true cause of the defect is shown by Koninck's further observation, that, by employing a solution of Rochelle salt, rendered alkaline with caustic soda, he was able to obtain better results.

By a similar method Roppe,[3] in 1880, in order to render Willis's platinum process more capable of general application in practice, suggested the substitution of platinic chloride or of the double salt of platinum and sodium (both of which are readily obtainable) for the less known potassium chloro-

[1] In this specification, Willis lays stress on the fact that he proposes to use the *platinous* salts, whereas in his previous specifications he mentions only potassic chloro-platinite.

[2] " Photographische Mittheilungen," vol. 16, p. 73.

[3] " Bulletin de l'Association Belge de la Photographie," vol. 6, p. 302.

platinite. He also proposed to add this latter salt to the developer, the same as Willis does in his second process. This method, however, possesses the great disadvantage that the ferrous salt formed in the developing bath, especially when the latter is deficient in platinum, is dissolved out before it has had time to effect the necessary work of reduction, and it therefore becomes difficult to make the prints sufficiently vigorous. On the other hand, it must be recollected that in operations with a developer containing platinum considerable loss is inevitable through splashing, adhesion of the solution to the prints, &c., so that the process becomes too expensive for working in general practice.

Both these defects are satisfactorily got rid of by Willis, in his latest improvements, by using no platinum in the developer, but, in its place, adding a larger quantity of the metal to the sensitizing bath. In this way the exposure to light brings out a provisional image in ferrous oxalate, which, on dipping into the developing-liquid, is converted into one of platinum, just as if a platinum bath had been formed in the film itself.

We have been induced by the many and great advantages offered by the platinum process, by its remarkable sensitiveness, by the simplicity of the manipulations required, by the permanence of the prints, and by the facility with which effects scarcely obtainable in any other way can be produced, to devote special attention to this process. Since, however, in Willis's specifications of patent, for causes which can be readily understood, only general instructions are to be found, and no reason is given for the selection of any particular preparation, as also the account of the results obtained by use of the substances specified is altogether wanting, we found ourselves compelled, quite independently of these publications, to undertake a series of investigations of all the salts of platinum and iron which, in our opinion, could be used for photographic purposes, as well as to study closely the capabilities of different developing-solutions.

THE SALTS OF IRON.

All the ferric salts are, in the presence of organic bodies, more or less sensitive to light, the ferric salts being by the action of light reduced to the corresponding ferrous salts.

In principle, therefore, every ferric salt is capable of being used for the production of platinum images, so long as some organic substances, such as paper, gelatine, or starch, is employed as a support for the image. Those salts, however, must have the preference by whose aid the reduction is accomplished in the least possible time,—that is to say, those which permit of the exposure to light being reduced to a minimum. In selecting the particular salt of iron care must also be taken that in the operation of reduction none of the stronger acids, especially the mineral acids, are set free, as they are antagonistic to the reduction of the platinum salt, and so prevent the development of the image. For this reason the so highly sensitive mixture of ferric chloride and oxalic acid cannot be employed, since under exposure free hydrochloric acid is developed. It will be found that the compounds of ferric oxide with the organic acids,—in other words, the organic ferric salts,—are best adapted to secure the fulfilment of the above-named conditions.

Of all these salts, according to the researches of Dr. Eder,[1] the oxalate and its double salts take the first rank as regards sensitiveness to light ; and then follow the tartrate and the citrate. Dr. Eder determined the sensitiveness of the aqueous solutions of these ferric salts from the amount of ferrous salt precipitated by the action of light in the same time. The following is his table of the results of the photo-chemical decomposition of the ferric salts obtained in this way, at a temperature of from 17° to 20° C.:—

Ferric chloride + oxalic acid	100
Ferric oxalate	89
Ammonio-ferric oxalate	80
Potasso-ferric oxalate	78
Ferric tartrate	80
Ammonio-ferric tartrate	80
Ammonio-ferric citrate	15
Ferric chloride + citric acid	19
Ferric chloride + tartaric acid	25

[1] Dr. Eder, " Recent Investigations on the Sensitiveness of the Salts of Iron," " Photo. Correspondenz," vol. 17, p. 219.

The numbers here given are only correct when the solutions contain from one to five per cent. of ferric chloride, or the equivalent amount of ferric salt. As a general rule, the sensitiveness increases with the degree of concentration, at the same time that the differences in the quantities of ferrous salt precipitated from the solution become smaller.

For this reason the mixtures of the above-mentioned ferric salts when dried into paper behave quite differently from the aqueous solutions when exposed to the light. In order to discover the variations in sensitiveness under these circumstances, Dr. Eder soaked strips of paper in the different solutions of the salts, and, when they were dry, exposed them simultaneously to the light under one of Vogel's paper photometers. By then treating these strips with a solution of ferricyanide of potassium he was able to read the degree of light-action by the depth of the blue colour brought out. In these experiments the same order was shown in the degrees of sensitiveness as in those with the solutions: the mixture of ferric chloride and oxalic acid proved to be the most sensitive of all; the ferric oxalate was less so; then follow the ammonio- and sodio-ferric oxalate, and the potasso-ferric oxalate was the least. The differences in sensitiveness between the double salts alone were not so great as in the case of the aqueous solutions, —the sodium and ammonium salts, especially, being almost equally sensitive.

Probably the reduction which these salts undergo under the influence of light is principally due to the fact that with the formation of the corresponding ferrous salt carbon is separated as carbonic acid. This decomposition of the aqueous solutions when exposed to the light was first observed by Döbereiner[1] in the year 1831; afterwards by Suckow,[2] Draper,[3] Reynolds,[4] and Eder.[5] The reaction is most regular in the case of the oxalate, as the quantity of carbonic acid given off agrees very closely with that determined theoretically; it is not so regular in the case of the citrate and the tartrate,

[1] " Schweigger's Journal," vol. 62, p. 90.
[2] " On the Chemical Action of Light," 1832, p. 29.
[3] " Dingler's Polytechnic Journal," vol. 146, p. 29.
[4] " British Journal of Photography," 1861, p. 9.
[5] " Photo. Correspondenz," 1880, vol. 17, p. 219.

since, in addition to carbonic acid, acetic and oxalic acids are also formed.

Of all these salts of iron examined by Dr. Eder, the most sensitive, the mixture of ferric chloride and oxalic acid, cannot unfortunately be used in the production of platinum prints, as already mentioned above. On the other hand, it was expected that the oxalate, citrate, and tartrate would be more generally serviceable. To satisfy ourselves on this point we made the following experiments :—Solutions [1] of the salts in question were mixed with equal quantities of potassium chloro-platinite, and applied to the paper ; strips of this paper were then dried and exposed to the sunlight, underneath a paper scale, for equal periods of time. When developed with a hot solution of potassium oxalate, it appeared that (1) the black colour on the strip prepared with ferric oxalate was much more intense, and (2) its sensitiveness considerably greater, than was the case with the strips prepared with the tartrate and citrate. Experiments with the acetate and the formiate proved that the former is very little sensitive, and that the latter causes the reduction of the platinum salt very rapidly, and even without exposure to light.

The double salts of the ferric oxalate possess the great advantage of being readily procurable in a crystalline form— a property altogether wanting in the ferric oxalate alone. It became, therefore, important to submit these salts to an examination in respect to their suitability for the platino-ferric process. The potassium salt cannot well be employed, on account of its insufficient solubility ; but the sodium and ammonium salts, of whose composition, especially of the amount of water of crystallization contained in them, Dr. Eder's investigations have given complete information, are also unable to comply with the requirements. The paper prepared with these salts is only slightly sensitive, and the photographs taken thereon are inferior as regards intensity and depth in the shadows to those produced by the aid of ferric oxalate. This unsuccessful result may be explained on the supposition that the complete reduction of the double salts under exposure

[1] The degree of concentration of the solutions was so arranged that, after exposure, there might be one molecule of platinous chloride to every two molecules of the ferrous salt.

is not effected with the same readiness and regularity as is the case with ferric oxalate. We endeavoured to rectify this by reducing the quantity of the double salt in the sensitizing solution by one-half, and making up the requisite amount of iron by the addition of neutral ferric chloride. But, even with this combination, we were unable to obtain reactions of any great value ; though the intensity of the blacks was improved, the sensitiveness was still further lowered, and, besides, the prints had a nasty yellow-brownish tone.

Through the above-mentioned experiments we arrived at the conclusion that in platinum-printing only ferric oxalate can be employed with advantage ; consequently, in our further experiments we considered this substance alone as the sensitizer. Ferric oxalate is produced by dissolving ferric hydrate in oxalic acid ;[1] a greenish-brown solution is obtained, which, on being evaporated, leaves a brown syrup, not capable of being crystallized. When perfectly protected from the light, and at temperatures of from 15° to 30° C., this solution will keep for months without undergoing alteration.[2] At a higher temperature, however, as, for instance, when heated for several hours to 50° C., a gradual reduction to ferrous oxalate takes place ; and this reduction will be effected much quicker if the solution, or paper coated with it, is exposed to the action of light. The ferrous oxalate thus formed consists of a light yellow crystalline powder, soluble with difficulty in water,[3] but which even in a moist condition resists the action of light and air.

Moistened with solutions of the alkaline oxalate, Dr. Eder found that this salt has a very powerful reducing action, and, according to our experience, solutions of the alkaline acetates, benzoates, succinates, borates, and phosphates, as well as the solutions of the alkalis and of the alkaline carbonates, produce the same effect. In this reaction are formed either soluble double salts or insoluble ferrous salts having energetic reducing effects ; with the caustic alkalis, and especially with the alkaline carbonates, ferrous oxide itself is formed—a well-known reduction agent.

[1] For the details of this process see further on, under "Practical Instructions."

[2] Dr. Eder and E. Valenta, "On the Iron Oxalates and some of their Double Salts," Transactions of the Imperial Academy of Science at Vienna, Part 2, October, 1880.

[3] One part of the salt dissolves in 1,000 parts of water at 15° C.

THE SALTS OF PLATINUM.

In the process now before us, the salts of platinum play a much more important part than those of iron, as from them is derived the metal of which the image finally is composed. As already stated, in the production of this image the salts are reduced; hence only those salts of platinum are suitable which are capable of being readily reduced by the above-mentioned reducing agents, and which, for this purpose, require the use of comparatively small quantities of the ferrous salts. Further, as in sensitizing the paper the salt of platinum is applied simultaneously with that of iron, all those compounds of platinum are excluded from consideration which, in mixing with the salts of iron, may give rise to disturbing reactions. Of all the salts of platinum, the chloride, bromide, and iodide seem best to fulfil the first of these conditions; while the sulphite, the double cyanide compounds, and the double salts of ammonium and platinum are either not reduced at all, or are reduced with very great difficulty. Independently of this, however, the first-named salts are to be preferred, on the ground that they can be prepared more easily, and are therefore cheaper.

The chemical reaction in the formation of the image is, according to Berkeley,[1] most simply represented by the following equations :—

For platinous chloride—

| Ferrous oxalate. | Platinous chloride. | Ferric oxalate. | Ferric chloride. | Platinum. |

$$6FeC_2O_4 + 3PtCl_2 = 2Fe_2(C_2O_4)_3 + Fe_2Cl_6 + 3Pt$$

Analogous is that for platinic chloride—

| Ferrous oxalate. | Platinic chloride. | Ferric oxalate. | Ferric chloride. | Platinum. |

$$12FeC_2O_4 + 3PtCl_4 = 4Fe_2(C_2O_4)_3 + Fe_2Cl_6 + 3Pt$$

The correctness of these equations is, however, rendered

[1] "Phot. News," 1882, p. 157.

doubtful by our observation of the formation of gas when the image is developed in a hot solution of potassic oxalate. Now, this reaction can only be due to the fact that the remainder of the oxalic acid combined with the iron is displaced by chlorine, and separates as carbonic acid in a gaseous form. We may therefore assume that the reaction is not quite so simple as the equations would indicate, but is probably much more complicated. It should also be borne in mind that the platinum salt itself, as we have already had occasion to mention, undergoes a slight alteration under exposure to the light.

But, whatever the real process of reduction may be, it is clear that the platinic chloride requires just twice as much ferrous oxalate for its complete reduction as the platinous chloride. This explains why it is scarcely a matter of no importance whether with Willis we employ, for developing the image, a platinous salt, or, with Koninck and Roppe, a platinic salt. The quantity of ferrous salt need not be so large in the first case as in the second; and as the ferrous oxalate is only formed by exposure, the duration of that exposure may be considerably less, when a platinous salt is used, than is required in the case of a platinic salt.

As in every other photographic printing process, we find also in this, that the more sensitive substance gives soft pictures with a hard negative, and with a soft negative weak pictures, while the substance requiring a longer exposure will give, in the one case, a hard, in the other a brilliant, picture. It will, therefore, be most advisable to employ generally a platinous salt as the sensitizer, and to mix with it, when the negative is soft, a little of the corresponding platinic salt, or, when the negative is weak, a larger quantity of the latter.

According to our own experience, of all the platinous salts, the platinous chloride and the double salts of platinous bromide best comply with all the required conditions, and, of the latter, the platinous bromide of potassium is to be preferred. The double salts of platinous iodide cannot be used, as in mixing with the ferric oxalate salt they reduce it, with separation of iodine. The corresponding simple salts—that is to say, the platinous chloride and bromide—are insoluble in water; before they can be used, therefore, they must be dissolved in solution of the corresponding haloid acids—a process

which, as has already been explained, cannot be carried out, on account of the free acid present.[1]

Potassium chloro-platinite and the corresponding bromo-platinite possess the advantage of being easily prepared and purified, but, on the other hand, the disadvantage that they cannot be mixed with platinic chloride and its double salts without the formation of an insoluble precipitate of potassium chloro-platinate. This defect is not found to exist in the case of the sodium, lithium, and magnesium double salts; but the two first crystallize only with difficulty, and it is on that account troublesome and costly to obtain them pure. Besides, they are hygroscopic and deliquescent in a high degree; and as the quantity of water they contain is so variable, they cannot be accurately weighed without special arrangements and precautions. The magnesium salt is not deliquescent; but it does not readily crystallize, and cannot, therefore, be easily obtained in a pure state. The calcium, barium, and strontium salts cannot be used, from the fact of their forming insoluble precipitates with ferric oxalate.

A consideration of the comparative advantages and disadvantages possessed by the above-mentioned platinum compounds led us to give the preference to the potassic salts; and, as the preparation of the potassium bromo-platinite is much more troublesome than that of the corresponding chloro-platinite, we determined to carry on our experiments with potassium chloro-platinite. We desire, however, to draw attention to the circumstance that, according to our experiments, the double salts of potassium, sodium, lithium, and magnesium all give identical results in the production of the image, both as regards their reducing powers and as regards the appearance of the finished picture.

When preparing a sensitizing solution of chloro-platinite of potassium, adapted to the character of the negative from which

[1] True platinous chloride (the formula for which is $PtCl_2$) is, like platinic chloride ($PtCl_4$), insoluble in water. Dissolved in hydrochloric acid, it forms chloro-platinous acid ($PtCl_2 \cdot 2HCl$), a substance which corresponds to chloro-platinic acid ($PtCl_4 \cdot 2HCl$). The latter compound is generally, but incorrectly, designated platinic chloride; commercial platinic chloride contains, in addition, six molecules of water of crystallization. For the sake of brevity, we follow the common practice, and call the compound above alluded to ($PtCl_4 \cdot 2HCl + 6H_2O$) platinic chloride.

the copy was to be taken, we were compelled to leave out of
the question the direct addition of a platinic salt, partly
because a mixture with the double salts of platinic chloride
is not feasible, partly on account of the difficulty and expense
of preparing a more suitable platinic salt. But we tried
whether the required advantage could not be obtained by
adding the oxidizing substances, which have not the effect of
immediately decomposing the sensitizing solution, but only
convert more or less of the platinous into the corresponding
platinic salt at the time when the solution dries up on the
support. This point we shall go into with more detail
further on.

THE SUBSTANCES SUITABLE FOR THE DEVELOPMENT OF THE PLATINUM IMAGE.

When a sheet of paper, sensitized with a mixture of potas-
sium chloro-platinite and ferric-oxalate is exposed to the light,
a weak but perfectly visible image is formed, consisting prin-
cipally of ferrous oxalate.[1] As the ferrous oxalate possesses
some slight power of reduction, the treatment of the image
with hot water will partially reduce the platinum salt. But
this reduction will be more complete, that is, the image will
appear more vigorously, if there be selected for the developing
solutions substances which are able to increase the action of
the ferrous oxalate. When treating of the salts of iron, we
cursorily mentioned substances of this kind, and described
their mode of action. Solutions of these substances we will,
for the sake of brevity, call developers. Some of them act
best when cold and in a dilute condition; others, on the
contrary, must be used hot and in concentrated solutions, in
order that the reduction may be carried out as quickly and
perfectly as possible. If the reduction is slow, both the
platinum and ferric salts might be dissolved before they had
time to act on one another. The reaction would then either
not be effected at all, inasmuch as the dilute solutions are

[1] The alteration effected in the platinum salt is, with the very short
exposure which is sufficient to produce the image, not appreciable by
the eye.

unable to act on one another, or it would take place only in the developing liquid, and not on the support of the image.

The following developers have been tested by us, and are enumerated below in the order of their reducing power ; and it must be here noted that, with the exception of the caustic alkalies, the carbonate of sodium, and the ammonia, they are all applied in a hot (80° C.) and concentrated condition :—[1]

(1) *Sodium acetate* acts very energetically, and gives soft pictures, which, however, owing to the formation of basic ferric acetate, have a yellowish tinge. Although this yellow colour can be nearly entirely got rid of by subsequent treatment with hydrochloric acid, we endeavoured to prevent the separation of the insoluble ferric acetate by rather strongly acidulating the developing bath with oxalic or citric acid.

(2) *Sodium acetate + oxalic acid* works exactly the same as sodium acetate alone, but gives pure whites.

(3) *Potassium citrate* behaves almost identically with (2).

(4) *Sodium carbonate* in a hot solution

(5) *Ammonium citrate* (neutral)

(6) *Ammonium citrate* (acid, as used for developing chloride-of-silver pictures) ...

(7) *Potassium oxalate*

(8) *Rochelle salt*...

(9) *Ammonium benzoate* ...

(10) *Sodium succinate*

All these act much the same ; only those solutions numbered (4), (9), and (10) give, through the formation of basic ferric salts, yellow-coloured images. There also is formed in the developing bath (for the same reason) an insoluble precipitate.

(11) *Caustic potash* (dilute solution, 1 : 25)

(12) *Sodium carbonate*

(13) *Sodium phosphate*

These act almost identically the same, but are considerably inferior developers to those before mentioned.

[1] We carried out this experiment by cutting into strips a piece of platinum paper which had been exposed beneath a paper scale, and developing these strips in various solutions.

(14) *Water* (hot) ⎫ Possess only a moderate
(15) *Ammonia* ⎬ power of developing.
(16) *Oxalic acid* ⎭

In practically working the platinum process the citrates must be altogether left out of the question, as they are too expensive; sodium carbonate, ammonium benzoate, and sodium succinate are not adapted for the purpose, for reasons previously stated. Caustic potash, sodium phosphate, and the solutions numbered (14), (15), and (16) are equally useless, as they do not act sufficiently energetically.

We recommend the mixture of sodium acetate and oxalic acid, the potassium oxalate and the Rochelle salt, as the best developers; and of these three we give the preference to potassium oxalate, notwithstanding its somewhat higher price. This salt is now largely used in the negative process, and will therefore find a place in most laboratories, whether of amateur or of professional photographers.

THE EFFECT OF THE PRESENCE OF FOREIGN BODIES IN THE SENSITIZING AND IN THE DEVELOPING SOLUTION.

Many substances, when present in the developing or still more in the sensitizing solution, produce special effects on the composition and character of the image. To prevent mischief, therefore, the greatest care must be taken to secure perfect purity and exactly correct composition in the chemicals employed; also to attend conscientiously to the preparation of the solutions.

Influence of Acids.—Both the sensitizing and the developing solutions must have a distinctly acid reaction; when this is not the case, the paper will, owing to the formation of basic salts of iron, have a yellow colour which does not disappear after treatment with dilute hydrochloric acid, or even with a mixture of the latter and sulphuric acid. Ignorance of this fact was, at first, with us the cause of many failures; we can only strongly advise that particular attention should be paid to this point. In another respect an excess of acid acts just as injuriously as an insufficiency; this is true both for organic acids as well as (and in a higher degree) for free mineral acids.

Excess of acid in the sensitizing solution prevents com-plete reduction of the platinum, and hence is the cause of the picture being weak. The reason for this phenomenon is probably due to the circumstance that, in developing, potas-sium binoxalate forms in the print, which has but little power of dissolving ferrous oxalate. At the same time some of the very soluble platinum salt passes into the developing solution before it can be reduced in the image-film. Especially with an excess of oxalic acid [1] we observed the effects of solariza-tion ; the deepest shadows of the picture have then a grey instead of a black tone, and this grey is even lighter than the adjacent darker half-tones. Acid solutions also penetrate the paper more readily than neutral ones ; a very acid sensitizing solution would, therefore, enter too deeply into the paper, and would even come through on the other side. In this way the image, instead of being on the upper surface, would be in the interior of the paper, and would lose all vigour.

After numerous attempts we came to the conclusion that mineral acids must absolutely be avoided,[2] and that (as pre-viously remarked) the ferric oxalate solution must be acidulated with oxalic acid in the proportion of six to eight grammes of oxalic acid to every hundred grammes of the salt.

The presence of free acids exerts a peculiar effect on the colour-tone of the picture. When quite neutral[3] solutions are used, the picture assumes a brownish-black colour; but if they have a slightly acid reaction, it has a bluish tone. These effects remind us of the analogous phenomena observed in toning the silver image with a platinum solution.

Free acids in the developing-bath are much less injurious, provided they do not exceed a certain limit. We make it a rule to test the developer from time to time, and, when necessary, we add oxalic acid until blue litmus paper is distinctly turned red. Instead of oxalic, citric or tartaric acid may be used; but not acetic acid, since not only is the latter

[1] This reaction was even observed when not more than 8 per cent. of oxalic acid was mixed with the sensitizing solution.

[2] Such acids may occur in carelessly prepared chloro-platinite of potas-sium ; this salt should, therefore, be carefully tested for a neutral reaction.

[3] Like nearly all the metallic salts, ferric oxalate has a distinctly acid reaction, even when no free acid is present ; the condition " neutral," there fore, if taken literally, does not apply to ferric oxalate.

fugitive, but also it cannot prevent the formation of basic salts of iron.

Reducing substances, such as formic acid, hyposulphite, &c., in the sensitizing or developing solutions cause the reduction of ferric oxalate, and, consequently, sometimes fogging of the image.

Oxidizing substances may possibly convert the potassium chloro-platinite wholly or partially into insoluble potassium chloro-platinate. As the latter, when present in the paper, will, as a platinic salt, alter the character of the image (it makes it harder), oxidizing substances can often be used with advantage when this object is in view; but, of course, they must not act so energetically that the oxidation is able to take place in the sensitizing solution ; the crystalline precipitate of potassium chloro-platinite which is thrown down could not by any means be made to distribute itself equally over the support of the image. We find that chlorate of potash is the oxidizing substance which gives the best results. If that salt is added to the sensitizing solution, the latter will not be decomposed ; but, so soon as the solution has dried into the paper, the chlorate of potash exerts its oxidizing influence. This reaction can be explained by the fact that ferric chlorate is first formed—an exceedingly unstable body, which decomposes in drying, and then produces the oxidation of the potassium chloro-platinite. It is, however, necessary to be extremely careful in using chlorate of potash, as the presence of even one-hundredth per cent. of that substance has a noticeable effect on the image. This effect will be observed in the heightened brilliancy of the picture, which, when the proportion of chlorate is increased, may have the character of hardness. A further consideration is, that the addition of potassium chlorate will, as may naturally be conceived, lower the sensitiveness. By regulating the amount of this salt to be added to the sensitizing solution with due reference to the character of the negative to be copied, every desired effect within certain limits may be obtained.[1]

[1] In the place of potassium chloro-platinite, the corresponding salt of sodium may be used in the sensitizing solution ; the chlorate of potash may then be dispensed with, and, instead thereof, sodium chloro-platinate be substituted directly for part of the platinite.

PALLADIUM, IRIDIUM, AND GOLD.

Although from the first we did not promise ourselves any very favourable results from the use of the above-mentioned metals, particularly as their enormous cost must stand in the way of any advantage to be derived from their use, we were yet compelled to bring them into the sphere of our experiments, for the reason that they appear in Willis's specifications of patents, not only as additions to the solutions, but also as capable alone of producing a photographic image.

So far as *palladium* was concerned, since that metal possesses very similar properties to those of silver and platinum, it was to be expected that it could be used in this process as a substitute for the latter metals. Our experiments have also completely confirmed this expectation. Photographs may be taken with palladious chloride equally as well as with platinous chloride; they have a sepia-brown colour, and, on being developed, after a lengthy exposure they show the deeper shadows actually lighter than the darker half-tones, so that the picture appears to be solarized. A further peculiarity of palladium photographs is that they can be toned rapidly in a bath of gold, taking a violet colour, when the previously mentioned effect of solarization disappears.

Mixtures of the palladious and platinous chlorides have a colour which varies between brown and brownish-black, according as the quantity of the former salt prevails. This brown colour, however, as we shall show in the practical details of the process, can be obtained in a simpler and less expensive way; so that we do not recommend the employment of palladium, either alone or combined with platinum.

Iridium, which is also included in the platinum group of metals, behaves, in its action with reducing agents, quite differently from platinum and palladium. The properties of the compounds of iridium have considerable similarity with those of the compounds of platinum; but, on the other hand, they resemble in many points the salts of iron. These purely chemical considerations are sufficient, notwithstanding Willis's assertions, to lead us to the conclusion that the salts of iridium cannot be used in any photographic process depending

on iron.[1] For the reason already given, however, we endea-voured to use iridium chloride and its double salts for taking photographs, but obtained only negative results : we were unable to develop an iridium image.

As regards *Gold*, most compounds of this metal are reduced by solutions of the oxalate to metallic gold, even in the cold. On this account, the employment of gold chloride and its double salts seemed not to be feasible. One of the salts of gold, the hyposulphite, might perhaps be used with effect. This compound is not reduced by ferric oxalate in the cold ; but the reaction takes place when hot solutions of potassium ferrous oxalate are employed. Our experiments, however, with this substance added to the sensitizing solution gave no results worthy of mention ; so that we refrained from pursuing our investigations further in this direction.

ON THE RELATIVE PROPORTIONS OF PLATINUM AND IRON SALT IN THE SENSITIZING SOLUTION, AND ON THE DEGREE OF CONCENTRATION OF THE LATTER.

According to the description which we have already given of the course of the reaction in the developing solution, the quantity of ferrous oxalate theoretically necessary to reduce one gramme of potassium chloro-platinite to metallic platinum ought to be 0·69 gramme. This quantity of ferrous oxalate, which should be formed by exposure to light, would corre-spond to 0·9 gramme of ferric oxalate to every gramme of platinum salt in the developing solution. But, in order to

[1] The metals of the platinum and iron group may be arranged, accord-ing to their properties, in the following way :—

Fe	Co	Ni	Cu
Ru	Rh	Pd	Ag
Os	Ir	Pt	Au

An examination of this table shows us at once that Platinum (Pt) and Palladium (Pd), which approach nearly to Gold (Au) and Silver (Ag), are adapted for the production of the photographic image by means of develop-ment with the salts of iron ; while the compounds of Osmium (Os), Iridium (Ir), Ruthenium (Ru), and Rhodium (Rh), which come closer to Iron (Fe), will probably not answer the purpose. It also explains the reason why palladium images, which approach closely to silver images, can be readily toned with solutions of gold, while this property is only moderately apparent in platinum images.

avoid loss of platinum, it will be always better to obtain a slight excess of ferrous oxalate,—quite apart from the doubt already expressed as to the perfect correctness of Berkeley's formula.

That, in fact, a small excess of ferric oxalate is necessary in order to obtain good results is shown by a series of experiments undertaken by us, in which we found that the ratio of platinum salt to iron salt varied from $1 : 0.9$ to $1 : 1.5$. Our best results were obtained with from 1.0 to 1.2 part of ferric salt to one part of platinum salt. A less or a greater proportion of ferric salt produces incomplete reduction of the platinum salt, and gives weak pictures with grey instead of black shadows. In order to explain this result in cases where a large excess of ferric oxalate is used, we can only suppose that, during the exposure necessary for producing the image, some of the ferric salt remains and settles itself in the interstices between the particles of ferrous and platinum salt, and that this remainder acts as a restrainer during the development.

The amount of platinum salt in relation to a given surface of the selected support for the image—paper, canvas, or wood—depends, in the first place, on the character of the result which it is desired to obtain. When deep blacks are required in the picture, we may estimate that for every thousand square centimetres of surface there should be from 0.02 to 0.025 gramme of potassium chloro-platinite. But it should be noted that, when the support is more porous and absorbent, the quantity of platinum salt must be increased somewhat, as, if the image has a tendency to sink into the support, part of the effect will be lost. On the other hand, when the picture is not to have any great depth, or when it is intended to retouch the image, or to paint over it (as, for instance, in the case of enlargement), the amount of platinum salt may be reduced. It is, therefore, necessary to dissolve the platinum and ferric salts in sufficient water, that the above-mentioned quantity of platinum salt may be equally distributed over the unit of surface of the support. Care must be taken that the solution is as concentrated as possible, in order to prevent it from sinking too much into the support. Further instructions on these points will be found in the practical details of the process.

II.—PRACTICAL DETAILS OF THE PROCESS.

From the results of our experiments, as already described in the foregoing theoretical division of this treatise, we have been able to construct a method for producing platinotypes which, we believe, will be found to be easy for any one to work. The details of this method we now proceed to give at some length. The process itself naturally falls into the following operations :—(1.) Preparation of the paper, or other suitable support; (2.) Sensitizing the same; (3.) Copying; (4.) Developing; (5.) Finishing the picture.

Choice and Preliminary Treatment of the Paper.

For the purposes of the platinum process any kind of properly sized paper is suitable, provided it has an even surface, and is free from all kinds of impurity, especially from particles of metal. As a general rule, therefore, the papers specially prepared for photographic work will be found best adapted for our object, since they comply most closely with the above-named conditions. In selecting the particular kind of paper two points must be carefully attended to, namely, its strength and the nature of its surface. Ordinary photographic papers, as bought in the shops, are rather too weak to withstand the manipulations presently to be described; they tear easily, and can therefore only be used for pictures of the smaller sizes. The stronger papers are also to be preferred to the weaker sorts for another reason—because of the greater vigour and brilliancy of the photographs taken on tough paper.

In deciding whether to use a paper with a smooth or with a rough surface, reference must be made to the nature of the picture it is required to copy. Pictures in which the finest details have to be reproduced, such as smaller portraits, should be taken on a smooth paper; those, on the other hand, which depend for their effect on the general impression they convey, or which have to be finished and coloured in pencil or chalk, like landscapes, copies of paintings, enlargements, &c., will be best taken on rough paper. This rough

paper must have a felt-like surface, not one showing the grain, as so many drawing-papers dô. Paper of this kind is seldom found in the market; it is a plain unglazed paper, which does not leave the mill in the state in which it is required for the platinum process, but only after being hot pressed.[1]

We ought also to warn our readers that ultramarine is used to blue many of the papers to be met with commercially, and that papers thus coloured turn yellow on being treated with hydrochloric acid. Any paper to be employed in the platinum process should therefore be tested for this pigment. It will be found that papers coloured with cobalt blue (smalt) are best suited for this purpose.

Paper which has been bought in the shops must, before being sensitised, be treated with a solution of gelatine arrow-root or algeine. This is done in order partially to close the pores of the paper, and so to prevent the sensitising solution from sinking too deeply into its substance. But the pores must not be quite stopped; otherwise the image, which consists of metallic platinum in a highly subdivided state, will be entirely on the surface of the paper, and is liable to be washed away in developing. For this reason albuminized paper, of which the film has been coagulated, or highly gelatinized paper cannot be used.

The strength of the gelatine, starch, or algeine solution, depends entirely on the kind of paper employed; paper not very strongly sized takes a concentrated solution, that more highly sized a more dilute solution, of gelatine. A couple of trials are sufficient to enable us to regulate this operation. In the papers tried by us,[2] whether smooth or rough, we used

[1] For the information of those who wish to take up platinum-printing, we may mention that the paper used by us in our work was made expressly for us by Messrs. Gustav Röder & Co., of No. 10, Wallfischgasse, Vienna I., at their paper-mills at Marschendorf. It bears the name of "ivory vellum paper," and may be obtained either hot pressed or unglazed.

[2] The paper we use is half sized (resin-size). More highly sized rough paper can be treated with a from 10 to 20 per cent. solution of dextrine, instead of gelatine or arrowroot; this is passed over the surface with a sponge. Dextrine forms a temporary coating, which prevents the sensitizing solution from penetrating too deeply, but which is again removed by developing and washing, so that the paper recovers its original velvety appearance.

baths containing 1 per cent. of gelatine or arrowroot.[1] Gelatine paper gives a bluish-black, arrowroot paper rather a brownish-black, tone ; and this difference of colour is more perceptible with smooth than with rough paper. The treatment of the papers by floating on these solutions will be an easy matter for those who are accustomed to prepare albumen or arrowroot paper ; those who have had no practice in the operation of floating will have some trouble to get rid of the air-bells which, especially in the case of rough paper, adhere to the surface. For the latter, it will be perhaps easier to dip the paper in the solution, as we ourselves generally do. The following is our practice in this operation :—

PREPARATION OF THE SOLUTIONS.

Gelatine.—Ten grammes of this substance[2] must be allowed to soften for about half an hour in 800 c.cm. of water; the water is then poured off into a clean porcelain or perfectly enamelled iron basin, and heated therein to about 60° C. The gelatine is placed in this hot water, and, when it is dissolved, 3 grammes of alum,[3] and 200 c.cm. of alcohol[4] are added ; such a solution does not set, if kept in a warm room (heated to 18° C.). It must be filtered through clean canvas into a porcelain or papier-mâché tray, which is somewhat longer than the paper on which the print is to be taken; and care must be taken that the bottom of this tray be not covered to a greater depth than 3 cm., or there will be some difficulty in dipping the paper properly into it.

Arrowroot.—Ten grammes of arrowroot are rubbed up in a mortar with a little water, and then poured slowly, with continuous stirring, into 800 c.cm. boiling water. After the liquid has boiled for a few moments, the vessel is taken from the fire, and to the thin paste thus formed 200 grammes of alcohol are added. The whole is then strained into a tray.

[1] Paper treated with algeine behaves just the same as that treated with arrowroot.

[2] Any kind of good gelatine, such as is used in collotyping or emulsion-making, may be used.

[3] The addition of alum makes the gelatine after drying insoluble, and therefore better able to resist the hot developing solution.

[4] Alcohol must in every case be added to the solution to prevent the formation of air-bells, which are liable to occur in large number.

Preparation of the Paper.

The paper is prepared in precisely the same way, whichever of the solutions is used. The sheets are dipped, one by one, gradually into the solution, with that side downwards which is to receive the print, beginning at one of the smaller edges. After any air-bells which may adhere to the surface have been removed by means of a hair brush, the sheet is drawn out of the solution, and then dipped into it again in a reversed position. By gently shaking the tray the sheet may be kept continually submerged in the liquid. After about two or three minutes of this bath, the sheet is held by two of its corners, and drawn out with a single rapid and continuous motion ; it is then fastened to a string by means of clips, or to a wooden rail by means of drawing-pins, and left hung up to dry. Air-bells which remain on the reversed side of the sheet need not be noticed ; but if there are any attached to the front side, they can be removed with the tip of the finger.

Drying the paper should be effected in a warm place, and the temperature must be such that the superfluous gelatine solution may drop off, and not collect at the lower edge of the sheet to set in a ridge. As, owing to the vertical position of the sheet during drying, the part towards the lower end will contain always more gelatine than the upper, the above-described operation will have to be repeated, taking care to hang it up, after it has been gelatinized the second time, with the originally upper edge downwards.

Coating the paper can be accomplished very rapidly ; if it be dried quickly (in winter near a stove, in summer exposed to the sun), the second application of gelatine can be undertaken from 15 to 20 minutes after the first. The sheets of paper, when perfectly dry, are kept ready for use, protected from dust and moisture. They will keep for any length of time, and can, therefore, be always kept in stock.

Preparation of other Supports.

Linen or other Fabrics.—These can be treated in the same way as paper. To keep them smooth, they should be stretched on wooden frames, after the second coating with gelatine, by

means of drawing-pins. Smaller pieces, which become creased in drying, can be made smooth again by pressing between sheets of cardboard.

Wood.—When this substance is employed as a support, it must be in the form of plates, planed or rubbed smooth by the carpenter ; these are then coated with a solution of gelatine, or a three per cent. part of arrowroot, until they no longer absorb moisture. So soon as they are dried on the surface, they can be kept ready for use between two boards, so as to prevent them from warping.

SENSITIZING THE PAPER.

The mixture of chloro-platinite of potassium and ferric oxalate, which, as mentioned above in the theory of the process, is used for sensitizing the paper, must, on account of its great sensitiveness, only be employed under a very faint light. Lamplight, by reason of its yellow colour, is not suitable for laying on the solution : the parts that are coated cannot be distinguished from those that are untouched, and it therefore becomes difficult to avoid leaving smears and other inequalities. Perhaps the most convenient light is that at the back of a room darkened by curtains, but, even then, great care must be taken to expose the sensitized paper only in the bare time required for coating, otherwise fogging is liable to be caused. During the operation, the bulk of the sensitizing solution must be kept in the dark : sufficient to sensitize a single sheet being each time measured off and brought to the light.

PREPARATION OF THE CHLORO-PLATINITE OF POTASSIUM.[1]

As only brief and scanty directions for preparing this salt are to be found in works on chemistry, we examined ourselves all the methods adapted to the purpose, and selected those which, on the one hand, worked in the simplest and

[1] The preparation of chloro-platinite, as well as that of ferric oxalate, are operations which can only be properly carried on in a chemical laboratory. Those who are not chemists will do best to obtain these salts from a chemical manufactory.

most rapid manner, and, on the other hand, gave the most productive result. For our raw material we naturally took the common chloride of platinum, which can be obtained everywhere commercially.

Our objection to the method generally given for the production of the required double salt—that by means of chloroplatinite of potassium and cuprous chloride—lies in the fact that it implies, first, the formation of the double chloride and afterwards the separation of the chloro-platinite of potassium from the cupric chloride. It therefore seemed to us to be more convenient to commence with the conversion of the platinic into the platinous chloride, and then from the latter to produce chloro-platinite of potassium by adding potassic chloride. The first of these operations is best effected by reducing with sulphurous acid. With this object 50 grammes of chloride of platinum are dissolved in 100 c.cm. of water, and the solution filtered, if necessary. This solution is then heated to 100° C. in a water bath, and a strong stream of washed sulphurous acid, in the gaseous state, is passed through it. After a while the intensely yellow liquid will begin to turn red, and this is a sign that the platinum chloride has for the greater part been converted into the platinous chloride. From time to time a drop of the liquid is removed by means of a glass rod, and tested, to see whether with a solution of ammonium chloride it produces the characteristic yellow precipitate of chloro-platinate of ammonium. This test is best performed by bringing together, on a watch-glass, a drop of the solution of sal-ammoniac and one of the solution of platinum. By a comparison of the quantity of precipitate formed, it is easy in this way to regulate the process of reduction ; if only a slight formation of the chloro-platinate of ammonium is observed, the stream of gas should be moderate, in order to prevent the reaction from being completed too quickly. So soon as there is no precipitate formed, and none can be produced by rubbing the watch-glass with the glass rod, the flow of gas must be at once interrupted. The conversion of the chloride is now complete, and any further flow of sulphurous acid would be injurious, since a continuation of it means loss of platinum. For, if the action of the gas be continued too long, the platinous chloride is converted into platinous sulphide—a salt which cannot be reduced by an organic ferrous salt. If, on

the other hand, the stream of gas is too soon interrupted, the liquid will still contain some platinic chloride, and this, when the solution of platinum is afterwards mixed with one of potassium chloride, will separate as insoluble chloro-platinite of potassium.

Hence the reduction of a solution of platinic chloride by means of sulphurous acid gas is an operation requiring the greatest care and attention, particularly towards the end. The solution thus obtained consists of a mixture of platinous chloride, sulphuric acid, and free hydrochloric acid. To convert it into chloro-platinite of potassium, it must be poured, when cold, into a porcelain basin, and a hot solution of 25 grammes of chloride of potassium[1] in 50 c.cm. of water mixed with it, stirring all the while. The chloro-platinite of potassium then separates in the form of a crystalline powder. After allowing this to cool for twenty-four hours, the crystalline precipitate is collected in a filter, and the mother-liquor is drained off; it is then washed with very little water, and afterwards with alcohol, until the latter has no longer an acid reaction.

The powder is now spread out on filtering-paper, and placed to dry in a room to which the light has no access. This precaution seems to be necessary, for the reason that a salt of platinum moistened with alcohol is very liable to become reduced if exposed to the light. The salt prepared in this way is perfectly pure, and in a state to be used for making the sensitizing fluid ; any further purification by recrystallization is therefore quite unnecessary. Provided the above directions are attended to, 74 or 75 grammes of the double salt will be obtained from every 100 grammes of platinic chloride, amounting to about 93 per cent. of the quantity which should be obtained on theoretical considerations. No effort need be made to obtain from the mother-liquor a still further production of potassium chloro-platinite. The former may be worked up with the other platinum residues.

When the chloro-platinite of potassium is bought from the manufacturer, it should be tested for purity in a twofold direction :—(1) One part of the salt should be completely

[1] An excess of potassium chloride is purposely used, in order to effect the complete separation of the double salt.

soluble in about six parts of cold water; and (2) the solution thus obtained must not possess an acid reaction. Both the salt and its solution resist perfectly the action of light and of the atmosphere, and no special precautions are therefore requisite in preserving them. For the production of platino-types, a solution is prepared of 1 part of the salt in six parts of distilled water, and this can always be kept in stock. We shall call this the normal solution of platinum.

PREPARATION OF THE FERRIC-OXALATE SOLUTION.

For the preparation of this solution of ferric-oxalate the following operations are necessary :—(1) Manufacturing the ferric hydrate; (2) dissolving that substance in oxalic acid; (3) determining the amount of iron and of oxalic acid contained in this solution; (4) diluting and acidulating the same.

The method of preparing ferric hydrate is generally well known, but for the sake of completeness we will give a brief description of it. Ferric chloride, 500 grammes, are dissolved in from five to six litres of water, and, when the solution has been brought to the boiling point, solution of soda is added until it gives with litmus paper a distinctly alkaline reaction. For this purpose about 250 grammes of caustic soda will be found necessary. The precipitate is then washed with hot water by decantation, until the wash-water is no longer alkaline. It is next placed in a cloth, and by pressure freed from the greater part of the water. With the ferric hydrate thus obtained, which ought to have a syrupy consistency, there should be mixed about 200 grammes of finely crystallized oxalic acid, and the mixture be then left to itself for a few days at a temperature of not more than 30° C., and in a place completely protected from the light; under these circumstances the formation of ferric oxalate will go on steadily. Some persons recommend the promotion of this process by digesting the mixture for some time at a high temperature; this we are decidedly opposed to, since, by heating for even a few hours to 50° or 60° C., the salt will be partially reduced to ferrous oxalate. At the commencement the solution has a pure green colour; by continued digestion it turns yellowish-green, and finally greenish-brown. When this moment has arrived the remaining ferric hydrate should be

filtered off, and the solution be submitted to a quantitative chemical analysis.[1]

Although the determination of the amount of iron and oxalic acid contained in the solution is one of the simplest of analytical operations, we tried at first to dispense with it. Closer investigation, however, proved to us how necessary it is to confine the relations between rather narrow limits, in order to ensure the success of the platino-ferric process. Now as ferric oxalate cannot be prepared in a stable form, so as to have a constant composition, there remains no other way than that of determining the composition of the solution by analysis and then diluting it to the required degree. Further it should be noted that any quantity of the solution may be prepared at once, and then kept in stock.

From the analysis we ascertain the quantity of ferric oxalate contained in 100 c.cm. of the solution, as well as any slight excess of oxalic acid which happens to be present. The liquid is then diluted with so much distilled water, that every 100 c.cm. of it may contain 20 grammes of ferric oxalate [$Fe_2(C_2O_4)_3$]. Crystallized oxalic acid is then added, until, with the free acid already in the mixture, that substance amounts to from 6 to 8 per cent. of the ferric oxalate already in the solution—the normal ferric solution.

An iron solution purchased from the chemist must be tested in the following manner before it is used :—It must not turn blue with a solution of ferricyanide of potassium (red prussiate of potash). When boiled and diluted with ten times its quantity of water, it must not become turbid. From the first reaction we ascertain the absence of ferrous salts ; from the second, that of basic ferric oxalate.

In order to introduce into the sensitizing solution some chlorate of potash, which in certain circumstances is necessary, the best way is to keep ready for use a mixture of chlorate and

[1] To perform this analysis a few c. centimètres of the solution are measured off, and the oxalic acid then determined from measure by means of permanganate of potash ; the amount of iron in the same liquid may be ascertained in the same way, after reduction by means of zinc. But it is perhaps more convenient to determine by weight the iron in a separate portion of the solution ; this can be done by evaporating, heating to redness, incinerating with nitrate of ammonia, and weighing the ferric oxide which remains.

ferric solutions. It can be prepared by measuring off a certain quantity of the normal ferric solution, and mixing with it so much chlorate of potash as to cause 100 c.cm. of the liquid to contain 0·4 gramme of the salt. This is the normal chlorate of iron solution.

Both the ferric solutions must be kept away from the light.

PREPARATION OF THE SENSITIZING SOLUTION.

The sensitizing liquid is prepared by mixing portions of the platinum and iron solutions and afterwards diluting with water. In the normal sensitizing solution we give the following prescription :—

24 c.cm. of platinum solution,
22 „ „ ferric solution,
4 „ „ water.[1]

This works very soft, with deep blacks.

In order to produce rather more brilliancy, the following composition may be used :—

24 c.cm. of platinum solution,
18 „ „ ferric solution,
4 „ „ ferric-chlorate solution,
4 „ „ water.

To obtain results corresponding to silver images mix—

24 c.cm. of platinum solution,
14 „ „ ferric solution,
8 „ „ ferric-chlorate solution,
4 „ „ water.

For very weak negatives, reproductions, engravings, &c.—

24 c.cm. of platinum solution,
22 „ „ ferric-chlorate solution,
4 „ „ water.

When the pictures have no perfectly black shadows, as in the reproduction of pencil drawings, the mixtures, as given above, may be diluted with half or equal volumes of water. If the solutions are to be applied to surfaces with but little

[1] Distilled water must always be used for diluting. Ordinary spring water contains lime, and produces turbidity owing to the formation of calcium oxalate.

absorbing power, *e.g.*, highly sized and hot-pressed paper, the addition of water to the mixtures may be altogether omitted.

COATING THE PAPER.

Immediately before using, one of the mixtures recommended above should be prepared by measure in a measuring-glass,[1] in quantity corresponding to the size of the sheet to be sensitized. While it is being coated, it will be best to keep the paper stretched, by means of clips, on a strong plate of glass which is only a little larger in dimension than the sheet itself. For this purpose we adopt the following simple arrangement.

FIG. I.

In Fig. I, A is the glass plate (a copying-frame plate), whose corners have been cut off obliquely for about $1\frac{1}{2}$ or 2 centim. It is kept fixed immovably on the top of a table, or on the surface of a plane drawing-board, B, by means of the little wooden ledges, *a, a, a, a*. At the corners of the board are screwed on small hooks, *b, b, b, b*, to which, by means of elastic threads, *c, c, c, c*, are attached the wooden clips, *d, d, d, d*.

[1] For the particular kind of paper which we had selected (the size of the sheet is 50 × 66 centim. = 3,300 sq. centim.), we used 10 cub. centim. of one of the above-mentioned aqueous solutions per sheet. This is according to the proportion of platinum and ferric salt per unit (1,000 sq. centim.) of surface, as obtained on theoretical considerations.

The sheet of paper to be sensitized is laid on the plate A, and kept stretched by the clips which seize the corners of the paper where they project over the edges of the glass. By means of this arrangement the paper remains stretched during the process of coating, since as fast as it expands, through absorption of the sensitizing liquid, the elastic threads contract and draw the clips outwards. When a smaller sheet is to be coated, or when an experiment merely is being tried, it will be sufficient to stretch the paper to be sensitized on a clean plane drawing-board by means of a couple of drawing-pins, taking care, however, to prevent the sensitizing liquid from coming in contact with these latter, or it will be contaminated.

The platino-ferric solution is now poured into a shallow basin, and then spread equally over the surface of the paper with a flannel pad. The pad is drawn, without pressing,[1] in every direction backwards and forwards, until the sheet is every-where equally moist, and appears to be quite free from streaks. Instead of the flannel pad, a soft bristle brush, mounted on a wooden handle, may be used with effect for applying the solu-tion, and it may then be distributed equally by means of a round brush, also mounted in wood. When the sheet is sen-sitized, it must be hung up, by means of clips or drawing-pins, in a dark room, and so soon as the moisture has disappeared from the surface, it is left to dry quickly at a moderate tem-perature (30° to 40° C.) near a stove or in a drying-oven.

Great attention must be paid to the operation of drying, as an error therein may jeopardise the success of the whole process. If the paper is placed too soon to dry in the warmth, the sen-sitizing liquid will remain too much on the surface of the paper, and the image is liable to come off in developing. On the other hand, if the paper is left too long before being hot-dried, the sensitizing liquid sinks too deeply into the substance of the paper, and the print will be weak, without soft blacks. As a rule, the operation of drying, reckoning from the time when the coating is completed, should not extend over a longer period than ten minutes. In the rapid desiccation, the limits of temperature above given should not be exceeded, otherwise

[1] Any strong rubbing with the pad, particularly when the paper is rough, may affect the homogeneity of the film, and the picture when finished has a grainy appearance in the half-tones.

partial reduction of the salt of iron may take place, even though protected from the action of light.

The flannel pad should be changed every quarter of an hour. As the paper is coated with the sensitizing solution by weak daylight, and the pad is therefore exposed to light to a certain extent during the operation, the ferric oxalate absorbed by it is reduced, though the reduction may only be very slight. It should also be remembered that the sensitizing solution, when once mixed, will gradually decompose, even though kept carefully in the dark. Hence, with continuous use of the same pad, some of the ferrous oxalate would be left on the paper, and produce spots and streaks on the picture after development. When a brush is used to apply the sensitizer, it should be washed from time to time in clean water. For the reason above given, the sensitizing solution should be all used up as soon as possible, and it is also distinctly necessary to mix only so much of the solution as will be directly required.

When thoroughly dry, the sheets of sensitive paper, as well as the finished copies, are kept in chloride of calcium boxes. The construction of a box of this kind is shown in the cuts below (Figs. 2 and 3). A is the space in which the papers are

Fig. 2. Fig. 3.

kept. The cover B is divided into two parts : the lower part, C, which is placed on the top of the box, consists of a cylinder, a, perforated with holes, like a sieve, sliding into the box A, and contains some lumps of perfectly dry chloride of calcium,

D

wrapped in a piece of swansdown calico. The upper part D fits on to and closes the top of the cylinder, *a*. In damp localities it will be well to keep the slots, *m*, *m*, air-tight by slipping over them an elastic ring. From time to time the calcium chloride should be examined to see that it is perfectly dry. If it is observed to be at all moist, it must be changed for a fresh and dry supply. Damp calcium chloride can readily be deprived of its moisture by heating in an iron vessel, and so rendering it again fit for use.

An indispensable condition of obtaining good prints is the absolute dryness of the paper, both before and after copying. Moist paper will give, probably in consequence of more or less reduction of the ferric salt, weak and foggy images; moreover, its sensitiveness is less. For this reason it is advisable to place a piece of waterproof cloth in the printing-frame behind the sensitized paper, and this will protect the paper from any atmospheric influence while it is being printed. In damp weather it may be necessary to warm and dry the pad of the printing-frame before arranging the latter.

PRINTING THE PICTURE.

Printing in platinum-printing requires greater care than in silver-printing, because the actinic impression, although distinct, is, comparatively speaking, only faintly visible. It is necessary to get accustomed to controlling the progress of the printing-operation; but the experience for this purpose is acquired after a few trials. By the action of the light, the yellow colour of the paper becomes changed to brown, and after longer exposure this again turns of a lighter shade, so that often the deepest shadows appear lighter than the darker half-tones.

Accurate instructions as to the time required for printing can, of course, not be here given, as it depends entirely on the density of the negative and on the conditions of light prevailing at the moment. We can, however, state with certainty that platinum paper is at least three times as sensitive as silver paper, and that this greater sensitiveness makes itself more felt in dull than in bright weather. This is owing to the greater sensitiveness of ferric oxalate to the less refrangible rays of the spectrum. For a good portrait negative of average intensity, we gave from

twenty to twenty-five minutes with a clear sky in April; with a thinner negative we printed for fifteen minutes. When the prints have been taken, and it is not desired to develop them at once, they are kept, as already described, in a chloride of calcium box.

DEVELOPING THE PICTURE.

To develop the picture we take a saturated (in the cold) solution of potassium-oxalate,[1] acidulated with oxalic acid.[2] For heating the solution we may employ either a glass boiling-flask or a vessel of enamelled iron ; but this supposes that only a small number of pictures of moderate size are to be developed in a basin by pouring the solution over them. When they are of large size and in greater number this method would not answer, as the solution cools by being poured over the picture, and therefore will have to be heated afresh.

FIG. 4.

In this case we prefer to use a vessel of flat or bent enamelled iron of the same width as the picture, which can be placed over a water bath. The section of a developing-tray of this kind is shown in Fig. 4; A is the enamelled iron vessel, containing the oxalate solution, a its cover of zinc plate ; B is another hollow vessel, with double wall of zinc plate, which acts as the water bath; C is a gas or spirit lamp. The vessel B is filled with hot water through a tube let into the upper side, and the hot solution of oxalate is then poured into the tray A ; it can readily be kept at the required temperature by means of the lamp underneath. To develop it, each print is taken separately

[1] For other good developing solutions, see Part II, " The Theory of the Process."

[2] In Part II it is explained why the solution of potassium-oxalate must have an acid reaction.

by two opposite sides and drawn slowly through the solution.[1] Development takes place at once, the brown colour changing immediately to a deep black.

If, by chance, any part of the picture does not come in contact with the solution, as, for instance, where any air-bells adhere to it, it must be again drawn through the solution. When there is danger of the print having been too long copied, a somewhat cooler solution of potassium-oxalate may be used, though the hot solution always works best. The temperature of 80° C., as given above, may be exceeded when the print has been copied for too short a time; we have ourselves very often employed a developing solution in a boiling state.

Finally, we would again direct the attention of our readers to the remarks in Part II, "The Theory of the Process," on the necessity of having always an acid reaction in the developer. When the solution is kept continuously at a high temperature, it may happen that the evaporation will cause crystals of potassium-oxalate to form, which will be deposited on the sides of the vessel; those being over-heated will partially decompose and form potassium-carbonate, so that in certain circumstances the solution will become alkaline. It is therefore imperatively necessary to keep testing the liquid from time to time with litmus paper, and, if necessary, to acidulate the developer with oxalic acid.

After being used, the developing solution may be poured back into a flask, and can be employed again. The water which has evaporated should occasionally be replaced, and, as often as necessary, fresh potassium-oxalate should be added.

Finishing the Picture.

Directly the picture is developed it must be immersed in a solution of

Hydrochloric acid	1 part,
Water...	80 parts,

and left there until any of the iron-salt still present has been removed. This solution of hydrochloric acid must be changed

[1] To prevent the hands from coming into contact with the liquid, it is advisable to hold the print with a forceps made of bone or horn.

(twice or three times) until it no longer turns yellow. We ourselves generally change the solution three times, and leave the print in it each time for about ten minutes.

Finally, the print should be laid for a short time in a pan of water in order to remove the hydrochloric acid : ten to fifteen minutes will suffice for this purpose. Should any hydrochloric acid remain in the paper, it would not have any bad effect on the print itself, but might injure the substance of the paper, so that in the course of time it would be destroyed. To be perfectly easy on this point, it may be advisable to try the last wash-water with litmus paper, whether it comes off quite neutral.

After washing, the picture is dried in the ordinary way, and can then, if desired, be mounted on cardboard. Prints on smooth paper may be hot-pressed, to give them a slight sheen, which brings up the deep parts.

Prints on wood or linen are treated just the same as those on paper. As the plates of wood are very liable to warp, through being moistened with the sensitizing solution and then heated to dry, they should be fastened by small points cr drawing-pins flat on a strong board. Linen can be kept stretched on wooden frames after being coated with the sensitiser.

At this point we ought further to point out that platinum prints in a wet state appear always more brilliant and lighter than they do when dry. A print, therefore, which while still wet after development seems to be quite right as regards tone, would be too dark when dried.

RETOUCHING PLATINUM PRINTS.

As the prints have a smooth horny surface like albumen pictures, they lend themselves admirably to retouching, either with colour or chalk, and may even be painted or drawn upon all over. Their permanence and the absence of any substance in the film which can affect the applied colouring material protect them from the defect which in silver prints always presents itself after a time,—that is, the parts which have been painted or drawn over are observed to vary very disagreeably in colour-tone from the copy. Many sorts permit any kind of retouching ; others again, as, for instance, those which are not properly sized, become disintegrated, and fall to pieces when

treated with a hot solution of ferric oxalate and dilute sulphuric acid. Such papers as these should, after being washed, be dipped for several minutes in a saturated solution of alum ; they should then be dried, either with or without previous washing.

Defects, their Cause and Remedy.

1. The pictures are vigorous, but more or less fogged.
 a. *Cause.*—The paper was affected by light, either in sensitizing or printing.
 To prevent it, sensitize only under a weak light, and dry either in complete darkness or by lamplight. When examining the course of the copying operation, be careful to avoid too strong a light in arranging the frame.
 b. *Cause.*—Too high a temperature in drying.
 It should not exceed 40° C.
 c. *Cause.*—Spoiled ferric solution.
 The ferric solution is best preserved from the influence of light by being kept in a hyalite flask. If you are not confident as to your solution, you must assure yourself, before using it, by testing with red prussiate of potash, that it is free from ferrous salt. Should it contain only a trace of ferrous salt, it can be made fit for use again by carefully adding red prussiate of potash. In order to try this, mix a few cub. centims. of the normal ferric-chlorate solution with every 100 cub. centims. of the iron solution, and ascertain, by actual experiment on paper, whether the restoration is complete.
 d. *Cause.*—Too long exposure in the copying-frame.
 The time of copying should be shortened, and, if the picture is not yet developed, use a cold developer.
2. The prints appear weak under the developer.
 a. *Cause.*—Paper which has become damp.
 The paper should always be kept in the chloride of calcium box, even after being printed, if not immediately developed. Paper once spoiled cannot be made good again.

b. Cause.—The paper is too old.

Paper can generally be kept in good condition for at least six or eight weeks, and sometimes even more ; but after that time a gradual change appears to take place, even though it be kept in the dark, and not only weak, but also fogged, pictures are the result. As neither time nor trouble are required for sensitizing the paper, we recommend only to make at once as much as may be necessary for use during three or four weeks.

c. Cause.—Weak negatives.

Use more chlorate of potash in the sensitizing solution.

3. The prints come out vigorous in developing, but become weak after being dried.

a. Cause.—Paper not sufficiently sized, for which reason the images sink into its substance.

When this is the case, employ stronger solutions of gelatine or arrowroot.

b. Cause.—Drying has been too slow.

The drying process should not take longer than ten minutes ; if this is exceeded, the sensitizing solution sinks too deeply into the paper.

4. The whites of the print have, after drying, a more or less yellowish tinge.

a. Cause.—The sensitizing solution in the developer is not sufficiently acid.

Attention should be paid to the instructions on this point in the previous divisions of the subject.

b. Cause.—Insufficient immersion in hydrochloric acid.

The solution of hydrochloric acid must be changed two or three times until the last change no longer turns yellow at the end of ten minutes.

c. Cause. Paper blued with ultramarine, which when treated with hydrochloric acid turns yellow.

Before using the paper, you must be certain that its colour does not suffer from contact with a hot solution of oxalate and from treatment with hydrochloric acid.

5. The prints come out hard.

a. Cause.—Exposure too short.

b. Cause.—Too much chlorate in the sensitizing solution

The remedy for this defect stands to reason.

6. Spots and streaks.
 Causes.—Dirty brushes; ·touching the paper with wet fingers; dirty glass plates, vessels not kept clean, &c.
7. Black spots.
 a. Causes.—Particles of metal imbedded in the substance of the paper, causing a reduction of the platinum.
 b. Causes.—May be due also to insoluble impurities in the chloro-platinite of potassium. These spots have a black nucleus, with an extension, like the tail of a comet, of lighter colour.
 In such a case, filter the sensitizing solution.

USING UP THE PLATINUM RESIDUES.

Considering the high price of platinum, it will reward the operator carefully to collect all the waste and residues from this process, and to convert them again into the metal or the chloride of the metal.

1. *Using up old Developers.*—With proper treatment, we can work with the same developing solution for a considerable time; only when it becomes overloaded with salts of iron to such an extent that crystals separate, or that the colour of the liquid begins to turn dark yellow, will it be advisable to have recourse to a fresh developing solution.

Old solutions of this kind are best used up in the following way. The solution is mixed with about one-fourth its volume of a saturated solution of ferrous sulphate and heated to boiling point in a porcelain basin. Platinum then separates in the metallic state, and can be collected on a filter. The filtrate is a solution of ferrous oxalate, and can, in the same way as the old iron developer of the negative process, be converted into potassium oxalate.

2. *Using up waste Platinum-paper, spoiled Prints, &c.*—The whole of the paper, linen, flannel, &c., containing any salt of platinum or metallic platinum, is collected, and, when a considerable quantity has been brought together, it is incinerated. The ashes remaining after the incineration are stirred up into a thin paste with a mixture of three parts concentrated hydrochloric acid and one part nitric acid; this is then set to digest for a few hours at a temperature of from $50°$ to $70°$ C. After this, it is diluted with an equal quantity of water, then filtered, and the

insoluble remainder washed in the filter with water. From the filtrate and wash-water the platinum is precipitated by adding ammonia, as chloro-platinate of ammonium, and this being heated to redness is then converted into metallic platinum.

3. *Residues of the sensitizing Solution.*—Any other liquids containing platinum may be mixed with the filtrate obtained by the method described under (2) ; they can then be worked up together. The metallic platinum obtained by (1) and (2) must be digested in hot hydrochloric acid, to get rid of any remaining trace of iron, and then converted by the well-known method into platinum-chloride by means of *aqua regia.*

Value of the Platinotype Process.

The chief advantages of this process are (1) the simple nature of the manipulation, which can be carried out much more plainly and readily than in any other printing process ; (2) the great sensitiveness, to which attention has been already drawn ; (3) the perfect permanence of the prints ; (4) the peculiar character of the pictures, which, from an art point of view, give them a much higher value than belongs to silver prints. Owing to the exceeding sensitiveness of the platinum process, from three to four times as many prints may be taken in the same time as is possible with the silver process. This advantage should, as we have already pointed out in the Introduction, be appreciated in dull weather, more especially in winter-time, when printing by the silver process is nearly impossible.

After being printed, the pictures can be completely finished in half an hour, and are then ready to be mounted. All the wearisome washing, toning, fixing, and again washing, which are necessary for silver prints, are dispensed with in the platinum process, and the great care which must be taken to obtain good results by the former is quite unnecessary in the latter process. Only very careless treatment causes the picture to be spoiled. For producing platinum prints only one opera-tion—that of sensitizing—requires any degree of attention ; while, for silver prints, time, trouble, and care must all be given to obtain pictures which, after all, are only of doubtful perma-nence. When we take into consideration also that if silver prints are not washed with extreme care and attention they, in

a short time, are quite spoiled, while a mistake in the same direction with platinotypes is of no importance, we cannot fail to see the great advantage which platinum prints possess over those in silver.

Even most carefully prepared silver prints fade in the course of time, owing to the finely divided silver and gold not being able to resist for any length of time the influences to which even under the most favourable circumstances they must be submitted. Now, in the platinotype the image consists of platinum—metal which can be attacked by scarcely any known reagents. There can, therefore, be no doubt that such an image may be regarded as completely unchangeable. According to our own experiments repeatedly made, the image is quite unaltered after being submitted for hours to the action of hydrochloric acid, mixtures of hydrochloric and sulphuric acids, even of solution of calcium chloride; only *aqua regia* was able to affect it, and then the paper itself was also destroyed; while nitric and sulphuric acids, ammonia, caustic potash, and potassium cyanide were equally without effect.

We have been greatly puzzled by the statement of Van Monckhoven[1] that platinum images are quite as liable to fade as those of gold; according to his view, platinum is attacked by the compounds of sulphur and of chlorine which are found in the atmosphere. This opinion appears to us, to say the least, a rash one, for there can be no doubt that platinum has a far greater power of resisting chemical action than gold. Gold[2] is acted on by gaseous chlorine, as well as by liquids containing bromine and iodine; it is even dissolved by aqueous solutions of sodium chloride, potassium nitrate, alum, &c., while platinum is not affected by anhydrous liquid chlorine, and even a stream of chlorine gas at so high a temperature as $200°$ C. produces scarcely any effect on spongy platinum. From this remarkable power of resistance of metallic platinum even in a finely divided state, it may be concluded that a platinotype will never be affected by any traces of sodium chloride or of sulphur-compounds which may be present in the atmosphere.

[1] " Bulletin de l'Association Belge de Photographie," vol. vi, p. 335.

[2] Gmelin's " Handbook of Inorganic Chemistry," vol. iii, pp. 1007 and 1058.

When the paper is prepared with gelatine the tone of the platinum print is a pure black; when arrowroot is employed, a sepia-brown; the deep shadows are velvety, the modelling tender, and the high lights a pure white. Rough paper is free from glitter, and gives the pictures the appearance of etchings; smooth paper, when hot-pressed, has a dull sheen, which makes the details of the picture come out clearer. The great depth of the shadows is characteristic of platinum prints, and this cannot be obtained in silver prints without employing a brilliant coating of albumen.

Our opinion is that the process will become very popular, but that it will probably not supersede that of silver printing. In the latter process, on the one hand, the operation of copying is more easily regulated; on the other, the public is too much accustomed to the brilliancy and colour of the silver prints. But for certain purposes, for instance for enlargements, reproduction, and copies from landscape negatives, the platinum process will, we believe, have the decided preference. Especially for amateurs this process offers advantages which cannot be overrated, on account of the simple nature and rapidity of the operations, and particularly on account of the small number of instruments and apparatus necessary for working it.

INDEX.

THE LITERATURE OF PHOTOGRAPHY
AN ARNO PRESS COLLECTION

Anderson, A. J. **The Artistic Side of Photography in Theory and Practice.** London, 1910

Anderson, Paul L. **The Fine Art of Photography.** Philadelphia and London, 1919

Beck, Otto Walter. **Art Principles in Portrait Photography.** New York, 1907

Bingham, Robert J. **Photogenic Manipulation.** Part I, 9th edition; Part II, 5th edition. London, 1852

Bisbee, A. **The History and Practice of Daguerreotype.** Dayton, Ohio, 1853

Boord, W. Arthur, editor. **Sun Artists** (Original Series). Nos. I-VIII. London, 1891

Burbank, W. H. **Photographic Printing Methods.** 3rd edition. New York, 1891

Burgess, N. G. **The Photograph Manual.** 8th edition. New York, 1863

Coates, James. **Photographing the Invisible.** Chicago and London, 1911

The Collodion Process and the Ferrotype: Three Accounts, 1854-1872. New York, 1973

Croucher, J. H. and Gustave Le Gray. **Plain Directions for Obtaining Photographic Pictures.** Parts I, II, & III. Philadelphia, 1853

The Daguerreotype Process: Three Treatises, 1840-1849. New York, 1973

Delamotte, Philip H. **The Practice of Photography.** 2nd edition. London, 1855

Draper, John William. **Scientific Memoirs.** London, 1878

Emerson, Peter Henry. **Naturalistic Photography for Students of the Art.** 1st edition. London, 1889

*Emerson, Peter Henry. **Naturalistic Photography for Students of the Art.** 3rd edition. *Including* The Death of Naturalistic Photography, London, 1891. New York, 1899

Fenton, Roger. **Roger Fenton, Photographer of the Crimean War.** With an Essay on his Life and Work by Helmut and Alison Gernsheim. London, 1954

Fouque, Victor. **The Truth Concerning the Invention of Photography:** Nicéphore Niépce—His Life, Letters and Works. Translated by Edward Epstean from the original French edition, Paris, 1867. New York, 1935

Fraprie, Frank R. and Walter E. Woodbury. **Photographic Amusements Including Tricks and Unusual or Novel Effects Obtainable with the Camera.** 10th edition. Boston, 1931

Gillies, John Wallace. **Principles of Pictorial Photography.** New York, 1923

Gower, H. D., L. Stanley Jast, & W. W. Topley. **The Camera As Historian.** London, 1916

Guest, Antony. **Art and the Camera.** London, 1907

Harrison, W. Jerome. **A History of Photography Written As a Practical Guide and an Introduction to Its Latest Developments.** New York, 1887

Hartmann, Sadakichi (Sidney Allan). **Composition in Portraiture.** New York, 1909

Hartmann, Sadakichi (Sidney Allan). **Landscape and Figure Composition.** New York, 1910

Hepworth, T. C. **Evening Work for Amateur Photographers.** London, 1890

*Hicks, Wilson. **Words and Pictures.** New York, 1952

Hill, Levi L. and W. McCartey, Jr. **A Treatise on Daguerreotype.** Parts I, II, III, & IV. Lexington, N.Y., 1850

Humphrey, S. D. **American Hand Book of the Daguerreotype.** 5th edition. New York, 1858

Hunt, Robert. **A Manual of Photography.** 3rd edition. London, 1853

Hunt, Robert. **Researches on Light.** London, 1844

Jones, Bernard E., editor. **Cassell's Cyclopaedia of Photography.** London, 1911

Lerebours, N. P. **A Treatise on Photography.** London, 1843

Litchfield, R. B. **Tom Wedgwood, The First Photographer.** London, 1903

Maclean, Hector. **Photography for Artists.** London, 1896

Martin, Paul. **Victorian Snapshots.** London, 1939

Mortensen, William. **Monsters and Madonnas.** San Francisco, 1936

*Nonsilver Printing Processes: Four Selections, 1886-1927. New York, 1973

Ourdan, J. P. **The Art of Retouching by Burrows & Colton.** Revised by the author. 1st American edition. New York, 1880

Potonniée, Georges. **The History of the Discovery of Photography.** New York, 1936

Price, [William] Lake. **A Manual of Photographic Manipulation.** 2nd edition. London, 1868

Pritchard, H. Baden. **About Photography and Photographers.** New York, 1883

Pritchard, H. Baden. **The Photographic Studios of Europe.** London, 1882

Robinson, H[enry] P[each] and Capt. [W. de W.] Abney. **The Art and Practice of Silver Printing.** The American edition. New York, 1881

Robinson, H[enry] P[each]. **The Elements of a Pictorial Photograph.** Bradford, 1898

Robinson, H[enry] P[each]. **Letters on Landscape Photography.** New York, 1888

Robinson, H[enry] P[each]. **Picture-Making by Photography.** 5th edition. London, 1897

Robinson, H[enry] P[each]. **The Studio, and What to Do in It.** London, 1891

Rodgers, H. J. **Twenty-three Years under a Sky-light,** or Life and Experiences of a Photographer. Hartford, Conn., 1872

Roh, Franz and Jan Tschichold, editors. **Foto-auge, Oeil et Photo, Photo-eye.** 76 Photos of the Period. Stuttgart, Ger., 1929

Ryder, James F. **Voigtländer and I:** In Pursuit of Shadow Catching. Cleveland, 1902

Society for Promoting Christian Knowledge. **The Wonders of Light and Shadow.** London, 1851

Sparling, W. **Theory and Practice of the Photographic Art.** London, 1856

Tissandier, Gaston. **A History and Handbook of Photography.** Edited by J. Thomson. 2nd edition. London, 1878

University of Pennsylvania. **Animal Locomotion. The Muybridge Work at the University of Pennsylvania.** Philadelphia, 1888

Vitray, Laura, John Mills, Jr., and Roscoe Ellard. **Pictorial Journalism.** New York and London, 1939

Vogel, Hermann. **The Chemistry of Light and Photography.** New York, 1875

Wall, A. H. **Artistic Landscape Photography.** London, [1896]

Wall, Alfred H. **A Manual of Artistic Colouring, As Applied to Photographs.** London, 1861

Werge, John. **The Evolution of Photography.** London, 1890

Wilson, Edward L. **The American Carbon Manual.** New York, 1868

Wilson, Edward L. **Wilson's Photographics.** New York, 1881